PARANORMAL
ANGLESEY

Bunty Austin

D1470661

AMBERLEY

First published 2013

Amberley Publishing
The Hill, Stroud
Gloucestershire, GL5 4EP

www.amberley-books.com

British Library Cataloguing in Publication Data.
A catalogue record for this book is available from the British Library.

ISBN 978 1 84868 315 0

Typeset in 10pt on 12pt Sabon.
Typesetting and Origination by Amberley Publishing.
Printed in the UK.

Contents

Foreword

Once more I had the pleasurable, but hard task of gleaning the fruits of Anglesey folklore. Stories of haunting and the reasons behind them are fast dying out; this generation is one of the first to grow up on a diet of such transient things as Facebook and Twitter, with no curiosity about the fascinating world of ghosts and legends. So here is another offering, given by people of wide experience in all forms of life and work, who want to know why and how these inexplicable things take place.

I have gone to great trouble to verify (as far as is possible) the truth of a particular story, in fact I've followed up so many clues, I now feel I could qualify as a private detective! But please, keep the stories coming, they are invaluable, and only belong to Anglesey – no other island has such a rich store of history, which must be kept alive at all costs.

Bunty Austin

Acknowledgements

Here are my heartfelt thanks once again to everyone who has gone out of their way to help me complete this book. These kind people come from many and varied areas of work and life. I can't name them all here, most of them are named in the stories they provided, but here are a few:

Mr John Owen, Tanrallt Farm, for his very wise advice, and his tenacious ability to track down names and numbers of people with various knowledge of obscure stories; Mr Barry Hodgson, retired Liverpool pilot and deep-sea skipper, who told me of the lives and deaths of many of his fellow pilots; Mr and Mrs Arthur Lane for stories of their house; and Mr Lane's wide nautical knowledge from when he was in the Merchant Navy.

Once again, for their great help and kindness, thank you to the ladies of Amlwch Library and the staff at the County Archives.

Thanks to Mrs Sarah Parker, at Amberley Publishing, for her unfailing cheerfulness and very hard work, and for young Alice who sends me any favoured reviews to keep my spirits up (withholding the negative ones, I think!)

I can't name everyone, they are numerous, but they know themselves how grateful I am, and in what high regard they are each held.

Thank you, and God Bless.

Bunty Austin

CHAPTER 1

The Nurse's Tale

In our district we are fortunate to have a very able community nurse, who performs her taxing job with cheerfulness and care. Last week, she told me the sort of small, impressive story, which enables me to write up all the true folk lore of Anglesey. This is the story that Mrs Julie O'Connor told me to pass on:

When I was about eleven years old in the early 1970s a little gang of us used to play out at night. We all lived in Llanerchymedd, a big village in the heart of Anglesey, where at one time, over 250 shoemakers plied their trade; mainly clogs and boots for all the working men. If you have ever been to Llanerchymedd, you will know where the square is; opposite to the church stands a very big, very old building made of stone, which was once a thriving successful hotel called the Kings Head. When trade (shipping, mining, shoe-making etc.) was at its zenith, the bedrooms of the Kings Head were always full. It had a large dining room and was well known for its delicious food and a big friendly bar that was always warm in winter with roaring, crackling log fires.

As a child I used to work there, quite a few of us did at different times. We used to prepare vegetables, wash dishes, carry coal in, and suchlike jobs. We all enjoyed it in our own ways. I used to carry used dishes from the dining room to the kitchen; that was the one job I didn't like. I had to go through the cellars to where the dishes were washed in the back-kitchen, and I used to run through the cellars to get there. The cellars were horrible, they had such a bad feeling about them. Although there was nobody about, I always felt as if there was someone there that I couldn't see; someone waiting and watching me.

Anyway, when the boom years passed, the hotel became emptier. In the end the owners had to cut their losses and close it. No-one bought it, and it started to crumble into disrepair – it was sad to see. Although no-one broke in, I don't think, the porch door, which had a lot of glass in, was smashed along with the lock, and anyone could walk in. But the front door was thick, solid wood, and no-one could open that without a key. The porch itself was the size of a small room; it was a grand entrance in its day, but now the floor was littered with broken glass from the porch windows.

I haven't got a clue how old the King's Head Hotel was. I was told it was very, very old, and it was a great shame to see a once-grand building falling into decay. Well, like I said, a little gang of us, all about eleven years old, used to go out and play at night, winter or summer. One time, I shall never forget it, on an early winter's night, it was quite dark and we were playing in the square when it started to rain. Not much, just a fine drizzle, but we

thought we would go and shelter in the porch at the King's. Which we did; we all piled in, two boys and three girls. I can't remember what the boys were called, but I do remember the girls, Sandra, Irene and myself.

When we got in, we pushed the porch door closed, and we could hear the rain, heavier now, and pattering on the roof. It was very quiet, and a bit spooky, and I told the kids about the cellars, and how it always felt like there was somebody in them. Of course, that led to everybody telling ghost stories, and trying to frighten each other to death. The two lads were leaning against the big front door of the hotel, and one of them did a crafty back kick on it, and it made a loud bang. That made us all jump, I can tell you, but the other lad had been leaning next to him and he felt him kick so knew it was him.

Anyway, we all told him off and made him come and stand with the rest of us, leaning against the porch door. His mate came too, so that we were all looking out through the broken windows. We were pretty quiet by then, feeling a bit bored, and wondering what to do next, when all of a sudden there came an explosive, booming bang at the bottom of the front door of the hotel. It came from the inside and the stout oak door shuddered in its frame; it was so loud and sudden. Even the porch shook, and a few bits of the remaining window glass tinkled to the floor.

For an instant we all stood petrified, then as one, the five of us flew out of the porch, straight across the road, and we didn't stop until we had reached the other side of the square, directly opposite the King's Head. We were all so terrified we stood speechless for a moment, looking back at the hotel. It stood dark and deserted with no sign of any living body, when suddenly I noticed something. "Look," I whispered, and pointed with a trembling finger. On the first floor of the hotel were seven bedrooms. I knew that because I had so often taken the used sheets and towels downstairs, while the chamber-maids made up each bed with fresh linen.

Everyone looked up, and there was a sharp intake of breath. In the bedroom on the furthermost left-hand side, a dim light flickered. As we stared, it moved slowly across the bare window panes, it was the light of a candle, in an old-fashioned candle-stick.

It guttered and glowed until it had crossed the breadth of the window; when it reached the edge it vanished. It then appeared immediately in the window of the next room, where it guttered and glimmered across that window too. So it went on, across one window and on to the next, until it came to the edge of the extreme-right window, and all the windows ended. Then it vanished.

I watched in disbelief, there had been no lapse of time for whoever, or whatever, was carrying the candle to have crossed each room, gone out of the door, entered the next room, and moved to the window to show the light there.

"What was it?" whispered Sandra.

"I don't know, but whatever it was, it must have walked through the walls," I said.

CHAPTER 2

'And in the Dead Corner...'

The dining door opened and Sid's head appeared.

'Have either of you two just moved a 15-amp plug off the hall table?' he asked. We both looked at each other, then at Sid. 'Not guilty your honour,' said Mike, 'I've never moved out of the room.'

'Me neither,' I said, 'Perhaps it's fallen down the back.'

'While you're about it,' Mike called to the retreating head, 'see if you can find my big screwdriver, it has gone walk-about.'

We went on with our work. A lady had moved into a big old house in Llangefni and had spent a lot of money redecorating it. The whole place had been re-done, and she had only just finished having it papered and painted inside. Putting a new plug in for a kettle, we had found the electricity was ancient, rotting, and had to all be replaced. Well, of course, she wasn't best pleased, it meant thousands of pounds would be needed, and all, or nearly all, of her new interior decorating would be ruined. We'd only been in the house two days, but we weren't enjoying it. Although newly papered and painted all white, the whole place felt dark and gloomy, one of those houses that make you feel depressed as soon as you walk in.

'Well it's time for dinner,' I said, laying down my wire-cutters, 'and am I ready for a brew.' We got up from where we were kneeling near the cistern cupboard, and picked up our sandwich boxes off the pile of jackets. 'Sid!' I yelled, 'dinner time!' There was a grunt from Sid and we all made for the kitchen. While we were eating, we talked about the rugby, and football, and what rubbish they put on television every night. Then in a lull in the conversation, I said, 'I went for a pint at the Bull last night, and one of the blokes told me this place was haunted.'

'What? This house?' Mike asked.

'Yes, when I told them where we were working, he said everybody knew about it, that's why it's been on the market for so long, and he was surprised it had gone at last.'

'What's it supposed to be haunted by?' Mike said curiously.

'As I can gather, the ghost is, or was, a big bloke who used to be a wrestler. The story is that he used to travel round the country putting on shows, and he came home early one week and found his wife in bed with another man.'

'Blimey!' said Mike, intrigued.

'He is supposed to have knocked the bloke out, and his wife ran into the bathroom and locked herself in, but he bashed the door down, and strangled her, then he kicked the man to death.'

'How did everybody find out?' asked Mike.

'Well, apparently he was overcome with remorse, because he loved his wife, and he went down to the police station and gave himself up. So now it's his ghost that haunts the place, he's looking for his wife to say he's sorry.'

'Poppycock!' Sid muttered indistinctly through half a corned beef sandwich. He swallowed hastily and said 'No such thing as ghosts, I'll believe in them when I see one, and that's not likely.'

He delved into his lunch box again, pulled out a large ginger-bread man, complete with eyes and buttons, stared at it, harrumphed at it, and bit its head off. At that moment, while we were still drinking tea, with that funny taste it gets in a thermos flask, and finishing the last of our food, we heard footsteps going along the landing above us.

'Down here Bill, in the kitchen!' Sid yelled. Bill was the boss, working on another job nearby. We sat and waited for him to come downstairs. Nothing happened. 'What's he doing?' Sid asked. 'Bill we're having our dinner!' he shouted again. Silence. 'Going deaf in his old age,' Sid grumbled. He got up and, opening the kitchen door, walked a few steps along the hall. He paused, and then we heard him go upstairs. He went along the landing, and we could hear him open every door. Still silence. After a bit, he came down again, and walked into the kitchen wearing a puzzled frown. 'Nobody there,' he said, lifting his shoulders, 'I could have sworn I heard someone going along the landing.'

'You did you know,' Mike said, 'we heard them too, didn't we Ian?'

'Yes, very clear, let's go and look again, there's a lot of valuable stuff here.' We all went, and this time we searched every room, every wardrobe, every cupboard, nothing. When we met up again in the hall, Mike said, 'No, nothing, the house is completely empty except for us.'

'I thought somebody had got in, but the front door is locked, and we were all downstairs anyway.'

'Must have been the old planks on the landing springing, they do it all the time when the weather is changing,' Sid said.

'No way,' Mike argued 'that noise was footsteps and what's more, they sounded as if they were on bare wood, and the landing is all fitted carpet.' He looked at me and winked, 'No, if you ask me that was the ghost we heard.'

We both looked at Sid. I was waiting for the sarcastic comment we expected from Sid, but he was looking very serious and thoughtful. He said nothing.

'What was his name?' Mike asked.

'Who's name?'

'The wrestler – ghost – whatever – what was his name?'

'Haven't got a clue,' I answered, 'it all happened about a hundred years ago.'

'Oh, I see,' Mike grinned, looking at silent Sid.

'A big bloke was he? A wrestler, but at least if he's looking for forgiveness he'll be a harmless sort of a gentle giant.'

'Oh no, no way, he's said to appear like he was when he first opened the bedroom door and found them; he's in a murderous rage!'

We were sending Sid up to some tune, hoping to get some sort of reaction from him, but he stood there with his back to us, fiddling with some cable, as silent as a stone. Mike rolled his eyes at me, I shrugged, and we gave up. We went back to work, but that wasn't the end of things, no way.

It was December, getting dark by half-past three, and of course, no electricity and no lights. Just as we were cleaning up, Sid went to the bathroom, and as usual he closed and locked the door. Although he was a big man, a bit thick, with absolutely no sense of humor, he lived with his mother, had never had a girlfriend (we all thought that was because of his very bossy mother) and was painfully shy and most awkward around women, he was a really kind man, a good mate, and all the blokes liked him. We all sent him up like mad, but only in fun, never cruelly. We only vaguely heard the lock shoot across on the door, but a couple of minutes later there was an almighty crash, and we heard the bathroom door fly open with such force it slammed back against the wall. Then there came an almighty scream from Sid, it made my blood run cold. We stood frozen with shock for a minute, and then we both sprang into action. We hit the stairs at the same time in a bit of a mix-up at the bottom, and then I tore ahead taking them two at a time. The bathroom was the first room on the landing, Mike had caught me up, and we both stood staring from the doorway. The door itself was thrown back as far as it would go, the hinges hung loose at the top, and the flimsy lock was splintered. Inside Sid had collapsed on the edge of the bath, as if his legs wouldn't hold him up, he sat there looking dazed, and his hands were trembling violently. The rest of the bathroom was empty. Sid stared at us blankly for a moment, and when he spoke his voice was just a croak.

'Has he gone?'

'Yes,' I said, 'there's absolutely nobody here except us.'

He nodded and swallowed. 'Come on down,' I said, and then I turned to Mike. 'There's a tray with a bottle of brandy on it in the dining room, go and pour a strong one for Sid.' Off he went, and we followed him downstairs. Sid flopped onto an armchair, and Mike proffered him the large brandy he'd brought in. 'Down it in one,' he said, 'brandy is good for shocks.' Sid downed it in one obediently. It made him cough like mad, and his eyes popped out, but when he had got his breath back, I saw he had more color in his face. Without any preamble, he looked up at us and said, 'I was just going to come out of the bathroom, I'd put the towel back and turned round when there came a tremendous bang on the door. It flew open and there he was, he looked as big as a bull, great shoulders on him, and his hands in front of him like this,' Sid held his hands in front of him, half outstretched, the fingers like hooked claws. He looked down at them, and then up at us, to see if we believed him. We did. 'He stood there for a minute, glaring at me and sort of snarling, but it was his face, his face was the worst, the rest of his body looked as if he was still alive, but looking at his face you could see he'd been dead for a long, long time. His skin was all shrunken, and his eyes, well they were all dull like a dead fish, the pupils had dropped down to the bottom of the eyes and gone all mushy. He frightened me to death because he started to come towards me, and I screamed.'

'We heard you,' Mike said.

'I was watching him come towards me with those big hands like claws ready to strangle me, when all of a sudden he vanished.' He looked from one to the other of us, and said, 'I'm not making this up you know, it's all true, one minute he was there, the next he'd gone.'

Sid looked down at his empty glass, and then proffered it wordlessly to Mike. 'Make that three large ones,' I said.

We felt better after the brandy, and started to talk a bit. 'Why did he disappear I wonder?' asked Mike.

'Probably when he realized it wasn't his wife,' I said.

'No, I don't buy that, there must have been hundreds of women who have used this bathroom over the years, I think he just doesn't like me.' Sid said thoughtfully. He stood up then, he looked as if he'd got over the shock a bit, 'He won't have to worry about me, I'm never going to set foot in this house again, even if I do lose my job.' He gathered his things together. 'I'll tell Bill now, that I'm not coming back.' He looked at us sharply, 'I suppose you lads will please yourselves. Goodnight now, may see you tomorrow, or you may not.' He nodded at us and left.

He didn't turn up at the house next day, he was working with Bill, and we didn't see either of them. There were only tidying-up jobs left, a few covers to put on, cables to straighten etc.; so the two young apprentices came to do that and Mike and I moved on to another house. We saw them a couple of days later, and one of them came up to me holding a long screwdriver, a 15-amp plug, a pair of snips, and a few other things in a box. 'Do these belong to you?' he asked putting the box down. 'I found them in that house you'd been working on in Llangefni.' I recognized Mike's screwdriver, 'Thanks Bob,' I said 'where were they?'

'Under the dining room table,' he said, beginning to wander away, then he turned around again. 'Hey Ian, did you find that house was, well, sort of weird?' I raised my eyebrows and tried to look non-committal.

'Why?' I asked.

'Well, I wouldn't do another hour there if you paid me in diamonds.' He thought for a minute, then swallowed and said,

You'll probably think I'm having you on, but it's true every word of it. We were just finishing up. I was brushing the bits up in the kitchen, and Tommo was upstairs in the bathroom, putting the shower curtain back, when suddenly this great rumpus started in the front bedroom. It sounded like two guys were fighting. One was yelling and swearing and the other was shouting a bit, as if he was afraid; then the shouting turned into a sort of gurgle and there was a big crash as if someone had fallen down. Well I dropped the brush and raced upstairs, and Tommo was just coming out of the bathroom. We ran along the landing; the front bedroom door (the one on the left I mean), was wide open and we could see inside. There were two guys there, one was lying on the floor groaning, trying to protect his head with his arms, and another guy, very big he was, was kicking his head in, with his heavy boots. It was terrible; the one on the floor stopped moaning and lay still. You couldn't see his face it was a mask of blood. The carpet was thick with it – thick blood all over the place. The guy with the boots on kicked the other in the face with all his force, it broke his nose or jaw or something – I heard the bone go. It was horrible. Then he looked up and saw us at the door, and there was a bright flash, and when I could see again, everything had vanished. No men, no blood, everything ordinary again. Well, we just ran. Tommo grabbed our things and we flew out of the back door. We found Bill and told him, and he just said, "I'm not surprised; I heard something like that yesterday."

He looked at his watch and said, "You lads might as well get home, I'll check everything is alright in there and lock up, it's nearly five o'clock anyway, see you tomorrow, we've got a big job at Treadder Bay. Meet Sid in the usual place, he'll take you in his van. Now, I'll just check up, and then I'm going home myself, goodnight lads." And he walked towards the house.

I grabbed Tommo's arm, and dragged him round the corner. "We'll wait here until he comes out," I said "just to check he's OK." We waited there for about ten minutes, peeping round; then we saw Bill come out, walk down the garden, and get into the van. He looked the same as he always did, obviously nothing happened to him, so that was OK. We were dead quiet walking home; I think we were still in shock. The only time we spoke was when Tommo said, "Well, I hope Mrs T. is happy there; rather her than me."

"I wonder if he only haunts men?" I asked thoughtfully.

"Haven't got a clue, but he won't be haunting me, that's for sure," said Tommo, turning up his coat collar against the cold evening wind.

I haven't given the lady's name, or the name of the house, but here is one small clue. Do you know the only house with the gable, past the Bull in Llangefni? – The one with the lovely silver fir in the front garden? Well...

By the way, all this happened in January 2011. I never did find out why the tools and things were moved.

CHAPTER 3

Murder at the Mine

This is a ghost story that must be nearly 200 years old, and only came to light when an old cabin trunk, left in a cellar, was discovered to be full of old papers, closely written on in copper-plate handwriting. It was written by the gentleman to whom the story was told, and who had been sworn to secrecy. It is the story of a murder, and the subsequent haunting by the hapless victim. The writer put it down with much eloquent description, the only things left out were the names of all the people involved, and of course false names were used, for obvious reasons. I have added the preface myself, because I had heard this story quite often from different people who live locally.

The said preface is that many people who live in the village of Penysarn, near Amlwch, swear that in the darkness of winter mornings; they hear the phantom footsteps echoing along the streets of the long-dead miners of Parys Mountain copper mine, clattering along in their clogs and boots, on their way to work. Nothing can be seen, but the sound has been heard for many years.

Now to the story, or as much as I could interpret from the faded writing; the storyteller begins:

This story was told to me over a pint of ale in the Adelphi Vaults, a public house in Amlwch Port. The teller was a man, tall and gentle-natured, but given to long periods of silent depression. He told me this story after I had been sworn to secrecy, which I promised, but even so, he would often halt in his tale and look searchingly into my face. He is dead now, but I have kept to my sacred oath, and never spoken a word; but I feel the need now to write his story down, before I die in my turn. He started like this (remember it's the murderer's story):

Years ago, when I was young, times were very bad. People were very poor, there wasn't much work about, and things were made harder by the return of many soldiers and sailors now that the war was over. I came to Penysarn from Bangor where I lived because I had been taken on as a miner at the copper mine on Parys Mountain. I didn't know much about mining, but I was young and strong, and that's what they were looking for.

I slept rough for the first couple of nights, until I found digs. The bloke I was teamed up with made inquiries for me, and he came back the next day to take me to the home of his sweetheart Nia. I went to see her parents, and they said I could have lodgings there. I was made up, they were kindly people, and the room was very comfortable.

Murder at the mine.

The lad I worked with, Bryn, was a cheerful young lad with a great sense of humor. He would call for me every morning, and we'd go to work together. He was very much in love with Nia, they were going to get married next year. I think he was more in love with her than she was with him, because I'd often look up and find her looking at me, with a secret smile. The thing was, living in her house and seeing her for hours every day, I found that I was falling in love with her. She was a great flirt, and would touch me when she passed by me, and she always managed to be at home when I got in from work. So I admit, I fell for her hard, and I hated it when I saw her with Bryn.

I got more and more jealous, but I had to hide it from him as he was such a nice lad, and a very good mate to work with. Work at the mine was very dangerous, but everybody took it for granted. This was a different type of mining to what had gone on previously. Copper had been taken for hundreds of years, and at first it had been easy. The old mine had copper near the surface, and the whole of the side of the mountain had been blown up – it looked like a vast quarry. Veins of ore had been found deeper in the rock, some veins only a few inches, so they had to be followed into the mountain to see if they widened out; so further in they went. The men had to make vertical shafts like wells into the rock, and it was hard work indeed. The shafts were about 3 feet wide, because metal buckets had to be lowered to be filled with the ore, and then pulled up to the surface again. For the miners to go down ladders had to be affixed to the wall of the shaft; wooden ladders where the surface was smooth, and rope ladders where the rock had been too hard to chisel smooth, so the rope ladder followed the contours. Every so often, when an end had come to the wooden ladder, a small platform, no more than a foot wide, had been built very firmly into the rock face.

Shuffling over it, the man would transfer onto the rope ladder and continue his descent until he came to the vein he was working on, which would gradually become a tunnel, some even widening into a chamber. The workers would throw the rock they had chiseled out into the bucket, and signal it to be drawn up. The workers had to stick very close to the sides of the shaft when they were ascending or descending, otherwise they could be struck by the buckets, which moved at definite times. Their only illumination was a thick candle, stuck to their chests with clay.

They worked in parties of two, three, four or five; these were the men who were following the ore horizontally, sometimes in chambers 10 or more feet high. The vertical shafts would sometimes go down 200-300 feet and there were many of these dotted about the surface of the mountain, "like rat-holes in a roof-thatch" as one miner said.

Well, the morning the murder happened I was in a very jealous mood. Before we had left for work, I went into the kitchen to get my boots, and Nia was there all alone. As I was passing her, she caught hold of my arm and gave me a long, warm kiss. Then, laughing at my expression, she went back into the room where her parents were. I knew she was only flirting but she had no idea what emotions she had raised in me. I wanted her. She must be mine; she had feelings for me, and the only thing in the way of my happiness was Bryn. I had to get rid of him.

I must have been suffering from some sort of madness; I wasn't in my right mind. We set off for work; Bryn was his usual cheerful self, chattering and laughing. He had no idea what my thoughts were, in fact he had no idea how I felt about Nia. I had always been very careful to hide my feelings. When we got to work, there were plenty of miners about. Some (like us) were digging the first shafts through the topsoil and ever downwards, 300-400 feet and more. The shafts were in many stages of construction, some men were putting in their first ladders, others were nearly finished (like ours) and already had miners in chambers cut into the rock following the veins. Some were already equipped with hoists that automatically raised and lowered the buckets at great speed.

Today, we were going to put our last ladder in place. It was a rope one, because at one point the rock was too hard to chisel, it bulged out in a curve, so a rigid wooden ladder would have been no use. We had collected a coiled rope ladder from the stores, and Bryn had thrown it over his shoulder, keeping his hands free for the descent. We reached our shaft, there were already men working in the horizontal chambers they had dug in the sides, down below.

Other shafts were more advanced; they already had the metal hoists working the full buckets that were being lifted. We stood at the side and looked down into the blackness. Bryn patted the coiled ladder with a big grin and looked at me. He had an old canvas bag on his back that contained his rock chisel, a hammer and some more bolts. "Last one," he said, and got ready to enter the pit. At the top of each shaft, metal U-bolts had been hammered into the ground on one side of the shaft. These were about the size and height of chair arms, and the man who was going to descend down the mine held on to them as he turned his back to the shaft. His feet found purchase on the first ladder leading down, which was also firmly secured to the U-bolts by steel pins. Thus the beginning of the descent was made more gradual than an abrupt step from the earth into the blackness below. As Bryn's feet went down the ladder carefully, he lifted his head and gave me a nod. By now, I had worked out my plan of action, and had made the first move. I had picked up a large

piece of rock, rough and heavy, and even now I was lifting it above my head. Bryn was half-way down, and his hands were in the customary position for a descending man, one sliding down the ladder's side, and the other gripping each rung as he came down to it. By now, only his upper body and his arms were visible, and he looked up at me again with that jolly grin of his, which crinkled his eyes at the corners. Those eyes; I can see them now. First, they were smiling up at me, untroubled and calm. Then he saw the upraised arm, and the deadly piece of rough rock it was holding. Realisation dawned in that second, and the expression in his eyes changed to disbelief, blank misunderstanding, then in the next minute to overwhelming fear. It was in that instance that I brought the piece of rock down with all the strength I had. I aimed the first blow at his left hand that was firmly gripping the side of the ladder. It was an awkward blow, meeting the hand sideways on, but as it landed, the great force behind it splintered his knuckles; I heard them break as bright red blood flew. He gave a shriek of pain, and then I slammed the rock down on the other hand which was holding onto the rung above him. This time the blow hit the back of his hand squarely. I saw the splintered bones before the blood flew again. His reflex action was to pull the shattered hands away, and for a moment he just sort of hung there, unsupported, until his body weight dragged him backwards and downwards. He was still looking at me. I'll never forget those eyes, the next second he was gone. His scream was indescribable, the fear and terror filled the shaft, and it became fainter and fainter as he plummeted down to his death. Suddenly it stopped. I knew he had hit the bottom, and in that instant I threw the blood stained piece of rock after him.

I was trembling and felt sick, as I crouched there. I looked down. Lights were beginning to appear at the sides of the shaft where the galleries were, more miners who had heard the screaming looking down, but I knew they couldn't see anything in the dim light of the candles, stuck to their chests with clay. I moved back from the shaft, so weak I was unable to walk.

A few came running towards me. "He slipped." I muttered "He slipped and fell." I must have looked shocked. I felt it. The enormity of what I had just done overcame me. I had killed a man. I was a murderer. They led me away with great sympathy. They thought I had just witnessed the death of my best friend, when in reality I had been the cause of it. The mine was a very dangerous place to work, accidents were common, and life was cheap, but every death brought shock and grieving.

I was taken back to Penysarn in a pony and trap. The news had already reached the village and, unable to speak to anyone, I went and lay on my bed. I could hear the man who had brought me back talking to Nia's parents in the room below, and the heart-breaking sobs of Nia from her bedroom where she lay. The next few days were a blur. I had to attend Bryn's funeral, and could not take my eyes off his coffin, imagining his shattered body within. The miners who had brought his body up said that most of his bones had been broken, his legs and spine, but nobody mentioned his hands, I suppose broken knuckles all bruised and bloody weren't as important when his whole body was lacerated as it hit the sides of the shaft, as he fell struggling to his doom. Worst of all, I couldn't bear to look at Nia. She drifted aimlessly about the house, her face was pale and tear-stained, and I realised then, and only then, the depth of her love for Bryn; she had only been lightheartedly playing with me, and I had ruined her life.

One night that week, her father said he was going to the Vaults for a pint, and it would do me good to go with him. I was only too glad to. When we got there and with our drinks

before us, I told him I wasn't going back to the mine, I couldn't face it. He quite understood, and asked me what I was going to do. I said I didn't really know, but I might go to Holyhead and try my luck there. I felt a bit better after two or three pints and I told myself to stop looking back into the past, and look forward into the future.

When we got back, the house was quiet and dark, the women asleep.

That was when the haunting began. I climbed thankfully into bed, and lay on my back. I should explain that the bedroom was tiny, and my single bed was squashed against the wall. For the first time that week, my brain was a bit fuddled with the alcohol, and I felt a bit sleepy, so I turned to face the wall, and snuggled down to sleep. I heard a clinking noise by my head, and I opened my eyes. There, at the side of the bed, where there was no room, was Bryn, about to descend the mine ladder; his hands had just left the big U-shaped bolt, and were going down to the ladder rungs.

I was so unnerved I shot up in bed. My hands were both clenched in the blankets, but Bryn who had been smiling at me, now looked with horror at two spectral hands, raised above my head and obviously causing him great fear. Those eyes that I had seen all week, while asleep and awake.

The next thing I saw was his hand clutching the side of the ladder, exploding in a shower of blood and bone splinters. Then his other hand the same.

He never took his eyes off me. Those eyes that I could hardly look at now showed betrayal, great pain and fear. He was shrieking with the agony of his shattered hands, he leaned backwards and started to fall, and his shriek turned to a scream of panic, so loud it nearly burst my ear-drums as he fell into the blackness. It echoed off the walls of the shaft, down and down, then suddenly silence.

I sat there petrified. I was clammy and wet with the sweat of fear, waiting for the pounding of feet as people came running towards my room, their sleep shattered by the scream that still echoed in my ears, but no-one came.

So, obviously the scream was that of a ghost and no-one heard it but me. There was no more sleep for me that night. Bryn's face was always in my head. How had he managed to appear between the wall and the bed where there was no room?

But that was only the start. Next day was Sunday and we had all sat down to dinner. Nia's dad had just started to cut the piece of roast brisket and I was watching, when his hands became Bryn's, the carving knife and fork changed into the two U-shaped bolts, which secured the top of the shaft's ladder, and I was back there again. I groaned in fear, shoved my chair back so fast it fell over, and dashed upstairs to fall on my bed and pull the covers over my eyes and ears. I lay there muttering, as I was when Nia's father came to see if I was alright. I told him what had happened, not about the murder but the haunting. He, like everyone else, had thought that the shock of Bryn's death had made a deep impression me, and now I could see that Nia's father thought I had become slightly unhinged.

I was longing to be able to tell someone about my crime, but I couldn't confess to any priest or man of God, because they would only urge me to tell the police. I knew if I did that, it would mean Caernarfon prison and the hangman's noose. The atmosphere at the mine had changed too. The Cornish miners who had volunteered to work the shaft, laughing at the superstitious Welsh miners, only lasted for a day or two, using unlikely excuses not to go down, so work there was brought to a halt. They stopped laughing at the fears of the Welsh miners; now they had heard the blood chilling screams themselves.

During this time, Bryn's appearances didn't become any less frequent or fade with time, but his face was gradually changing. I thought perhaps if I left Nia's house, things would change for me. I couldn't bear to live there any more; its association with Bryn made it a living hell for me. I was drinking heavily now. I spent all my money on booze, and I looked like a tramp.

So I left Nia's house and got cheap digs at a poor little cottage in the port near the Adelphi. An old lady called Mrs Griffiths lived there, she was very deaf and her house wasn't too clean, but it was somewhere to eat and lay my head down when I got back from work or the Adelphi, where I spent most of my time and money. I stopped shaving as well, as that meant looking through a mirror, and seeing Bryn's face.

As I said, that face was changing. Now the jaw began to drop, and the cheeks sank inward. As soon as Bryn's face appeared in the old mirror on Mrs Griffiths sideboard (with the eyes still as brilliant as the day I killed him), or the dinner plate she lay before me, ready to spoon her tasteless stew on, I would get up and pretend to go to fetch my hanky, or drop my spoon on the floor, so that the face had vanished by the time I looked again.

The changes in the face were gradual at first; as I said, the jaw began to drop and the cheeks sank inward. Then the flesh became ridged and rotten, the eye-lids became shriveled, and the flesh on the nose was putrescent. The cheeks fell in and bones began to protrude.

I knew then that the phantom face was duplicating Bryn's earthly face in his coffin; it was becoming a skull. The only thing that didn't change was his eyes, still bright and as brilliant as they were the day I killed him.

I cannot tell you how many times and in how many places I saw him. I dared not look through a mirror or at a picture, without seeing that awful dead face with the living eyes. The only escape I had was to go to the pub. Being drunk most of the time made me less afraid and I took to buying bottles of cheap gin, so I hardly ever had time to sober up. I had no money to spare after buying my booze and paying for my digs, which meant that I could never buy new clothes, so people gave me their cast-offs. I had still kept my strength, even though I was nearly always drunk, but the fear and terror of his unexpected appearances were beginning to take their toll. I had taken to muttering to myself, and rushing out of the room if suddenly his skull-like face appeared in front of me.

The flesh on his face had all gone now. A few bits of withered skin still clung on to his forehead and cheeks, but his face was nearly all bone. He had now taken to appearing alone, not framed by pictures or mirrors, and suddenly that hateful face would appear suspended in the air in front of me. It was a face no longer, but a skull, all the flesh had gone now, and the only things unchanged were the brilliant eyes, which were now filled with hatred.

I still seem to be the only one who sees this apparition, God help me. I can't take much more.

That was all that was written by the narrator, the rest of the papers were written in a different hand. I took it that it had been concluded by the listener. This is what he wrote:

I only knew this man for a few months. I always met him in the Adelphi, and as most residents know, the little row of cottages where Ivor (for that was his name) lodged, was not far along from the Adelphi. The other side of the road is the dock, where the ships were loaded and unloaded for the mine.

The mine.

One sunny evening that summer, I went as usual to the Adelphi, and made my way into the bar. I was quite surprised to see Ivor's corner table empty. He was usually the first in and, while I was waiting for my pint, I asked casually if he'd been in. One of the men who had been standing talking to his mates in a low voice, came over and said, "No, he won't be in tonight mate, or any other night, he's dead!"

My mouth dropped open and before I could say anything another man sauntered over and said, "It was yesterday evening see, we'd all finished work at the dockyard, and we were going to have a drink before going home. Just as we came around the head of the dock and we were nearly at the pub, we saw Ivor coming towards us from the other direction. He was dressed in his usual shabby clothes and that long beard of his. You know how windy it was yesterday; well it was blowing about all over his face. We shouted about it to him, but the tide was at the full, and he couldn't hear us with the waves smashing against the wall. Perhaps as well really, we said a few cheeky things. Anyway, we'd nearly got to the door when Will here said "Look!" and pointed at Ivor. He'd stopped walking, and was staring in front of him at something we couldn't see. Then he put his arms up in front of his face and started to shuffle backwards. He was backing towards the dock, no railings or anything there, and we all shouted again because it was dangerous and he didn't seem to know what he was doing. We still couldn't see what he was shielding his eyes from, and then he reached the edge of the dock and fell. Gave a great scream he did, then he was gone. We all rushed there, but the dock was full then; as we said, the tide was full in, and the dock is about 12 feet deep. There was no sign of Ivor, he must have been swept out as soon as he hit the water. We searched and searched, until long after there was any chance of saving him alive.

Some of the lads were out all night, but they gave up this morning, his body will be washed up along the coast somewhere."

Well, his body was never found, and the end of the story leaves me with a big question I shall probably never find the answer to. Well, two big questions left actually – see if they puzzle you as much as they did me. If Ivor had only been a listener to the murder story, why did he become an unkempt drunk with a beard? And again, was it Bryn's face that suddenly appeared to him and drove him backwards into the dock? Remember, only the murderer ever saw the ghostly face. So which one was he, listener or murderer?

All this happened so long ago, it has only been kept alive by families passing it down by word of mouth to the generations that grew up after them. I haven't been able to find out a thing about the cabin trunk and its contents or fate. What I do know, however, is the screams have not stopped at the mine, even though the shaft has been blown up long ago. The erstwhile Copper Mountain is now a tourist attraction and now has a 'Copper Trail', led by official guides, and safely fenced off.

The area that once held the tunnels and galleries of copper ore is now an open space, but many reports of hearing a blood-curdling scream, which is abruptly cut off, have come from both tourists and guides, so it seems that Bryn still haunts. The last scream reported was in November 2011, but how many times has it been heard but not reported? And how many times has it happened unheard by human ears?

It is definitely not a haunting that fades out with time.

I have written this story at least three times and I am still not satisfied with it, there seem to be no answers to the questions the old writing throws up. Does anyone know anything?

Murder at the mine.

CHAPTER 4

Haunting of the Min-y-Don
Part One

There was a polite tapping at the bedroom door, just as Bob was tying his shoe-lace. 'Come in,' he called, and Jean pulled the bedclothes higher. No-one opened the door, but the tapping came again. 'Come in!' Bob called louder. There was no reply or movement. Bob muttered, 'Must be deaf,' and strode to the door, throwing it open. The passage was empty. Bob walked out of the bedroom and gazed up and down, then came back in, looking puzzled. 'Somebody playing games,' he growled, 'or else it's kids.'

'I don't think there are any kids in the hotel,' Jean said as she slid out of bed. 'Do you want any more tea?' She went to the tea-making tray on the corner table, and poured herself another cup, Bob didn't want any more.

Just then there was a slight fumbling noise at the door and Bob winked at his wife, moved soundlessly to it, and threw it open. There was a young maid there, with an armful of newspapers.

She nearly dropped them at Bob's sudden appearance. 'Gosh! You made me jump! Let's see, room 15, *Daily Mail*, here we are,' and she handed him a newspaper. Bob was fiddling in his pocket for money, and she stopped him saying, 'That's all right sir, you pay for your paper when you pay the bill.'

Bob took the paper with a smile, and then said, 'Were you here just a moment ago? Did you knock on the door?' The maid looked at him, and shook her head. 'No, I've only just come up; the papers are late this morning.' She moved across the corridor and dropped another newspaper in front of the door opposite, then turned to Bob and said, 'Why? Did you hear someone knock?'

'Yes, twice,' said Bob, 'and when I opened the door there was no-one there.' The maid was just going around the corner when she looked over her shoulder and said, 'Oh, of course! Room 15! You'll get used to that!' And with that she went. Bob turned back into the bedroom looking bemused. 'What did she mean? You'll get used to that?'

The day was hot and sunny, and the water in Red Wharf Bay sparkled like diamonds. Bob Burns and his wife had come for a two-week holiday from Birmingham, and were really looking forward to the break. They spent their first day lying about on the shore, and returned in the evening for dinner at the Min-y-Don Hotel where they were staying.

They wondered into the bar for a pre-dinner drink, and the lad who served them asked if they would like to pay now, or put it on the tab to be included with the hotel bill. 'Oh, put it on the tab,' said Bob. 'Room 15.' The lad who had served them looked up with sudden interest; he opened his mouth to say something, but quickly changed whatever it was to a

polite query about how long they were staying. He said laughingly that he could do with a holiday himself, he was a student at Bangor University, and bartending was his holiday job.

They had the sort of evening that one hopes for when on holiday – full of good food, good drinks and wearing the first dusting of a brown sun-tan. They wandered off to their comfortable bedroom about eleven o' clock. Jean fell asleep at once, but Bob lay awake for a little while looking through the window at the moon-lit view.

They hadn't drawn the curtains, and he could see the great limestone rock that was once a quarry, known as Castell Mawr. He imagined how busy Red Wharf Bay must have been with sailors, quarry-men, market people and all the hustle of a busy port. Nothing like that now, he thought, just a very nice place for the holidaymakers, no industry at all.

Suddenly, he widened his half-closed eyes, and concentrated hard on the window. He thought at first his eyes were playing tricks on him, so he blinked, and stared harder. No, he was right, there was someone standing by the window, looking out. Bob was astonished; a man was in their room. He had his back to the room, and seemed to be peering through the window, moving his head slightly as he looked sideways, past the great rock out to sea. Bob could see him quite clearly now. He looked like a middle-aged sea captain, complete with a captain's peaked cap, roll neck jersey and thick trousers. Bob sat up in bed, and was just opening his mouth to ask the man what the blazes he was doing in their bedroom, when the figure turned, saw Bob was awake, and with a funny little salute of greeting, smiled, raised two fingers to touch his cap, then promptly vanished.

Bob's jaw dropped, he put out a hand to wake Jean up and tell her, but suddenly thought better of it, and instead slid down in bed.

He told her the next morning, and he was so sincere she didn't make any cracks about having too much to drink. She lay there thinking, and reminded him about the tapping on their bedroom door in the morning, and she wondered if the two occurrences had something in common. He asked her if she was afraid; did she want to change bedrooms? But she didn't want to, she said, because the room had such a warm, welcoming atmosphere.

Nothing untoward happened the next day, but on the third day when they woke up, Bob's shoes, which he had carelessly kicked off the night before, had been placed neatly together at the side of the bed, and his clean socks, which Jean had taken out of the drawer and left on top were neatly folded and placed on top of the shoes.

That night, before dinner, they fell into conversation with a middle-aged couple who were also staying in the Min-y-Don. The man asked casually whether it was their first visit, and told them that he and his wife Maureen went there every summer, and had done for years. Then he asked Bob if they were the couple who were in room 15 and, when Bob said they were, they offered to buy a round of drinks, and Bob went to help him carry them. The men went together to the bar, and when they were out of earshot of the women, Bill Jenkins looked strangely at Bob, and then said, 'Has anything ever happened to you in that room?'

Bob was very surprised and said, 'Like what?' Bill looked a bit uncomfortable and said, 'Well, have you ever seen or heard anything weird?' Bob's interest quickened, so something had happened before? He told Bill about the knocking on the door, about the sailor at the window, and the incident of his shoes and socks.

Bill listened nodding. 'We stayed in that room once, never again, we asked for our room to be changed, and the manageress agreed at once, she didn't argue.'

'What happened?' Bob asked.

'Oh, lots of things. We were only there for a couple of nights, but I wouldn't stay there again for a gold clock. That room's haunted.'

'How do you mean?'

'Well, to tell you the truth, Maureen and I tend to have a few up-and-downers, and a few years ago when we first came here, we always seemed to be falling out. Most married couples do I know, but we are both on short fuses, and it doesn't take much to start a row. Well, the first night we stayed in room 15, we were having an argument about where we were going next day, and we were just getting riled, when all of a sudden the bathroom door slammed to with an almighty crash. Neither of us were near it, and we couldn't explain it.' He stopped and grinned. 'It shook us, I can tell you, we didn't argue after that! Then when we woke up next day our two suit-cases were standing in front of the door, with our coats folded over them. Talk about a hint! Anyway, we asked Mrs Holden if we could change rooms, and she agreed at once, she seemed to know all about the haunting.'

A few days later they saw Mrs Holden outside leaning on the sea wall, and they had a good old natter together. She admitted she knew about the haunting; the ghost was an old sea captain who retired from the sea, and went to live at Min-y-Don in room 15 – he died in there eventually.

'He was a lovely old man who used to skipper a coaster up and down from Liverpool. He picked up cargos of limestone from here, copper from Amlwch Port, anything that was going. He had never married, and had no relatives, and he treated the Min-y-Don as his home. He knew my mum and dad very well, because this place has been in the family since the 1940s. We've all seen him some time or another, he's patted the shoulder of one of the room-maids he passed in the corridor once; nobody's ever been afraid of him, he's harmless, but if he doesn't like somebody who's staying in his room, he certainly lets them know.' She smiled at them, 'He obviously likes you.' Then she said thoughtfully, 'You know the Hotel is going up for sale?' They shook their heads. 'Well it's time we retired anyway, and we haven't any children to take it over, so it will have to be sold.'

'I wonder what the old sea-captain will do then.' Jean asked.

'Goodness knows – him and the other ghost,' she said.

'What! You've got another ghost?' Bob said curiously.

Mrs Holden nodded slowly. 'Yes, he's very bad-tempered, fortunately he's in the cellar, so we don't see much of him, thank the Lord, but we do hear him.'

'Who is he then?' asked Bob.

'Oh, he was a young man who worked behind the bar about thirty years ago. He was very moody, always picking fights, and one night he flew from one end of the bar to the other, ready to grab the other bloke working behind the bar, but some-one had left the cellar trap door open, and he fell through it, down the stone stairs, and was killed outright. Before long, the bar staff started complaining about muttering and cursing going on in the cellar when there was nobody down there; whatever it was frightened the barmaids so much they refused to change the barrels. He did all sorts of things, turning taps on the barrels, putting the lights on, knocking on the trap door; nasty bit of work he was, alive and dead. Anyway we made the cellar outside and boarded up the trap door, so that was the last we heard of him.'

She looked at her watch. 'Gosh! Is that the time? I've got to go to Manchester now, so I won't be here when you leave tomorrow. I do hope you've enjoyed your stay?' They assured her they had, and that they would see her next year.

'I'm afraid not,' she said. 'It will be sold by then, but good luck anyhow.'

She was right about not seeing her next year or the hotel either, for by that time the Min-y-Don, which held so many happy memories for hundreds of holidaymakers, had been totally demolished and a block of privately owned apartments (many sold before they were completed) built on the site.

So I'm left with a question (or two!). What has happened to the friendly old sea captain and the bad tempered barman? Where do ghosts go when they've been evicted?

CHAPTER 5

Min-y-Don
Part Two

Apart from the friendly ghost of the sea captain who haunts the Min-y-Don, I was told last week of another, rather sinister spectra who has been seen there by holidaymakers and staff when the hotel was an up and running family business, enjoyed by holidaymakers and locals alike. I don't know how long ago the hotel was built, or how long since it was extended but I was told by Mr Roberts of Amlwch that when the extension was built, an old derelict cottage, which was on the site, had to be demolished. This was done and it was when the debris was cleared away that the haunting began.

Two of the workmen, who were beginning to lay the new foundations, reported seeing a thin old man moving away slowly from the site, and climbing the steep slope behind it, before he disappeared amongst the trees which grew at the rear of the Min-y-Don. They both saw him, and said he was dressed in old-fashioned clothes. One man said he thought they looked Victorian, whatever age they belonged to, and he said they looked very old and ragged. The next time he was seen was about a week later, by the same two men, and a third man who was with them. This time they said they were digging a trench. They saw no-one to begin with and then suddenly there he was again, facing them. The one who saw him first went by the name of Bryn, and this is what he said,

I was working, and not thinking of anything in particular, when suddenly I got the feeling I was being stared at. I could feel eyes boring into my back. I turned around, and there he was again, this time he was staring at me with hate, there is no other word for it. It was a look that gave me the creeps. He was dressed in the same clothes as before, but this time he had a little bag in his hand. It was round, made of some kind of skin or felt or whatever, and it had a drawstring at the top, which he was pulling closed.

I knew there was something unearthly about him, because although he looked real, he wasn't, if you see what I mean. Bits of him kept appearing and disappearing, one minute he was standing there quite normally on his legs, then suddenly his legs would vanish and he would be standing there without support, or his head would go all transparent and only his body looked real.

Then he stopped looking at me, and started to fiddle with the bag he had. He opened it, and laid it in his left hand. With his right hand he kept digging into the bag, and bringing out something that he bent down and laid carefully one by one on the earthen floor, which he appeared to be standing on. In reality it was part of our trench, but he seemed to be standing in a squalid room, with a bare wooden table and chairs. I watched him closely,

and saw he was half-burying what appeared to be small copper coins, under the table and chairs; then he stood up again, pulled the drawstring tight on the bag, and vanished. So did the room he was in and I found myself staring at the trench. The other two lads had seen it all too, and we spent the rest of the morning wondering who he was, and what he was doing.

Anyway, at dinnertime we went for a pint at the Old Ship Inn as usual, and as we were eating our "butties", I asked the landlord if he knew anything about the old man. He didn't, but he went into the tap-room and came out with a very old man called Bert, who came and sat with us. When he heard what we wanted to know, he told us that his mother (who had been dead for sixty years; she had lived into her nineties) used to tell him a tale that her grandmother was fond of repeating.

She confirmed that a two-storey cottage had once stood where the extensions to the Min-y-Don had been built. It was built by a quite wealthy ship-owner, and was a well-built cottage under the hill, with woods at the back and the extensive views of Red Wharf Bay to the front.

He was married with one son, and when his mother and father died, the son lived on in the house on his own. He kept on his father's ships; like his dad he was an astute businessman, but he was also incredibly mean. When he retired and sold the coasters, he didn't put the money in the bank, he put both it and the money he had inherited, upstairs in his bedroom, carefully hidden away. The house fell into disrepair, and what had once been a smart white cottage became a grey, peeling wreck. But he lived on as frugally as he could; spending nothing, he had amassed a fortune, but always pretended to be poor.

His great fear in life was to be robbed. He spent hours every night looking out of his windows; people used to see the ragged, half-crazed old man staring out for would-be robbers.

He had an idea, which he thought was very crafty, but which most of the villagers knew and scoffed at. Every night, before he went to bed, he would bring down a large bag full of pennies. These he would salt away very carefully on the kitchen floor, under the fire rug, under the table, beneath the chairs, and anywhere else he could think of. As he placed them carefully, he added them up, so he would know how many he had to pick up in the morning. He thought, in his addled old mind, that any robber, who came into the house looking for money, would steal the prodigious amount of his pennies, and leave contented with his haul. Most people knew his miserly habits, and being honest, contented working men let him get on with it.

One day, haggling over the price of a couple of pounds of potatoes, the old man had a severe heart attack, and was dead within a couple of hours. Bert said no-one knew what happened to the money (obviously someone knew and kept very quiet about it!), but people often speculated what the old man's thoughts had been during the time he was dying. Not to know of his beloved money's fate?

The villagers (some of whom had seen the ghost of the old miser) said he couldn't rest, and was still laying down the pennies. They too had never been found. I must admit that when we went back to the site, we kept our eyes peeled for any old pennies, but we didn't find any of course. The thin old ghost still haunted the site, even when the extension was finished, and quite a few of the staff still talk about it locally – apparently he brings with him a chill, and glares so hatefully at whoever he has manifested to. He appeared near a

chair where a lady guest was sat, at the Min-y-Don, and frightened her so much she had to be taken back to her room. She said, "His face and hands were all withered and wrinkled, as if he'd been dead for a long time." He put out a hand as if he was about to touch her arm, but just then somebody came in and when the door started to open he vanished, leaving an area of intense cold where he had been. This apparently was in one of the rear downstairs rooms. I can't find out what they were – kitchens, guest rooms, or dining rooms.

Now that Min-y-Don has been demolished I don't suppose I'll ever know. The last job I have to do to finish off this tale is to find out what, if anything, has been built on the site of the hotel.

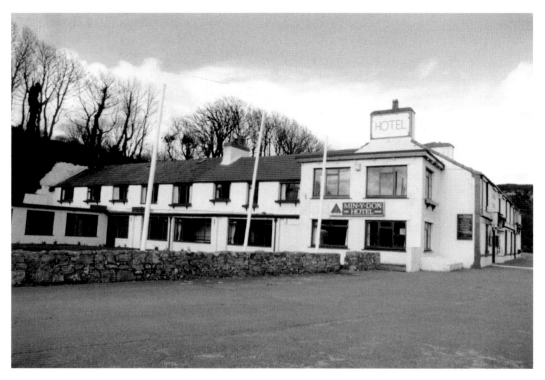

Min-y-Don Hotel.

CHAPTER 6

Did You Hear That?

'Well,' said Mrs Owen of Brynteg, when she had taken her coat off and had settled down in a comfortable armchair. 'I've really come because my husband has read your books about ghosts in Anglesey, and he wondered whether you had heard about our ghost?'

'Your ghost?' I said, 'which particular one is that?'

'It's a very old one, over sixty years I believe, but it's gone now, thank goodness. Bob looked through your books and he was very disappointed when he realised it wasn't mentioned.'

'That's means I haven't heard about it then,' I said, 'so put me out of my misery and tell me all about it.' Mrs Owen began to look at her ease now, she leaned back, and this is what she told me:

Well, you see, my husband Bob and I live in a house called Glanrafon, near Brynteg, where we have lived for the past five years. We were told about the ghost by a lot of people when we moved in, but of course we took all the stories with a grain of salt, we just didn't believe them. The old couple who we bought the house off didn't say anything about it, still, they wouldn't would they? They were both in their eighties and they'd moved down to Devon to be near their daughter.

She stopped for a moment and gazed into space. 'I wonder if that had anything to do with it?' She asked herself. 'Them being so old, and us so young?' She shook her head and went on:

Glanrafon was much too big for us really, but we fell in love with it as soon as we saw it, and we're both very fit. We'd only been in it for about a week, when the first strange thing occurred. It was about 11.30 p.m. and we had just fallen into bed, tired out as usual, we were settling down when Bob suddenly sat bolt upright again. He made me jump. "What's up? What's the matter?" I asked.

"Shush, listen," he said. So I sat up too and listened as hard as I could, just like him. "Can you hear it?" he whispered.

"Hear what? I can't hear a thing," I said, "and what are we whispering for?"

He breathed out. "It's stopped now," he said, "I thought it was someone coming upstairs."

He listened for a bit longer, and then lay down again, as did I. We were silent for a while, both still listening, and then I said, "What could you hear?"

"Footsteps."

"Were they from a man or a woman?"

"A woman I think, they were too light for a man. They came upstairs and went along the landing, then up the attic stairs, and then I didn't hear any more."

"Do you think we've got burglars?" I asked.

"No way, they were too loud and quick; a burglar would have been much quieter." He sat up in bed. "Might as well go and look anyway just to be sure." He got out of bed and put on his dressing gown.

"Oh Bob, do be careful," I said, swinging my legs out of bed.

"Don't worry love, I won't be long, but I'll have to be sure." He went out of the bedroom, and switched the landing light on. I reached over and put the bedside lamp on, then I sat listening and waiting. I heard him go along the landing, the whole house had bare floors; a team of men were coming to install new carpet in the morning, so I could hear Bob's footsteps as he walked across the attic above our bedroom very clearly.

We have two attics, probably where the maid slept, and they were both half-full of old bedroom furniture, which we intended to throw out. The next thing I heard was a terrific slam, and a startled curse from Bob. I leapt out of bed and was just climbing into my dressing gown when my husband came in, looking very puzzled and a bit shaken. "What was that?" I asked "It sounded like a door slamming."

"It was a door slamming," Bob answered grimly. "Don't ask me how, I'd gone up to the attics and looked around, saw nothing, and I just came out of this one," he pointed at the ceiling with his finger, "leaving the door open, and when I turned to close it, it swung and slammed shut with a tremendous crash, and I hadn't even touched it."

"Oh Bob," I said, and we just stared at each other. "What was it?"

"Haven't got a clue," he answered, "but it wasn't me, and it certainly wasn't a burglar. The way that door slammed, it made me jump I can tell you." In silence we took off our dressing gowns and got back into bed. We lay in silence, Bob had his arms behind his head, and I knew he was staring at the ceiling.

"Whatever it was," he said after a while, "it wanted me out of there; I could feel the rage the way the door slammed shut behind me." It took us ages to get to sleep.

We didn't know that was only the first time. Nothing happened over the next couple of weeks, and we were just beginning to settle down when I woke up in the middle of a wet and windy December night, and thought I could hear a baby crying. It was hard to hear over the sound of the wind, but it was that thin reedy crying that a newborn baby makes when it needs comforting.

It soon stopped, however, and Bob hadn't woken up so even though I listened for ages, I didn't hear it again, and I wondered whether I had imagined it; there weren't any houses nearby and we were alone, surrounded by fields. It didn't seem so bad in the morning – nothing ever does, does it? I told Bob of course, but as he had been fast asleep, he couldn't explain it either.

Then, just before Christmas, we heard the footsteps again, but this time they were running. Up the main staircase they came, along the landing, then up the attic stairs to the room above ours. They woke us up, I grabbed Bob's hand in bed, and we lay and listened. What frightened me most about them was the fact that everywhere in the house had been newly carpeted, even the attic stairs, yet the footsteps sounded as if they were running on bare wooden floors.

We didn't hear anything else that night, but we couldn't sleep properly any night; we kept waking up thinking we had heard something, and lack of sleep began to tell on us. Bob said one morning that in the night he'd heard a woman crying in the attic room above us, it went on for a long time, I slept through it and Bob didn't wake me up, but he said it had upset him because whoever it was sounded as if she was heartbroken. He was very quiet all day.

Mrs Owen looked at me.

To tell you the truth, I felt like leaving, but we'd only just done the place up – new windows, new cooker and all the new carpeting. It had cost us so much money, and we still loved the place.

Bob said perhaps we had disturbed something with all the work we'd done, and it would soon settle down again now we were quiet. So I asked around again, and one old man in the paper shop said his mother was friends (when she was alive) with the old woman who had lived there. The old woman lived there with her unmarried son. They had a cleaner who came up from the village to do all the heavy work, and a young girl who lived in and did all the cooking and such. That was all he knew, he said, but he did mention his sister (older than him) would know more.

Then the thing happened that almost frightened me to death. I had bought myself a lovely dark blue wool dress for winter. Actually I had got it for Bob's firm's annual "do" (he was a construction engineer). We'd been invited to the company's dinner, and they had booked us in at the Lamb Inn at Nantwich. We'd been there before, and it was a lovely old inn, so we were looking forward to it. Anyway, I'd bought the dress, shown it to Bob, who thought it was smashing, and then I hung it up carefully in the wardrobe in our bedroom.

Bob woke me up about two o'clock, reaching for his glass of water, and I turned over in bed. There was a full moon, and the room was as clear as day. I looked around as I was snuggling down, and my gaze stopped at the wardrobe. I thought I'd seen a faint movement of the wardrobe door. I had, it was slowly opening. "Bob," I hissed, "Bob wake up." He wasn't asleep and he turned towards me. "Look," I whispered. "The wardrobe, it's opening." I felt him stiffen, and I knew he'd seen it too. The door creaked a bit, and then it swung wide open. The moon went behind a wispy cloud, we could still see everything, but it had become a bit dimmer, and somehow the atmosphere had changed; it had become very heavy. Then it happened. From the dark recesses of the wardrobe there was a movement. Something came gliding out. I was very glad of Bob's warm strength behind me, I backed up closer to him and he put his arm around me. Seeing the movement, I lay there stiff as a stone. Then we could see it properly. It was my blue wool dress with the long sleeves and the roll-top neck. But it wasn't flat and empty; there was something in it, filling it out. The long sleeves looked as if they had arms in them, bent at the elbows. The roll top looked as if it was encircling a neck, the top part of the dress seemed pulled rather tightly over breasts, the belt was pulled around a slim waist, and the flared, knee-length skirt was obviously covering hips and thighs. But, no hands were at the ends of the blue woolly sleeves, no neck and head showed above the roll neck collar, and the space beneath the skirt and floor showed no legs.

The dress was occupied by something that was in the shape of a woman's body, but where was the woman herself? Silently, suspended in mid-air, the dress started to glide across the room. The full horror of this shell of a dress concealing something unseen within it made me freeze with fear, and as it approached the bed, the blue sleeves bent at the elbows, as if the unseen hands were stretched ready to encircle my throat. I screamed. As I did so Bob leapt into action, and threw himself down the bed. His hands had barely connected with the dress when the whole thing collapsed, and it fell emptily across his arms. He dragged it off as if it was something foul and alive, and it fell into a pool of cloth at his feet. I scrambled across the bed on my hands and knees and out of the bedroom door like a flash. We spent the rest of the night trying to get what sleep we could on the settee.

We decided to find out what had been happening in that house previously; we were thinking about everything that had happened in the house in the few weeks we had been there. Bob told me a surprising thing. "You remember the first night we had moved in, and all our furniture hadn't arrived, first the bed and the table, and a few things? Well, we fell into bed and dropped asleep right away, but in the middle of the night I felt something in bed with me."

"That was me," I said grinning fatuously.

He frowned. "No, this is serious. You were on your usual side, and I was on mine, the side nearest the door. Suddenly I felt this shape in bed with me, cuddled up to my side, icy cold it was and it was moving its body as close to me as it could get. So I backed away towards you, I thought I was dreaming."

"Oh, I remember that," I said. "You nearly pushed me out of bed, I woke up right on the edge – and I told you to get back on your own side, as I didn't have any room."

Bob nodded, "And as soon as you said that, it went. Whatever it was, I put my hand on the place where it had been, and it was icy cold."

"Why didn't you say something to me?" I asked.

He shrugged, "Oh well, you know how it is you just wake up and you can't tell whether you've had a nightmare or not."

"Obviously not in this case, I wonder what it was." I said, and went on, "I don't want to sleep in that room tonight, I don't want to sleep in this house tonight, come to that, but there's nowhere else to go." In the end, I had the bright idea of phoning the vicar to come and bless the house. He was a bright young man, no fuddy-duddy ideas and a great sense of humour, as well as a strong faith. We'd got to know him quite well, and when I told Bob what I intended to do, he was a bit reluctant but hadn't any other ideas about what to do. So I phoned him. He was very interested and listened to my story, I asked him if he could come up, and he said of course. Then he told me that his brother was staying with him; he was a sensitive, medium to you and me – and a very good one at that.

We arranged for them to come on the Saturday. I phoned on Tuesday and in the meantime we moved our bed and bedroom furniture (all except the wardrobe; Bob had thrown my little dress back into it on the floor, as I didn't want to see it again), and then we re-arranged our new room, before I went out shopping.

We decided on a pub lunch for a treat, and while we were waiting, he told the landlord all about the spooky things that had been happening. He served somebody with the pint he'd pulled, and then he came back to us, wiping his hands on a tea-towel.

"You want a word with old Ivor," he said, nodding in the direction of an old man laughing with one of his mates in the corner of the bar. "What he doesn't know about the Island isn't worth knowing." He caught Ivor's eye, and the old man took hold of his pint, and came over. After introductions, and to cut a long story short, Ivor told us what he knew about Glanrafon, and I must admit, it wasn't a lot; quite a bit was hear-say, because most of it happened in his parents' time. Apparently, when they were young, an old lady lived there with her son; her husband was dead, and she was old and frail. She was stone-deaf, and going blind, so they got a young girl to look after her and her son, and she lived in. She wasn't very bright, she didn't get much money, but it was a living-in job, and in those days people were glad of anything.

The heavy work was done by a woman from the village who came up once a week. "Well, Mum told me that in time the old woman died, the son got married, and the maid committed suicide. Threw herself into the sea – sad ending that."

"Did she do it because she'd lost her job?" I asked.

"Well, I suppose so, she wasn't needed with the new wife, and she didn't know anything else; she'd been there since she left school at twelve. They never did find her body, just her coat and shoes on the top of the cliff where she'd jumped."

"Didn't she leave a note?" Bob asked curiously.

"Couldn't read or write poor girl, never was any good at school they say." That seemed to be the end of Ivor's story; it was also the end of his pint, so Bob bought him another one and he drifted back to his mates. We sat in silence for a while, and then Bob said what we were both thinking. "It sounds like she's our ghost."

Saturday came, and with it came the vicar. (He was called Martin, but it seemed more respectful to call him vicar) and his brother Pete, a serious looking young man, with horn-rimmed spectacles. Pete also shared his brother's sense of humour, so we all got along fine over coffee and cakes. When we'd all finished, Bob started to tell Pete about our experiences, but he held up his hands and said, "I hope you don't mind, but I would rather not know anything about the case, until I've formed my own opinions. Do you mind if we look around now?"

We all stood up, and started going through the downstairs rooms. Pete looked calm and blank as we walked through them, until we came to the staircase where his face started to change into a frown. He stopped in our bedroom, where he looked around him, then slowly crossed to the wardrobe, with his face set, and his nose lifted like a dog on a scent. Then he turned, and went out into the landing. Without hesitation, he started up the attic stairs, and turning right, stopped outside the door which was over our bedroom, and then he turned to us who were following him, and held up his palm again. "I would rather do this without you, if you don't mind," he said in a kindly tone, "Martin, come." Martin passed us with a smile and a nod, then followed his brother inside and shut the door.

Well, we hung around for a bit, and then we sat on the stairs to wait. We waited and waited. From the room we could hear the medium's voice; sometimes he would talk for minutes at a time, sometimes he seemed to be asking a question, then there would be a silence; we never heard anyone's voice replying, then he would speak again as if his question had been answered.

After about half an hour, the door silently opened just a tiny crack, and Martin's face appeared, he put his finger to his lips to ask for our silence, and then he beckoned us in. We

crept in softly behind him, and we all stood in a row at the back of the room with the door closed. Pete was in the centre of the room, all alone, leaning against an old table, and gazing at someone (or something) that we couldn't see, but by the direction of his eyes was straight in front of him.

"Can you see it Ellin?" he was asking in a soft, loving voice, "Can you see it now, it's coming right in front of you, soon it will be all around you like a great beam of golden sunshine. Move towards it Ellin dear, that's right, now move into it, doesn't that feel better? Now when it moves, you must move with it." He turned his head briefly and said to Martin, "There, she's starting to smile; she is raising her hand to me as she moves away, and leaves us." He smiled himself, and raised his hand in a gesture of farewell. We stared and stared, but we couldn't see a thing, the room was empty, but even as we stood there, we felt a sense of great peace engulfing us, filling the room, and we felt a wave of happiness spreading inside us.

Pete suddenly sagged against the table, and brushed the back of his hand over his forehead. Martin went up to him and clasped his shoulder, "Alright old man?" he asked. Pete looked up at him; he looked utterly drained and exhausted, but managed a small smile. "Yes, thank you," he sighed, "that took some doing but it was well worth it, she's gone now, and she'll be happy at last."

"Let's get you downstairs, and get you a strong cup of tea, then you must have a rest," said Martin. He turned to Bob and I. "These things take it out of him – look at him – he's whacked." He turned to Pete and said, "When you have had your tea and rest, you can tell these two young people the whole story, and how you've changed the place." He looked back to us, "I bet you can feel the change already can't you?"

"A great feeling of peace." I said, smiling. It was so true.

When we were all relaxed downstairs, Pete said to his brother, "Well, when you feel up to it, we're all ears."

Pete straightened up in his chair, and then leaned forward in it, lacing his hands together, and looking at us. "It's a long story, but I know it to be true, I've never been told a lie yet by someone who has just been released from the dark. So I'll tell you all about Ellin, that's her name, just as she told me. She came here when she was a child, to look after the old lady and her son, and she hadn't been here very long before she fell in love with him. After a few years, he seduced her, and she would creep down from her bedroom at night, and get in beside him. She stayed on after the old woman died, and Ellin thought that one day he would marry her. He wasn't a very nice young man, he got drunk and was violent, but it made no difference, she still loved him. What she didn't know was that he was seeing another woman, and intended to marry her. Then Ellin found out that she was pregnant; she was happy about it, but when she told him he flew into a great rage, and said she had better get rid of it, otherwise he would throw her out. It was a very shameful thing to get pregnant as a single girl in those days. He told her he had never had any idea of marrying her, she was only a maid, and he was getting married to someone else in a few weeks' time. That broke her heart and the shock of the news brought on the premature birth of the baby. She had it upstairs in the night all by herself; he didn't know anything about it, he was snoring in a drunken stupor in his own bedroom. She muffled the infant's crying, and got dressed, then she carried the baby out and threw it over the cliff into the sea – poor girl, what she must have gone through." He paused briefly, and then continued.

"Well, he got married a few weeks after that, and Ellin lay upstairs sobbing her heart out, listening to them laughing and whispering in the bed which she had shared so recently with her lover. After a few weeks, she couldn't stand it any longer, she was racked with guilt about her dead baby, and one night she just went out and followed it over the cliff. The awful thing was, even in death she still loved him, and her spirit couldn't leave this house, she's been here ever since, even though the others have all been dead for such a long time. She didn't realise how time had passed, and when you two young ones came to live here, and she could hear you in your bedroom, she hated it; she thought it was her lover and his new wife, so she haunted you."

He gave another deep sigh. "Anyway, she's gone now, I've managed to release her, and she's no longer earthbound so she'll never trouble anyone again."

He stopped talking, and lay back in the chair. We were all quiet until I said, "What about the baby? Will she see it again? Will she be allowed in heaven after what she did?"

There was a short silence, and then Pete said gravely, "God alone knows."

Well that was the end of that, the whole house felt happy and peaceful. Ellin's old bedroom is all freshly decorated with new curtains and flowers. Now it's a little guest room, pretty and cosy. Nothing else has happened, and we're very happy there.

She smiled and reached for her cup of tea. 'Well, now I've told you our ghost story, you can tell everybody else,' and so I have.

CHAPTER 7

Ghost in the Coal Hole

One day last week, I had a visit from a Mrs O'Donague of Dublin, who had come back to her family home in Treaddur Bay for a holiday and wanted me to sign one of my books she had bought. She told me this story which I am writing down before I forget any details. In the late 1990s, she was studying for a degree (BA) at Bangor University and made many friends, one of whom she called Will, who lived at Beaumaris and travelled into Bangor every day. He told her he lived in a fairly big house, on the same road as the Buckley Hotel. Not only was it old, it was haunted.

His father had died the year before, and as he and his brother had now left home to be students, his mother wanted to 'down-size', sell the big house, and buy a bungalow somewhere on the Island. His family had all become used to the haunting, which wasn't a very frightening one, but the boys agreed with their mother that it might put prospective buyers off. The haunting consisted of muffled heartbroken sobbing in one of the attics, sobbing also in the big coal-cellar, but strangely enough, instead of only sobbing in the cellar, some days (or rather nights) they heard girlish giggles and laughter. Mary (Mrs O'Donogue) was very interested in this, as was her roommate Ann. When Will said his mother was going on holiday for two weeks in Spain, he also said the house would be empty, and he had been given permission to have a few friends to stay:

He asked and we jumped at the chance. His friend Dai was going to come too, and so we made a date. When we got there, we were quite amazed at the size of the house, which was in a terrace of other large town houses (it reminded me of 10 Downing Street), with the front straight onto the road, and the rear overlooking the Straits. When we went in, Will showed us all over the house, but first of all showed us into a large, very pleasant living room that had a roaring fire going in the gate. "Oh, lovely," I said, moving across to it and spreading my hands to the warmth, "I love to see a big open fire, especially a hungry one that has just been fed."

"That one's always hungry," Will said, "I get sick of filling that coal hod up, but it does give out some heat." The coal hod was a big brass one, and must have been very heavy when it was full. "Come on," said Will, "I'll show you the attic first, where the servants slept." We peeped into the tiny attics on the top floor; they were empty, but there was only space for a single bed and a chest of drawers, and they were very, very cold. Then we went down the servants' staircase at the back, which was very narrow and steep, to the next floor, where some of the guest bedrooms were. These were large and airy, and also cold because it was November, but each had a fireplace in, complete with hearth and coal-scuttle.

"You haven't got central heating then, up here?" asked Mary.

"We haven't got central heating at all," Will replied. "Mother's debating whether to have it put in before she sells, which will cost a bomb, or sell it without, which will make it cheaper to buy, but it would save her a lot of worry and mess."

"So in the meantime you just rely on fires?"

"Except for the stove in the kitchen," Will said and we moved on. There seemed to be a lot of rooms, each with a fireplace, poker and brass hod, which were mostly full of coal.

"Whose job was it to keep the hods topped up when there were guests staying, in the days when there would be quite a large indoor staff?" Mary asked.

"Oh, that would have been the scullery maid's job, or the kitchen maid's," Will answered. "They had to see that the fires were lit by 6.30 a.m. at the latest, so that everyone woke to a big fresh fire, and they could wash and dress in the warm." I had a mental picture of the little maids waking in those icy attic rooms, getting washed and dressed in the dark in winter, then creeping down that steep staircase to riddle out the old cinders and light a bright cheerful fire in all the rooms.

We went through all the upstairs rooms, the kitchen and scullery, etc., until we came to the final staircase that led down to the cellars. Will switched on the lights. We were in a long passage, with doors on each side. The lights were a row of bulbs, set in the ceiling at intervals down the center of the passage. Will picked up a torch, which was standing next to a packet of candles and a box of matches on a little table, and opened the front door. Inside were many hooks in the ceiling and walls, two plain wooden stools, and a wooden table.

"This is the plucking room," Will said, "where they used to hang the pheasants, grouse, poultry, etc., all the game that was to be dressed for the oven." He opened the next door. "This is the cold room," he said "where they used to store the blocks of ice for keeping the meat fresh, and the wine cool; you could buy blocks of ice from a man with a cart who sold ice."

"Where did he get it from?" asked Dai curiously.

"Oh, there were firms who specialized in it, they had deep dry wells somewhere cold; so deep the ice wouldn't melt, and then they used to put it on carts and sell it to houses like this." He grinned and said, "This was in the day before fridges!"

"What happened when it melted in this room?" asked Mary.

Will pointed down to the floor, where narrow channels had been scored pointing to the center, where there was a large grid. "It just went down there," he said.

We moved slowly along the passage; there were seven doors, three on each side, then the last one in the middle of the passage at the end. Each room had a different use. One had old trunks and boxes in, broken or disused furniture, another was a wood stove, and so on.

"Now, this is the only one I want to show you," Will said, throwing open the last door – the one in the middle of the corridor, "this is where the crying comes from." We all wandered in behind him, and looked around in wonder. Directly in front of us, and nearly filling the room was what I can only call a mountain of coal. It stood in the shape of a pyramid, coming to a peak at the top, and widening at its base until it nearly filled the cellar. I wondered how on earth it got there, but before I could open my mouth, Will pointed to the top of the heap, and said, "That's how it came in, through the coal hole." We all looked up, just where the coal peaked, near the ceiling, and there, set fair and flush, was a circular

metal lid. "That's how it was delivered." Will went on, "The coal man used to come along the back lane of the houses with his horse and cart, stop at his first customer's house, then go in the back gate and up the yard to the back door. One of the servants would tell him how many bags were needed for that week; I suppose it depended on the weather or how many guests were staying in the house. The usual amount was about six hundredweights, remember it was the only source of heat they had so the coal man (I don't know how or when they paid him by the way) would then go back to his cart, open the coal hole cover, which was made of metal, usually with a metal ring in the middle, and tip down the bags of coal, one by one. Some households usually put someone in the coal cellar to check he put the right amount of bags in – many coal men would always say they had dropped off six, when they had only left five, so someone was always left inside to keep check. You can see if you look around how the system worked. Only the best coal was used for the fires, so it was sorted here. On that side," he pointed and we all looked to the left, "are the big lumps that needed breaking up for use, you can see the big lump hammer is still there." I wondered how many hands had used that hammer, it must have weighed about seven pounds, it was probably over 150 years old at least. "Now on the right side, you can see the huge store of coal dust that was thrown there so that the fires couldn't smoke; my mum uses it to damp down the fires while she's out, shopping or whatever."

We all looked at the pile of dust. It was as long as the cellar, and it was shoulder height to Will. There must have been a couple of tons of it; it had been there for generations, with spider webs all over it.

"The maids who filled the hods had to sort it first, with that big coal shovel, dust to the right, lumps to the left, leaving just the best coal for the hods, then they had to stagger upstairs carrying them."

"Gosh! More than I could do," said Ann, "bet you couldn't get anyone to do it these days, not even strong men, let alone young girls."

"No unions in those days," Dai grinned, "and everybody was glad of a job, it meant food and a roof over their heads."

"Well, I've told you all the facts of the case," said Will, "now we come to the bit that can't be explained away." He looked around at us all seriously then he said, "The last fact we do know is there once was a young kitchen maid who worked here about 150 years ago? Maybe more, maybe less; she was young and pretty, and seemed to be quite happy working here, until one day she fell in love with the coal man. According to the story, he was handsome, cheerful, and had a winning way with the ladies. He had lots of affairs apparently, but he was married, and always used that as an excuse to put a stop to an affair when he'd got tired of it. Employers would never allow their staff to have "followers" as they were termed, and the head employer, butler, housekeeper, or cook, depending on the size of the staff, would keep a gimlet eye on the maids, making sure all staff entrances were locked at night so that no-one could slip in or out. The key taken out of the lock, and kept overnight by the staff-member in charge. As far as the story goes, the coal man and the maid met in a very crafty way. Sometimes when it was time for the next delivery of coal, our maid, let's call her Megan – a name makes things easier – would volunteer to go down to the coal cellar, and when the coal man took off the coal hole lid, she and he would arrange the time of their next meeting. The place would always be the same of course; the cellar, and usually it would be on the same night as the delivery. This was because on delivery day, the

young coal man would empty a sack of coal down the coalhole straight onto the mountain of coal beneath him, and then he would throw down the empty sack into the cellar, instead of folding it and putting it back on the cart. They arranged a time for the evening when all the staff doors would be locked, and this is how they met.

Late evening when his work was done, the young man would leave his home, and come back to the house, go round to the back, and walk along the back lane until he came to the coal hole cover belonging to the house where Megan was in service. In the meantime, after late dinner, all the coal hods would be filled, so there would be no interruptions. Then Megan would climb up the coal mountain, until she reached the peak and she would flatten it down a little, leaving enough space for her lover to drop onto from the coal hole cover. The empty sacks she laid on the coal for him to stand on as he climbed down to her, so his clothes wouldn't get thick with coal dust. He never put his best rig on anyway, but always came in his working clothes. Years later, an old army blanket was found hidden in the comer where the stock coal was never disturbed, and it was presumed then to be the blanket they lay on when they made love on the big area of slack in the cellar. [This tale intrigued me and, thinking about it later, I wondered how he got out. Had he left the coal hole lid off, or open or whatever, and if so, wouldn't it have been dangerous for anyone walking by who could have tripped over it, or fallen into it? – More of this in a moment.]

Then one day Megan disappeared. She just wasn't there. She had carried out all her duties for the day, but was missing when the servants had their supper. When they went to her room to see if she was ill, all her clothes and belongings were there, including her outdoor coat and hat, as well as her best walking out shoes. Everything except Megan. Her only living relative was her old grandmother, half-blind and stone-deaf, who lived in the local workhouse. She was of no use at all, as she couldn't remember she even had a grandaughter. Word went quickly around the town, and then it was discovered that the young coal man was also missing. The difference was, though, that he had left with a suitcase full of his clothes and belongings, so his disappearance had been planned. Putting two and two together, everyone thought that Megan and her lover had run away together. His embittered wife said he had had many affairs, and she always thought that he would vanish one day with one of his current lovers.

The one thing that puzzled everyone, however, was why Megan had left all her belongings in the house. Her position was taken by another girl, the coal man's job was quickly filled, and life went on. Gradually, over the years, facts were forgotten, and another generation took over. This was when the haunting started.

Firstly, it was the quiet sobbing in the attic which had been Megan's room. The strange thing was though; it could be heard by anyone in any other attic, or coming up the stairs, but never by anybody who was in the room itself. The same could be said of the coal cellar, sometimes the weeping, sometimes the girlish laughter, but never ever heard by the person who happened to be in the coal cellar at that moment. As no-one saw anything, and no-one was hurt, it was more or less ignored by the family living in the house at the time. Then, during the Second World War, fuel was becoming very scarce, and the big fires in the house were now fewer and smaller, and coal was not thrown onto them. So, the servants economised as much as they could, and the fires were kept lit, but dampened down with a few shovelfuls of slack from the coal cellar.

One day, as the young man whose job it was to extract the rock-hard slack from the almost solid ancient heap was ramming in his shovel, he withdrew it, and found that not

only did it contain the coal, but also the remains of a skeletal foot, still thrust inside the remnant of a shoe. He raced upstairs to inform his master, and together they examined the grisly object. Then with care, they started to expose the leg bone that was still attached to the foot. The shovel was exchanged for two small gardening forks, and very slowly and gradually the whole skeleton was exposed. It was the skeletal body of a rather small young woman, who once had blonde hair. A few bits of her clothing still remained, and although they were stained and rotted, they were undoubtedly the rags of what had once been the uniform of a maid.

Now, because this story is hearsay, no further facts are known. Whether the girl had been strangled, or whether she was pregnant or not, there are no records to show what happened after the discovery of her skeleton. I have no idea what happened next, or who paid for her cremation. The only thing that is widely believed was that her ashes were scattered in the Straits behind the house – a) because there was no garden to bring the urn in; b) no-one knew what faith she was; and c) it was only surprising that the missing Megan had now been found. If she had been pregnant, had the coal man (her lover) strangled her to keep her quiet, and had he then carefully buried her in the long pile of coal dust, which was never disturbed? So many questions to ask, which can never be answered. Out of them all, the most puzzling one is this: Why do people still hear the heartbroken sobbing and the occasional stifled girlish giggling?

Surely, after a Christian burial and her ashes peacefully scattered in the Straits, her spirit would be at rest?

Seemingly not so, one part of her still haunts the house – why? It would take a good, genuine medium to contact her, and find out what the problem is, which keeps her earthbound.

Well, this story of Mary O'Donogue had intrigued us both so much; we wanted to find the house. So yesterday we climbed into the car, and set off for Beaumaris to see for ourselves.

Not far from the Bulkely Hotel, a short left-turn with an arrow over a car park sign led us on to a small grassy car park, complete with a pay booth (empty and locked at this time of year), which overlooked the turbulent straits. We parked facing the water. Behind us was the road on which stood the Bulkely Hotel, and the row of town houses which held our interest.

Getting out of the car we got our bearings. To our left, the rear of the Bulkely, then the short entry to the car park, then the row of houses, whose rear faced us. They had the usual sash windows of the kitchens, servants halls, etc.; for they were fairly large houses. We were looking towards the back yards, back windows which went up three stories to the tiny windows of the attics. We counted along the back yards, and stopped when we got to the house that we wanted. I looked along the narrow strip of tarmac that lay between the houses and the green turf of the car park. Outside every back gate of the row of houses we were interested in was a circular metal cover, approximately 2 feet wide, made of cast-iron.

We walked towards the one we wanted, and I stood on it for a minute, thinking back across the years to when it was so significant to a courting couple. Walt gently pushed me aside, and we stood staring down at the circular plate, with its iron ring counter-set, that had been used (and probably still was) to lift it off, and replace it. I bent down and extended my hand to the ring, ready to lift it off.

'Shall we just have a quiet peep?' I asked.

Walt stayed my hand. 'No,' he said, 'there may be someone down there.'

So we didn't look, just stayed there staring down at the coal hole cover. What Walt was thinking I'll never know, but in my mind's eye, I could see the coal pouring down on the pile beneath until it became a miniature mountain, and the countless times the handsome young coal man had followed it down, while his horse had waited patiently in the shafts of the cart for his return. We stared silently for some time, and then we turned away, and got back in the car.

There we sat looking up at the attic windows. 'I wonder if she did become pregnant and he killed her and buried her in the slack,' I said finally.

'Don't know,' Walt replied, 'I wonder why she was heard crying long after she was cremated and her ashes scattered.'

'Do you think someone has had a good medium here and he's found out why?' I asked.

'Well, we can't just knock on the door and ask, have you still got a ghost, can we?' Walt replied.

'So I suppose it's one of those stories we will never be able to finish?' I said, looking at him.

'You never know, maybe we will someday.' He started up and we drove off.

I still don't know.

CHAPTER 8

The Lugger

The smart little blue-and-white newly painted crab boat was hove to at a marker buoy and the younger of the two men aboard her was busy hauling in the last pot of the day. As it was dragged in, he gave a satisfied grunt. The crabs were crawling well today; it had been a good catch. He emptied the pot, dropped its contents into the hold, and re-baited the pot from the pile of smelly bait, before dropping it back in the sea. 'Right,' he said to the older man who was busy in the wheel house, 'a swig of tea and make for home.'

Ted passed him a mug of steaming tea from the flask, and they leaned on the rail together, gazing at the rough, choppy Irish Sea which surrounded Anglesey. Bumps was slurping his first mouthful when Ted, who was squinting his eyes against the sun-sparkling water, pointed and said, 'Look at that.'

At first, Bumps could not see anything on the empty ocean; then he spotted a shape moving slowly across in front of them, about a mile away, on an east-north-easterly course. 'I can't see anything, oh yes, got her now, by God she's an old ship.' They stared in silence for a moment at the little craft. She was all black, with a white line painted around her deck-line. 'Never seen one like her before, she's a sailing ship isn't she? Wonder if she's one of these Government ships? Ted shook his head, 'Too small,' he said, 'not enough room on a lugger.'

'A lugger?' scoffed Bumps, 'there's been no luggers around since 1900 and starved to death.' He grinned and spat into the sea.

Ted scowled. 'She be a lugger,' he said flatly. 'I knows a lugger when I sees one.'

Ted had come up from Cornwall thirty years ago, but his Cornish accent was still thick. 'And they stopped being made in the 1890s, so any that are left are usually on show at the dockside for tourists,' he gazed at the small ship which was plainly visible in the sun. 'You always tell a lugger. Two masts, with four square sails set fore and aft.'

He was still staring at the little ship, sails billowing in the stiff breeze that had just blown up. 'If she's what I think she is, she's no ordinary vessel, people have been seeing her for nigh on 200 years.'

'What?' said Bumps grinning, 'you're having me on.'

The skipper ignored him. 'Mark me, she brings bad luck wherever she's seen; never thought I'd lay eyes on her, I wonder where she'll lay to? There's many a sailor who swears she's a signal that there is going to be a sinking or a collision a few days after she's been sighted.'

Bumps grinned again, 'You'll be telling me next she's a ghost ship! Well I've heard of the flying Dutchman, never heard of the flying lugger though!' He chortled to himself.

The skipper looked at him. 'There's always some truth in these old tales. That lugger has been the subject of many – you can ask any fisherman from Cornwall to Caernarfon about her and they'll give you a list of ships that were lost a couple of days after sighting her.'

Bumps' curiosity was aroused now. 'Is she seen round the British Isles?' he asked.

'No, it's just the western coasts mainly, from Cornwall up to Liverpool Bay.' They both had their elbows on the rail now, watching the small black boat skimming along as graceful as a swan.

Still with his eyes on her, Ted went on, 'The lifeboat lads know all the stories; some tell tales that their fathers told them.'

Bumps was intrigued now, 'When was the first sighting, do you know?'

'No boy, I don't, sightings have only been passed down by word of mouth, and a lot forget. I remember hearing that she was seen off the Great Orme before the hurricane on 25 October 1859 when the *Royal Charter* got wrecked. And there is the tale of the First World War; I think it was 1915, when a German U-boat sank the SS *Cambank* as she passed Point Lynas with a cargo of copper. The lugger was seen just before that by the coxswain of Bull Bay lifeboat and he told the crew there would be trouble to come. It came, like it does to many ships in the area the lugger is seen in, sometimes by one man, sometimes by two or three together. They're nearly all RNLI lads who record seeing her, they write it down to see if anything happens.'

'Where does she lay?' Bumps asked. The skipper shrugged his shoulders.

'Nobody ever found out; she just appears, sails along for a few knots, then she just sort of fades out as if she's in a mist, even when the weather is clear. She's been seen many times, even from the shore, but only seamen ever take notice. And she was seen again in 1939, long before your time, when the submarine *Thetis* dived 9 miles off Orme head and never surfaced. She jammed on the bottom. That killed all the crew, 99 of them, all drowned and that was a century after the *Charter* sank, so the lugger must have been old then. There must have been hundreds of times when she's appeared, probably when there are no witnesses about to mark her.'

'When was she seen last?' asked Bumps.

'Far as I recall the Holyhead lifeboat was called out to – damn, I can't remember the ship's name, I'll ask the lads when I go for a pint tonight. Anyway it was in December 2003, she may have been seen since then,' he stopped suddenly. 'She's going, boy.' They both stared hard at the little lugger as she sparkled in the sun, and watched fascinated as she sailed into a tiny patch of fog on the clear water. She never reappeared at the other side and even as they watched, the little patch of fog seemed to rise up and evaporate, like steam from a kettle, leaving an empty ocean devoid of any craft at all. The little lugger had gone.

'Damn,' said Ted softly.

Bumps was awestruck and there was a silence as they scanned the empty water. Then Bumps said, 'I wonder why we've seen her here today? I wonder if anyone else has spied her? Has anyone seen her hove to anywhere, like in the spot where the wrecking takes place? How many days is she seen before anything happens? I wonder where it will happen next time, maybe off Anglesey again?'

Ted straightened up, and slapped him on the shoulder. 'Too many questions boy,' he pointed to a thin grey haze on the north-eastern horizon, 'and that's a wind getting up; glass has gone down too – it's time we weren't here.'

He went inside the wheel-house and started the engine. Bumps took his foot off the rail and, with another uneasy look around the vast empty ocean, followed him.

Bumps told me this story in 2010, has anything happened since?

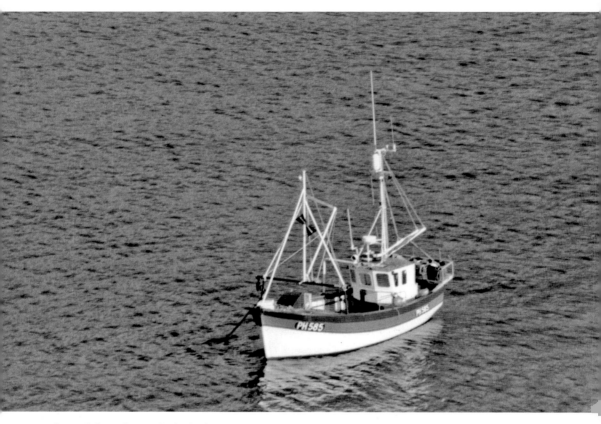

The crab boat from which the lugger was sighted, owned by Malcolm (Bumps) Baker.

CHAPTER 9

This is My House!

She lurched towards me along the passageway like an angry bull, her face distorted into a mask of fury. I had only got the front door open about a foot, and was about to come in, but her face invoked such a sudden abject terror that I took a step backwards and slammed the door shut again. There was an angry yell from Mollie behind me as I bumped into her, and nearly sent her and her case flying.

'What did you do that for?' she snapped, 'You nearly knocked me over.' I didn't answer and instead just backed down the two front door steps, waiting for the thud as the body of the fat woman hit it. It didn't come, so I expected her to fling the front door open and confront us. I was in shock. If ever I had seen murder on a face it was on that one as she flew down the passage at me. Nothing happened.

The day was sunny, the birds sang and everything was normal. Mollie was muttering to herself and picking up her case. When I'd got my breath back, I put my hand on her arm. 'Did you see her? That face! I thought she was about to kill me!'

'See who? What an earth are you babbling about Bunty?'

'That fat woman who just came thundering down the hall, you couldn't miss her!'

Mollie's face darkened. 'Oh, don't start that business already, I need a cup of tea.' She snatched the key off me, mounted the steps, and unlocked the door, muttering something about, 'you and your flipping ghosts'.

I stayed where I was and waited for her to push the door open, while I stood safely by the car. She flung the door open wide, and I flinched. 'See,' she said 'nothing here, let's get the kettle on.' I looked in behind her. There was a wide stone-flagged hall, with a strip of thin grey carpet down the middle, and a grandfather clock ticking comfortably against one wall. It was light, full of sunshine, but also a great feeling of anger.

'At last,' Mollie said, 'I'll make a cup of tea and we'll explore a bit before Mr Williams comes.'

We'd just driven down to Anglesey from Llandudno; we were first year students at Alnwick Castle (Northumberland) Training College. As it was the long vacation, we'd taken jobs for a month at the Country Hotel Llandudno, to make a few pounds for a two-week walking holiday in Anglesey. (Older readers will be able to tell how long ago all this happened; Mr Joe Davis, of snooker fame, owned the hotel then!)

I'd written to a firm in Benllech, which specialised in self-catering holiday cottages. They looked ideal in the brochure, but when we had made up our minds which one suited us both, the girl in the office said she was very sorry, but being the height of season they were all booked

up. There was one cottage, however, that they had only just been told about. The owner, an elderly lady, had died suddenly so her husband and son had gone to live with her sister, and wanted to put up the cottage for a temporary holiday let. The cottage, said the girl was very clean and had been well maintained and, although they were going to do alterations to it, like stripping out the kitchen and modernizing the bathroom, it was entirely suitable for a holiday let – if the holidaymakers didn't mind the furnishings being a bit old fashioned.

Well, Mollie and I discussed it. We had made plans for a walking holiday, and so we would only be using the cottage as a place to sleep and eat in, so as long as everything was clean and usable, we told the agents to send us some photographs. This they did, and we pored over them with great interest.

The cottage was quite large, a one-storey place, with a big garden, and hanging baskets. The windows were gleaming, and covered in lace curtains that were whiter than snow. It stood all by itself at the side of one of many back lanes that surrounded Benllech. The rent was very reasonable too; it didn't take us long to make up our minds.

Next Saturday found us in the estate office in Benllech, swapping money for a key. As we were going out, the girl said she hoped we'd enjoy it; we were the first people to take it, and if we wanted to come again, as she hoped we would, the alterations would have been done and we'd find a huge difference.

So here we were, at the front door of a chocolate-box cottage, Mollie fumbling with the key, and me cowering against the car. Not the sort of arrival I'd anticipated. Anyway, in we went, found our way through the hall to the kitchen at the back, and put the kettle on while we explored the other rooms. There were two quite large bedrooms, a double bed in one, two single beds in the other covered in snowy white, tasseled bedspreads.

We each chose a bedroom – both had lovely views of the garden and the sea beyond – when there was a smart rap on the back door. Standing outside were two men, very obviously father and son, with the dark good looks of the Welshman. They smiled warmly at us, and the older man said, 'Hullo, you must be the holidaymakers; I'm Will, and this is my son John. We used to live here, but since Bethan died we've moved into my sister's house.'

Mollie smiled back and said, 'Oh do come in, how nice to meet you, but I feel funny inviting you into your own house!' They nodded, and took off their wellingtons, left them outside on the step, and padded into the kitchen in well-darned socks.

'Oh, don't leave them there, the forecast is rain, and you don't want it to rain on them, you'll get wet feet!' She bent down to pick up the wellies, but Will laid his hand on her arm, drew her back in, and closed the door.

'Don't worry my dear,' he said in a soft musical voice, 'we always did leave them on the step, didn't we John?'

'We didn't dare come into Mum's kitchen with wellies on, or boots. We used to wear boots but it took so long to get them fastened or unfastened, we changed to wellies, much quicker,' John said as he came in, 'I got many a slapped ear when I was a kid if I forgot.'

'So your mum was a very house-proud lady, was she?' I asked as I warmed the teapot.

'Oh yes,' said John, 'it was, sit up straight John, put that cushion back, and don't talk with your mouth full – all those sorts of things when I was a kid.'

Will gave a rueful smile as he sat down in a chair that was obviously his. 'Yes, she lived for this house did Bethan,' he said. 'You see she grew up here; it belonged to her mum and dad, and they left it to her when they died, as she was the only child.'

'She kept it beautifully, and the garden,' I gestured at the window boxes which were a riot of colour on the outside of the window-frames, 'She must have loved it.'

Will nodded, 'It was her life – this house.'

'And death,' John added quietly. Mollie and I looked at him sharply. He could see the question on our faces and said, 'She was brushing the stairs down, she did them every day even though they didn't need it, and she was kneeling on the top stair when the postman knocked and came in through the front door. It was raining and the parcel that he had for her wouldn't fit in the letter box, so he was going to pop it inside in the passage to keep dry. He said afterwards that she turned around and saw him inside in his wet boots and she was dead mad and started shouting at him and waving her hand brush, then she overbalanced and came crashing downstairs.' He paused and looked up at us. 'She broke her neck,' he said quietly, and gazed into his tea-cup.

'How long ago did it happen?' Mollie asked.

It was Will who answered her, 'Oh, only two months ago, we didn't really know what to do, did we John? Then we decided to rent it out as a holiday home, until everything was sorted out.'

John finished his tea and said, 'Auntie Gwen is looking after it for us, that's Dad's sister, she's the only woman Mum would have in this house, she used to help her painting and decorating and things, but even so, she was always glad when Gwen went'. He gave us a small grin and said, 'Mum didn't like visitors, she always said they made the place look untidy.' Will was shaking his head sadly. 'A lot of people said that she was a hard woman,' he said, 'but she was a very good wife and mother; you couldn't have found a better one – best food, everything washed and clean, a spotless home, you could say we wanted for nothing.'

Except love, I thought, and perhaps a bit of tenderness. There was a short silence while we were all busy with our own thoughts, then Will said, 'Well, we came over to show you where everything is, and all I've done is talk.' He smiled apologetically, and stood up.

'Oh, it's alright Will, may I call you Will?' I asked. He smiled and nodded. 'You don't need to show us around, we can do that ourselves, and I promise we'll keep the place as tidy as your wife would.' Young John arched his eyebrows at me, and I got the message. No chance, he said with his eyes. We saw them out, and saw that the predicted rain had indeed arrived. It was quite heavy too, and splashed into the wellingtons. To my dismay, the men paddled out onto the wet step, and slipped very damp, socked feet inside them. Seeing my look of concern, John smiled and said, 'Don't worry, we're quite used to wet feet, I've had them most of my life, sometimes when we came in for dinner and left them outside, my toes were doing breast-stroke when I put them on again!' They both got into a battered pick-up truck, and with a friendly wave, drove away. We went back inside again, and as we made for the kitchen Mollie said, 'Blimey, the late Mrs Williams sounds like a right old battle-axe doesn't she? Wonder why Will married her?'

'I bet he hadn't much choice,' I said, 'if she decided that she was going to marry him, she probably chose the church as well!' We had arrived back in the kitchen by now, and I was making for the teapot, but Mollie had stopped and was looking with a puzzled frown at the table. 'Where are the other cups?' she asked. 'What cups?' 'The cup the Williams used; I left them on … Oh, there they are.' She pointed to the plate drainer on the sink. Sitting tidily in it, all washed and clean, were the two cups and saucers used by the men. As we looked back at the table, where our two used cups were, we saw, right in front of the Williams' chair, two

heavy pot mugs, obviously for everyday use. We stood and stared. Then Mollie shivered. 'Why do I get the feeling that she's trying to tell us something?' She asked in an awestruck voice. Then she tried to say lightly, 'Oh, I'm getting as bad as you, imagining things, come on, let's wash our cups up [before she does, I thought] and go and unpack.'

I went out to the car and carried in the bags of provisions we'd brought; we didn't want to come home and start cooking after a day's hard walking, so I had bought a lot of tinned and ready-made food, that would just need warming up. I took the bags into the kitchen and started to open the cupboards. Each one was filled with different things, dried and labeled home-grown herbs, lots of homemade jams and bottled fruits; the whole kitchen was well-stocked. Finally I found a cupboard in a top corner which only contained a small amount of beautiful cut-glass ornaments, so I decided to remove them, and stock all our own things in there together.

I stacked all the tins in carefully, meat, fish, macaroni cheese, spaghetti; all sorts of simple-to-eat food for a couple of hungry hikers. I hesitated whether to put the wrapped bacon, and the eggs in there, but knowing they wouldn't be in there for more than a couple of days I put them in, on top of the loaded shelves. I didn't quite know what to do with the glasses I removed, I was scared to death of breaking any, but then I had a brainwave and found a safe place for them on top of the units. There, that was another job done, and when Mollie suggested we should go for a wander outside before tea, I thought that was a good idea because the rain had stopped.

Outside, the garden was long with a small lawn on each side of the path, and very beautiful borders of many different flowers. I strolled out first, pointing out the hill in front of the garden, and the woods at the side. Mollie followed me, and leaned back to close the front door. She had her hand in the letter-box to give her a grip on the door. Just as she did so, she gave a yelp of pain, closely followed by a gasp of surprise.

I turned around just in time to see her crashing off-balance down the two steps, and I was able to catch her before she went flying. 'What happened?' I began, but whatever I was going to say afterwards, I was cut off abruptly by the smart slam of the front door. I stared at the door, then at Mollie; she was nursing one hand in the other, and I saw that the backs of her knuckles were scraped and red. She held up her injured hand for me to see. 'I was just going to pull the door to, with my hand in the letter-box, when all of a sudden the flap came down hard on the back of my fingers, it held then just like a steel trap … Good grief it hurt, then the whole door started to slam to, pushing me down the steps.'

She took out her hanky, and wrapped it round her hand, and said darkly. 'What made that happen? There's something funny going on here.'

'There's something going on and it's not funny!' I replied, as we went slowly down the path. The gate was wrought iron, and painted fresh white. I held it open for Mollie, and followed her, one hand on the gate to close it. No sooner had I got through however, when I felt a violent shove in the small of my back, and the gate crashed closed behind me. I spun round; shouting 'Hey!' but there was no-one there. Not a soul to be seen, just the flowers glowing in the sun, and that same feeling of great anger.

We looked at each other in silence, and hurried away along the lane. We were silent for a few minutes, and then when we reached a low field wall, Mollie pointed at it and we both sat down, looking at the cottage along the lane. It sat there in the afternoon sun, looking peaceful and friendly, no hint of the dark force which was living inside it. We explored

the district happily. The sudden views of the sea down the lush meadows, the unexpected splendor of small woodlands at the ends of fields, and the feeling that we could spend as much time as we liked just roaming about, made us feel very contented. After about half an hour, we turned homewards again, debating what we should have for tea. ('Something tasty but quick, like poached eggs on toast with buttered scones or something to follow.')

We sauntered back, and opened the gate into the garden with no trouble. Suddenly Mollie who was in front, drew in a quick breath, stopped and grabbed my arm. 'Look!' she said in a low voice, pointing at the car. I looked and gasped. The whole of the windscreen, and the two front doors were covered in a kind of slime, which when we drew nearer, resolved into raw eggs, white and yolks, which appeared to have been thrown at the car from some distance away.

We saw with horror that the raw eggs had turned into a horrible glutinous mass, sticking tightly to the glass and metal, and half-cooked by the warm rays of sun. As we stood there Mollie grasped my shoulder and pointing said again 'Look!' I followed the direction of her finger and looked across the garden at the side wall that sheltered the garden from the easterly winds that come sweeping across the field beyond. Down at the bottom of the wall, spread widely across the grass beneath it, was a great assortment of tins and packages. The tins were bent and flattened and the packages, mainly cereals and cooked rice, etc., had nearly all burst open, the contents blowing about in the wind. All spread along the length of the wall. I looked and gasped, 'Our food,' I said. 'That's the stuff I bought this morning.' 'Haven't finished yet,' said Mollie, pointing back at the car. I couldn't see what she meant at first then I looked at the rear window of the smart, new saloon.

It was smeared thickly with a spread of opaque greasy looking fatty substance. At the end of most of the smears stuck a pink-and-white shred of meat. It was bacon. Each rasher had been torn from the one below it, and rubbed in wide arcs across the glass with great strength, enough to leave the bacon hanging in grey strips.

We were speechless. We looked from the bent and battered tins, past the cereals and dried things fluttering in the wind, back to the messy car. Mollie sighed, 'Well, I think we know who did this, but why?'

'I know why,' I answered right away, 'We both know why, she wants us out of here, and secondly she threw this all over the garden so her precious cottage wouldn't be a mess.' We turned reluctantly towards the house, looking to see if there were any signs of movement (we knew it wouldn't be life!), but all was still.

'Don't go in yet,' Mollie said, 'let's see if we can rescue something for tea from those tins.' We searched amongst them. Mollie came up with a large tin of baked beans, slightly battered, and I found a tin of beef and onions and a squashed tin of peas, as well as half a sliced brown loaf, still in its paper; the rest of it lying in pieces in the mud. So we carried them into the house, it was just as quiet and serene as when we had left it, and it was no surprise to me to see the cut-glass ornaments back in their cupboard when I opened the door. We ate our make-shift tea, lit the fire because the evening had become chilly (it was freezing in the cottage), although the air outside was soft and balmy as the breeze blew gently through the bedroom windows. It was not yet sunset, so we decided we would go out and tidy up all the food stuff in the garden that looked such a mess. There were quite a lot of things that were still usable. Although most of the tins were battered and distorted, many were still intact and airtight, so we dumped them all into a carrier bag, and put them on the

front doorstep, ready to be carried in. We emptied the burst tins, and put the contents all in a pile near the compost heap, washing out the tins with the garden hose, and putting them in the recycling bins.

'Funny,' I called to Mollie, 'I bought two packets of chocolate digestive biscuits and a box of little apple pies, but I can't see any sign of them.'

'Probably the birds have had them,' Mollie said, as she wandered over to the car, 'we'll have to leave the car until tomorrow, we'll need gallons of hot water to get this mess off.'

'Well, the birds must like the biscuit wrappings too,' I said 'I can't see any here.'

Mollie was peering through a little clear space in one of the car's side windows. 'You're looking in the wrong place,' she said, 'the biscuits are here, what's left of them.' I joined her at the car, cupping my hands around my eyes to shield them from the sun, which was low in the west.

'Oh no!' I exclaimed. The interior of the car, both seats and floor, was covered in a mass of biscuit crumbs and bits of apple pies. They didn't look scattered, those on the floor had been trodden hard into the carpet, and those on the seats (both front and rear) were squashed down as if someone or something heavy had sat on them. The apple pies seem to have been squeezed and left in bits both on the steering wheel and all the control pedals. The whole car, both inside and out, was an indescribable mess. We gazed at the mess, and then stared at one another over the car speechlessly.

'It's going to take hours to clean this lot,' Millie said in a despairing voice. I was too shocked and downcast to answer her, and we walked slowly back to the cottage. It was quiet and peaceful just as we had left it, and we made a pot of tea and some corned beef sandwiches. We were very hesitant going into the kitchen, and we didn't use the best pots, or drop any crumbs, we had a very strong feeling as if someone was watching us carefully, all evening.

At almost 7 p.m., Mollie said, 'What a flipping first night this is! We're supposed to feel all happy and care-free and instead we're behaving like somebody under the death sentence. Thank heavens I put those bottles of wine in my pack, I'll get them out and see if they make us feel a bit more cheerful.' She started to dart from the room then she stopped and said,'Will you come with me?' I nodded, and we went into the back kitchen where we had left our packs and walking boots. We turned our heads around so much as we went, they were almost screwed off our necks, but nothing happened. Mollie looked in the cupboard,

'Wine glasses? What are those?' she asked sarcastically, and brought out two thick tumblers. 'Never mind, these will do,' she turned her head and said defiantly, 'and they'll hold more!' She strode out of the back kitchen into the hall, carrying two bottles of wine and the two glasses. As she entered the hall, the thin strip of carpet which lay down the middle started to billow at the other end slightly. Its speed and height increased very quickly as the billow moved along it, so that when it reached Mollie's feet, the wave was nearly a foot high. Mollie tripped over it. It all happened so quickly that she started to fall before I reached her, her feet entangled in the matting. She fell with a thump, but had fallen on her side, both bottles and glasses intact. She sat up slowly, passing the glasses to me, glaring around the empty hall and rubbing her bumped head. 'Damn you!' she hissed, 'What have we ever done to you? Damn you and your cottage!'

I held my breath waiting for the world to fall onto us, but nothing happened. Mollie got painfully to her feet, and limped into the living room, still holding the wine, which she passed

to me. I poured two hefty glasses full, passed one to her, and we sank down on the chairs by the fire. We watched television; we ate what was left of the bread with tinned ham on it, and went to bed feeling a bit tipsy. It was only early, but we wanted to be up and about in the morning to give the car a good clean. We'd picked up a couple of brochures about Anglesey from the office when we'd booked the cottage, so we sat in bed reading them, doors opened compatibly, and chatted, in full view of each other. I was just reading out an article about the Copper Mountain, outside Amlwch, when Mollie made a funny noise between a gasp and a cry of pain. I swiveled my head to look across at her, and saw why. Instead of lying back comfortably on her stacked up pillows, she was sitting bolt upright and hanging on to the bed clothes rigidly. To my horror I saw that both her arms in her sleeveless nightie were gripped above the elbows by a pair of beefy hands, a woman's hands, red and calloused by a life-time of hard work, scrubbing, polishing, cooking, everything a hard-working woman in the late middle-ages had done throughout her life showed in those hands.

They were pushing Mollie inexorably forwards towards the bottom of the bed, trying to force her out, and even though she was hanging onto the mattress as hard as she could, she was losing the battle. I could see the hands, the thick wrists, and the fat forearms, after that, nothing. I was so horrified I was frozen, and then gradually the rest of the figure materialized. The rest of the arms and shoulders, the neck and head all came together, but the awful thing registered finally in my head. The figure was emerging from the wall. The bed head rested against the bedroom wall, and yet the ample figure of this woman was now half-in, half-out of the wall as if it was mist. There was no room for it, not an inch; no living human could have got one hand between the bed and the wall, yet this thing was leaning out, pushing Mollie down and finally out of bed as if she was made of feathers.

'Bunty!' Millie yelled, 'Bunty! Help me!'

I leapt out of bed and rushed across the landing just as the woman, if that is what it was, gave Mollie a final mighty push which sent her flying out of the bottom of the bed in a tangle of bedclothes and pillows. The ghost, or whatever it was, now stood in the middle of the bed. She was invisible below the knees, her lower legs and feet were probably inside the mattress itself, just like they had been when she was inside the wall. As I flung myself into the bedroom, she turned her face towards me. I knew that face. It was the same hate-filled face that had looked at me that day when she came racing down the hall at me.

'Get out!' She was saying. 'Get out!' Then she emerged from the bed and stood on the bedroom floor.

I saw her more fully this time, the crisp ironed apron, the same clean, serviceable work-dress that covered her ample body, and the thick stockings and polished plain black shoes on her big feet. I didn't hesitate, I sprang at her, hands outstretched to grip her fat white neck and shake her till she dropped, my rage was nearly as strong as hers, and I extended my fingers to grasp her as she was well within my reach.

My hands encircled her neck, and I suddenly closed them tightly on … nothing. She had disappeared. There was nothing left of her. My anger evaporated, to be replaced by bewilderment. As I slowly lowered my arms to my sides, Mollie emerged from the tangle of bedclothes, where she had been dumped. She was white and shaking, so I put my arm around her and led her gently out of the room, closing the door behind us, and into the room with its two single beds, where I had been lying.

As I led her, I saw large red angry bruises coming up on her arms, where she had been gripped, and also, above her nightie at the back, the imprint of two large hands, which looked almost burned into her back, where she had been forcibly pushed off the bed. She lay down on the bed furthest from the door, and stared at the ceiling. Then she said, 'I want to go home.' I was busy closing the door, and pushing the flimsy lock across, for all the good it was, but it did give me a false sense of security. Mollie turned her head on the pillow, and when she saw what I was doing, she just said 'Huh.'

'We can't go home tonight, think of the car. But I'm with you, we'll go as soon as we can tomorrow.' I left the light on all night, but neither of us slept much, and we got up next morning tired and bleary-eyed. We couldn't eat breakfast, we were too tired and jittery; looking round, listening, and jumping at the slightest noise, but nothing else happened thank goodness. After a cup of tea, we collected all the cleaning things we needed, there were plenty in the house! Then laden with buckets of hot water, brushes, cloths etc., we staggered out to the car. To our surprise young John Williams was standing in the garden, gazing in disbelief at the car. He turned around when he heard us coming, and gestured at the car. 'Did she do this?' he asked. We both nodded. 'Whose car is it?' he asked.

Mollie answered him. 'It's my father's,' she said glumly. 'He and mum have gone for a long holiday to my sister's place in Australia. He lent it me as a great favour, because he says he knows I'm a careful driver, and I'd look after it.' We all gazed at the mess in silence. 'I'm jolly glad he can't see it now,' she said 'he'd have a heart attack, he loves this car.'

John patted her on the shoulder. 'Don't worry,' he said briskly, 'we'll have it looking like new again in no time.' Mollie nodded her head, but not with any conviction.

Mollie got busy on the interior, which was the most pernickety of all the jobs. Not only was the upholstery thick with crumbs, but the glove compartment, map compartment, and all the side pockets in the car doors were thick with crumbs and pastry. In the end, she went back into the cottage, and came out with the small vacuum cleaner, obviously used for furniture, and an extension lead. John and I worked on the outside, delicately cleaning the panels, John took over that job while I did the finicky bits – lights, number plates, door handles, etc.; we all worked hard, and it was mid-afternoon before we all took a breath and stood back.

'That's better,' John said, 'we'll wax and polish it tomorrow, and you'll never tell the difference.'

'Tomorrow! I won't be here tomorrow, I want to go today,' Molly said firmly. 'I'm not spending another night in that house, even if I had to hitch a lift, I'm going home.' John and I looked at each other; his eyes were wide and concerned. 'You can't leave today, I'm going to give you your money back and I haven't got it until the bank opens tomorrow. Besides, she might have frightened you, but I'm sure she'd never hurt you.'

'You want to bet on that?' Mollie asked furiously. She yanked off her cotton cardigan; underneath it she was wearing a tee-shirt. The red and purple hand-marks were fresh and distinct. She turned around to show her back to John, dragging up her tee-shirt. He gazed at the marks in horror, they were more like burns than bruises, and gasped. 'She did that to you?' he asked in disbelief. Mollie's answer was a short nod. John sank down on the garden bench as if his legs wouldn't hold him up, gazing at the ground. I could tell he was thinking hard.

'I can see why you don't want to stay,' he said, 'but I don't know what to say.'

'Goodbye will do,' Mollie muttered, pulling her tee-shirt straight.

'Listen,' said John slowly, 'I've had an idea. I can see you don't want to spend another night here, and I can understand why, but I'm going to give you your money back.' He raised his hand, palm first, as I tried to object. 'You could sue me if anyone saw that,' he nodded towards Mollie, 'now I've had an idea, my mate and I have just bought a caravan off a construction worker whose job has finished. It's not a posh one, but it's OK to use for a holiday and it's on a camp site called St David's near here. Nice place, it looks over the sea, and it's got all mod cons on the site and everything, would you consider it? I'll take you in the pickup, if you like it, it's empty now, and then you can come back here and pick up your things, how about it?'

We both nodded in agreement, it sounded like the answer.

'Come on then,' John said, getting up, and before we knew where we were, we were squashed into the old pickup, and on our way to St David's. John told us a lot as he drove. Apparently his mother had always been house-proud, but she got worse as she got older. The love she had for John's dad, lukewarm at the best of times, had finally faded altogether; he couldn't do anything right. Then one night she didn't recognise him when he got into bed. She said he had no right to be there, and had pushed him out. So he went into the other bedroom where John was, and from then on, he slept in the other single bed. She got worse; sometimes she got up and made breakfast at two o'clock in the morning, shouting up to tell them to hurry up or they'd be late for work. (They both worked on a farm). She refused point-blank to go and see her doctor, saying there was nothing wrong with her, so they brought the doctor up to see her. 'Mum was furious,' said John, 'she wouldn't answer any of his questions, and when he gave her a prescription she tore it up and threw it back at him. Anyway, she stormed upstairs and locked herself into her bedroom, so the doctor had a serious word with dad. He said she was "confused", and if she wouldn't take the drugs he had prescribed, she would only get worse. The only answer to it was to put her into a home if she would agree. We all knew the answer to that, and he went. That was just about six weeks before she died, and we were at our wits' end. We just didn't know what to do.'

He stopped talking as he took a sharp right-hand bend, then we were there. As he switched off the engine, he said, 'Perhaps her falling and breaking her neck was a blessing really, I'll be glad when we have sold the cottage, it doesn't hold any happy memories – that place.'

'If you sell it, will you tell whoever buys it that it is haunted?' John frowned and lifted his shoulders. 'We don't know what to do,' he said, 'maybe she will have gone by then, or realised she's dead and moved on.'

He sank down on a bunk while we looked around the caravan. It was a bit spartan, no little frills like cups and saucers, just thick mugs, and nothing much in the fridge besides cans of lager, but with a bit of dusting and sweeping, it was suitable for us. John insisted we had our money back, and in the end we had to accept it.

'Where will you and your dad live when you've sold it?' Mollie asked curiously.

'Oh, we're very happy at Auntie Gwen's at the moment, and she's glad to have us there for the company; anyway first things first,' said John, standing up. 'Well, if you've finished, we'd better go back and collect your things,' he paused by the door, 'unless you want to spend another night there?'

'You must be joking!' Mollie said angrily. So back we went. We certainly didn't lurk about, and we only had a few clothes and things to pick up. I steeled myself to go into

Mollie's bedroom, and when I opened the door and saw the mess it was in, I broke into a cold sweat.

The mattress had been dragged half-way down the bed by Mollie's desperate clinging hands, and on the floor at the end of the bed was a tumbled mass of bedding, sheets, blankets, pillows, and the white counter-pane all jumbled together. I remembered vividly Mollie, white-faced and shocked, climbing out of the pile in the night. I raced about the room, picking up her clothes, make-up, sponge-bag, etc.; I couldn't get out fast enough.

John was waiting for us, and when we had emerged, he locked the cottage door behind us. Carrying our packs, we made our way to the shining car. We walked along the path nearest to the cottage and as we did so, I couldn't resist a last look into Mollie's bedroom window. The room was immaculate. The bed itself was freshly made, and smooth, the pillows arranged neatly side by side. The bedspread looked as if it had been placed inch by perfect inch, and every tassel was in place, each equidistant from its neighbor and hanging perfectly. Mrs Williams had her bed back.

Well, as I said, all this happened years ago. Mollie and I still keep in touch, although she lives in Middlesbrough, and I live in Anglesey.

She phoned a few weeks ago, and we talked about Benllech, and the Williams men. She asked me if I ever saw them, and if the cottage was still there, but I had to say no. I intend to go with Walt when we have time. I hadn't realised how long it had been since Mollie and I were there.

I vaguely remembered the leafy lanes, and the whereabouts of the cottage, so we drove around where we thought it should be. Alas! Gone were the leafy lanes and quiet meadows. Benllech had become a mass of new houses, and hundreds of identical bungalows. Search as we might, we could find no trace of the Williams' cottage and when we enquired we were met by blank stares and shaken heads. It had obviously been knocked down, but did Mrs Williams know? Or was she still on the site of her home? No-one seems to know.

CHAPTER 10

Who Were They?

We bought Eilianfa from an Irish vet (Jim Heaney) and his wife Pat twenty-three years ago. Pat had quite a few short, but very interesting ghost stories to tell me. Here's one, exactly as she told it, and surprisingly another one seen by me at the same house:

One morning I was strolling down the drive to collect the post from the box, which is fastened to the gate-post. Opposite over the road, is another farmhouse, far older than Eilianfa, approximately 250 years old, with a modern addition. I glanced idly across, and then I stopped and stared. At the rear of the building, as in most old farms built all over Britain, was a door to what was mainly used as sleeping quarters for the farm workers in days gone by. As I looked at the building, the door opened and a man stepped out. There was nothing odd about that of course, except for his clothes.

He was wearing a pair of very old, rough trousers, fastened with a belt and braces. Around the knees was tied a folded sack, and his feet were encased in wooden clogs. No jacket, but an old flannel shirt without a collar, and with the sleeves rolled up. His face and forearms were sun-burnt to a red-brown colour. I stopped in surprise, and felt a little shiver of fear go up my spine, because although he looked normal enough, there was something about him that was wrong. He slammed the door behind him, and it was only then that I saw the door was covered in peeling brown paint, and it was not the modem door, painted with crisp white paint that I was used to seeing most days. Instead it was slightly rotten at the bottom. He walked down the flight of steps that went to the right, built alongside the house wall, and across the yard to where a flat open cart stood, behind a big cart-horse that was waiting patiently in the shafts. Climbing onto the seat, or bench, the man picked up the reigns and slapped them smartly on the horse's rump. At once, the whole scene vanished, and I was left staring at the empty yard. It was completely different from the one I had just been looking at. In that one there was no modem glass conservatory like there is now, and the buildings in the yard had changed too, but I had been too surprised to take in any details and in any case it had all happened in the blink of an eye.

I never saw anything like that again, and I often wonder why people see such mundane things as a man doing something he must have done a thousand times in his life. There doesn't seem any sense to it does there?

Mrs Heaney told me this story many years ago, and I have never included it in my books, because like a lot of stories given to me it is so short. Or it was until a couple of weeks ago.

I too was walking down the drive, head down as I examined the damage that the heavy continuous downpours of rain had done. In some parts of the downward sloping drive the thick layer of crushed slate we had covered it with had been completely washed away into the ditch; in others the potholes were inches deep, and 2 feet wide and, as the drive is at least 200 yards long, I knew it was going to be an expensive job to repair it. So I lifted my head up, and stared directly in front of me, trying not to look at the mess below my feet.

It was then that I saw her. I was looking across the road at the farmhouse Pat had mentioned. To begin with, Llaneilian Road wasn't tarmac. It was an earthen lane, complete with puddles and wheel-ruts. Each side of it the hedge-rows were tall and overgrown, it was thick with nettles and blackberry bushes, completely wild. But I was staring into the backyard of the farmhouse. A woman was standing in front of a clothes line, putting out washing that she lifted piece by piece from a large wicker basket at her side. There was a small basket at the side of that, which looked like a chip-wood basket we used to buy strawberries in, and from it she was taking clothes-pegs out – long thin wooden ones that looked very strong. She was ramming them down onto the corners of the white, newly washed sheet she was hanging on the line.

Just then another woman appeared around the corner of the house. It must have been a hot day, as she was wearing a pretty blue dress (muslin) with a high waist, and long skirt. She stopped to talk to the woman by the clothes line, then turned and pointed to the side of the house. I looked to where her hand was pointing, and saw that it led to a garden, in which stood a young lady. She was leaning against the trunk of a young tree, and gazing down at the ground with a very sad expression. Then she burst into tears and hid her face in her hands.

Her whole body shaking as she was racked with sobs. I saw there were two trees there, both pine. The garden was very different from what it is now. There was a damson tree, an apple tree, and gooseberry bushes, all growing around the edges, and I think the garden had plots of different vegetables where now there is only lawn and wide ornamental steps leading into the front of the house. I only had a moment to take this all in, when seemingly the lady in the print dress must have called the girl's name (I heard nothing), because the sobbing girl looked up, saw the woman, and fled quickly into the house (which was out of my view) and the lady ran after her with great speed. I swung my gaze back to the woman who was still stoically pegging out the washing, and just as she stooped down to the basket, the whole scene dissolved. What had happened, why was the girl so heartbroken, what did it all mean?

I made many enquiries, but I didn't know the year, the name of the families who had lived there, or anything else for that matter. The one small fact I did clear up, however, was years ago, two tall, mature Scots pine trees had been growing in the garden by the wall, and they had been cut down as they were a danger to nearby buildings. Pine trees keep their needles on all the year round and these two were exposed to the great winter gales; particularly the north ones, which we get in winter. So, was it one of these trees (then only saplings) the young girl was leaning against? Why was she crying, and who was the lady who ran after her into the house? What on earth was going on?

CHAPTER 11

Which One?

Well, nothing should surprise me in this job – look for the answer to one mystery, and hey presto another story surfaces. While I was enquiring about the Min-y-Don, another photograph turned up, taken by Walt, from when we were investigating the 'Flat Iron Murder' (*Haunted Anglesey*).

This house stood next to the Min-y-Don, and has a haunting all of its own, 'Sea Garth', which when I wrote about it was owned by a lady who wished to be known as Mrs Hughes.

Sea Garth, a lovely house built right under the great rock known as 'Castell Mawr', which was once a big limestone quarry exporting limestone to Liverpool, has a secret garden. It is known as the secret garden because there is only one gate (nearly hidden by trees) for entrance and exit. It has not always been like this though. Originally it was a fine, large garden, full of beautiful blooms. The family who lived there then, had a pretty daughter who was deeply in love with a young quarry worker from Liverpool, who used to meet her as often as possible (when his day-shift was over), in the secret garden, hidden by the trees.

He wasn't the lover her family knew about, and they had accepted that he was the son of a sea-captain and a sailor who worked on a local coaster that carried limestone from Red Wharf Bay. She had loved him at first, before she met the lad from Liverpool, who had supplanted him in her affections, and was getting ready to tell him she no longer loved him.

She was waiting in the darkness of the secret garden for her quarry-man. What she didn't know was her official lover, the sailor, had heard gossip about the girl and her new lover, and he also was waiting secretly in the garden. He saw her quietly slip out of the back door, and was now standing by the beech tree where she always met her new love.

He could hardly believe his eyes when he saw her standing there in a pale summer dress, the one he particularly liked, and his head filled with pain and jealousy.

She hadn't been there for two minutes when the quarry-man jumped over the wall near her, and at once took her into his arms. The sailor wrenched a rock from the wall, and with a yell of rage, flew at the pair, rock on high, ready to smash it into the head of his rival.

When the girl saw what was happening, she pushed her lover out of the way, and ran with outstretched arms at the attacker – too late. The hefty rock was on its murderous way downwards, giving her a tremendous blow on the head. She fell as if pole-axed; her assailant was frozen with horror at his mistake and to his shame the quarryman turned, leapt over the wall and made his escape.

I can't find out any more facts. No names or dates, but Mrs Hughes told me that the ghost of the girl is seen very frequently and everyone who has seen her describes her as desolate-looking, wearing a pale dress and wandering sadly around the garden, before she disappears through the wall of a modem bungalow built at the back of the garden. Everyone who has seen (and still sees) her says she is very sad and she seems to be searching for someone.

What I want to know is which of the men she is looking for? And will she ever find him? Do you know?

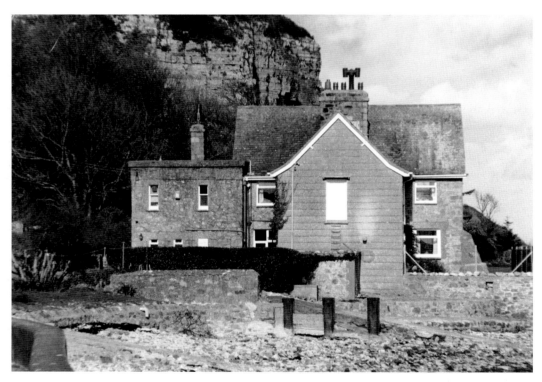

Built on the shore at Red Wharf Bay, the garden is almost hidden by trees.

CHAPTER 12

Where Are You?

Nellie Mason was happy. Tomorrow was her ninth birthday, and her mum was taking her to Amlwch to choose a new dress from Manchester House. Mum and her friend Mrs Owen were walking behind her, deep in conversation, and Nellie was skipping along about 10 yards in front.

They were walking along the main Amlwch road in Amlwch port, approaching the busy wharf on their left, and the shop that sold ships goods on their right. It was a hot, sunny morning in June, and as far as Nellie was concerned, all was right with the world. It was quite early, some of the shops were not yet open, and the road before them was deserted, except for one woman, who was coming towards them. Nellie didn't take much notice; she was much too involved in jumping over the cracks, which meant skipping along the pavement and trying not to step on the nicks between the paving stones.

But as she drew nearer to the woman, she stopped her game, and walked at a sedate pace; she was too shy to speak, but looked at the woman with a warm smile. It wasn't returned though; the stranger was gazing straight before her and didn't seem to notice Nellie. Something about the woman seemed very strange; the day was already hot, but the woman was wearing a thick, full-length fur-coat, with the collar turned up around her neck and chin, as if it was the middle of winter. As Nellie stared, she saw that the coat was old, very old, with bald patches on the elbows and pockets, and an uneven dipping hemline, which needed stitching.

She wore black shoes with a strap-and-button fastening, thick black stockings, and her footsteps made no sound. Taking all this in, Nellie looked again at the young woman's face.

The gaze was still set, the eyes still looking straight ahead, they didn't seem to see Nellie at all, and her progress was absolutely soundless. Nellie could hear her mum's footsteps behind her, and those of her friend, Mrs Owen, even her own feet tip-tapped on the flags of the pavement.

Suddenly Nellie felt afraid. There was a cold atmosphere surrounding the stranger, and it tightened Nellie's scalp, so that the hairs on the back of her neck stood on end. She dropped her gaze and scurried past this strange woman.

A few yards farther on, she stopped and looked back. Her mum was there, Mrs Owen still pushing her baby's pram, but there was no sign of the woman. She ran back to them, and said, 'Where did she go?'

The two women stopped talking and looked at her blankly.

'Where did who go?' asked Mrs Owen.

'That woman that just went past, she looked sort of funny.'

'No woman passed us,' said her mum positively, 'I didn't see anyone, did you Megan?'

Megan shook her head.

'But you must have done, she's only just passed me.'

Megan shook her head again.

'She couldn't have gone past without us seeing her,' she said 'she'd have to step into the road; this pavement is only wide enough for us two and the pram. You must have been seeing things.' They all looked up and down the empty road. Still frightened, Nellie went back to her mum and gripped her hand as they stared.

'She just vanished, like a ghost,' she said, looking at her mum with round eyes. Her mum shook her hand and frowned at her daughter.

'Don't be silly now,' she said, shaking her head, 'I keep telling you, there's no such thing as ghosts,' but Nell saw her mum and Megan exchanging strange looks. 'Now, that's enough nonsense for today, let's hurry up and go and see your dress, we'll go there first.'

So Nellie had to be content with that, but she couldn't forget the strange woman who gazed at something no-one else could see, and who walked without a sound.

The next day, her birthday party was a great success. All her friends from the village came, and some of their mums too, to help to organise the games and help with the washing up. She was hiding behind the sofa during blind man's bluff when she overheard a scrap of conversation between three of the mums in the kitchen.

'Yes, she's still walking, Ann saw her last week down on the wharf, frightened her to death,' she said. 'She saw her as plain as day, and her husband never saw a thing.'

'That's where she is always seen,' said another voice. 'There, and sitting on her front steps – a lot of people have seen her, she just fades away.'

'I thought of her for a lot of the time I was growing up,' said Nellie, who was telling me about her experiences at the Dinorben luncheon club, when I was giving a talk about my books.

I only saw her once after that, oh, years later, when I was grown up and married. I'd been to the Pilot stores for some bread, and when I came out, there she was in the same fur coat, standing by the rail and looking down at the wharf. I wasn't a bit frightened, I decided I'd go and speak to her. I turned around to shut the door, and when I looked back she was gone.

I was determined to find out more about her, and now I was a grown woman and married, my mother told me the whole story. Apparently, the ghost was the ghost of a lady called Sian Pritchard who lived in the port ages ago, probably over 100 years. She wasn't born locally, she came from Holyhead, and she met and married a seaman called John Pritchard, who lived with his mother and father in the port. They rented a cottage in a little row of cottages near the wharf, and were very much in love with each other, and very happy. He had to go away very often, and would always bring her a present back from wherever he had been. Once he went to northern Canada, and brought her a lovely fur coat; she was so proud of it she wore it right through winter, and it looked very new then.

Well, when they had been married for just over a year, he got a berth on a cargo ship; he was an engineer by the way, and a very good one they say. Nobody seemed to remember the name of the ship, but apparently she was a new one, built about the same time as the *Catharine*. I don't know exactly which year, but it was sometime in the mid-1800s I think.

Anyway, she was bound for North America and everyone went down to the harbour to wave her off on the tide, and Sian walked back to her cottage in tears when the ship had disappeared from view, taking her beloved John with it.

The ship had only been gone for about four days when a great storm occurred, and it overturned and sank.

Some of the crew managed to hang on to wreckage in the sea, and luckily for them, there was a ship nearby which came to their rescue and managed to save four or five. Of course, when the news got through to Amlwch, everyone was shocked.

Everyone tried to keep Sian's spirits up, by telling her John might be one of those that were saved, and she mustn't give up hope. So, she came down to the wharf every day trying to get news of him, she spent hours and hours here, and finally, after a couple of months, one of John's shipmates got home, and she learnt that her husband had drowned.

She couldn't seem to take it in. She spent all the time down the wharf, or sitting on her front step gazing out to sea as if she could make the ship appear by magic.

People said she went a bit funny in the head with grief. Then one morning her neighbours found her missing, and her body turned up weeks later in the sea near Bull Bay. The only way they could identify her was by her coat; she'd been got at by the fish. So had her coat apparently; instead of looking new, it was nearly bald in places, but it was her and the coat alright.

They decided she must have walked into the sea, because she couldn't face life without her beloved husband, and had gone to be with him. She can't have found him, however, as she is still walking along the wharf, looking out to sea. She can't sit on her steps now though, the row of cottages have been knocked down, but what baffles me is why she is still looking for him; I thought they'd be together now they are both dead!

Nellie promised to ring me if she heard of anyone seeing Sian walking. You couldn't mistake that fixed and far away stare and the fur coat, but so far I haven't heard anything.

I hope someone does contact me if they see her. How long do ghosts go on haunting for – and why?

CHAPTER 13

Which of Us is the Ghost?

'The first time it happened,' said Mrs Evans,

Was a few weeks ago when I'd been shopping. I had four bags of groceries and I had to put them down on the steps to open the front door. When I'd opened it, I picked up my bags struggled in, and slammed the door shut with my bottom.

Then I got into the kitchen/living room (it's only a small cottage, you probably know it, it's near the Market Tavern at the bottom end of Mona Street), and I put all my bags down on the table.

That was when my two dogs, Tex and Mint, they're rescue dogs and I love them dearly, who usually would have their noses in the bags by now seeing what I'd got for them, for the first time ever, weren't even there. For a moment I couldn't believe my eyes, and I went to the door to see if they were in the scullery. No sign, so I went back again calling their names all the time, and when I stopped to listen, I thought I heard a whine from upstairs, so I went to the bottom of the stairs and looked up. There they both were, standing at the top of the stairs. They were looking at me and wagging their tails, but both of them were whining and making no effort to come down.

I asked them what on earth they thought they were doing, and I started to go up. The nearer I got to the top, the more they backed away. Then they got as far as they could go, the bedroom door, it was shut, but they squeezed against it, and when I bent down to pick them both up, they looked terrified.

Fortunately, I could carry them both, as they are only small dogs, but they clung to me like limpets when I took them into the kitchen, and they bolted for their sofa and sat on it, making themselves as small as possible. They didn't even bother to explore the shopping and they were uneasy all evening, kept waking up and looking around the kitchen. Usually when it was bedtime they would stay on the settee and sometimes, very rarely, they would come upstairs with me; but this night they stayed downstairs, and kept so close to my feet I kept tripping over them.

Well, that was the first time, and the next was a few weeks later. It had been a lovely sunny day, and I'd been outside gardening, and the dogs were with me. I came back in about five o'clock to make tea, and when I opened the door I thought it was the wrong house. All the furniture was different, none of it was mine, and it was very old-fashioned. My electric fire had gone; there was an old-fashioned fireplace with a real fire in it, and a side-oven. There was a kettle sitting on an iron plate thing at the front of the fire, with

steam coming out of the spout. There was a rag rug in front of the hearth, with a black and white cat on it, curled up and fast asleep. All my lovely fitted carpet had gone too and there was just a stone-flagged floor with a couple of rush mats on it.

I saw it all in a flash; it was like looking at an old photograph, a black horse-hair sofa, and a square wooden table set for tea, with four chairs around it. There was a big old-fashioned sideboard laden with Victorian vases and all sorts of fancy dishes and things.

Sitting by the fire, and putting a teapot on the hearth to warm, I saw a little old lady in a long blue dress with a pinafore over it, and a mob-cap on her grey hair. When she'd finished moving the teapot nearer to the fire, she started to lean back, but she must have caught a glimpse of me in the doorway, because she turned round to look at me.

I'll never forget the look on her face. At first she looked surprised, but that soon turned to bewilderment, and then to shock and fear. The fear was the strongest emotion and it had hardly registered on her face before she, and all the contents of the room vanished, and my familiar furniture returned and the room was normal. I didn't go into the room, I couldn't, the old woman wasn't the only one who was afraid – so was I.

My friend Nia called in later, she'd been to the library for me, and she'd hardly got in before I started to tell her all about my visitation.

She asked me all sorts of questions, but I couldn't tell her much. She asked me if the ghost had seen me, and when I said yes, she looked thoughtful.

"That's interesting," she said, "and you said she looked frightened?"

When I nodded vigorously, Nia said, "Perhaps she thought you were a ghost, different clothes and hair style; maybe she thought you were from a different age, so I don't think she could understand your appearance, any more than you can understand hers."

As you know, these cottages are very old; they were built when the copper mine near Amlwch was running, and they employed lots of people – both men and women. The women used to smash pieces of ore with hammers, and they were called the "Copper Laddies".

They worked as hard as the men, and were paid less, so there was always room for them.

Nia and I wondered whether the old lady had been the mother of one of the miners or quarry workers, but there was no way of finding out. About two weeks later I saw her again in the back garden, she hadn't seen me looking through the window, and I didn't feel so afraid this time, she looked so ordinary. I wondered what an earth she was doing, so I watched her. She still had the long dress on and the pinafore, but the mob-cap was a pale blue this time.

I have a big nettle patch at the bottom of the garden in a bit I don't use, and she was busy there. She had a big shallow garden basket – I think they call it a trug – on one arm, and she was carrying a heavy-looking cloth and a pair of scissors in her other hand. She seemed as solid and as busy as a living person, and for the first time I felt no fear of her, and I watched her with great curiosity.

Her movements were regular and precise. First she would cover her hand with the cloth, take hold of a handful of nettles with great care, then cut off the nettle heads, about four inches long, and place them in the basket. She continued to do this until the basket was full of nettles, then she covered it with the cloth, and turned to walk up the garden path to the back door.

As I said, these cottages are tiny, and the back door leads straight into the kitchen. I suddenly realised that even though she hadn't seen me looking out of the kitchen window,

she would only be about 3 feet away from me when she opened the kitchen door, which she was now approaching. I looked around wildly, but there was no escape, I didn't have time to cross the kitchen before she appeared. So I gritted my teeth, and turned to stop my legs from shaking as I stood there, what would happen when she came in? My fear came back, so strongly that I felt faint.

She was a ghost for goodness sake, a creature from another world. My heart hammered in my chest as I waited ... and waited ... and waited.

The door remained closed. No footsteps on the path, but come to think of it did a ghost's footsteps make a noise? How long I stood there in that empty kitchen I don't know, with just the kitchen clock ticking away in its usual measured fashion, and the sunshine creeping across the floor. Finally, I plucked up enough courage to open the back door. The garden was empty. Not a soul in sight. I walked down to the nettle patch and peered at it. Most of the tender tops were missing, cut off. So it had happened. I hurried back into the house and grabbed the phone. It only took Nia about six minutes to get to my house. I was just making a cup of tea, and as I told my story she listened very intently.

She was silent when I'd finished, and then she gave a great sigh.

"Well," she said, "I've asked nearly everybody in town especially the older people, but nobody seems to have heard of her, never mind her name or who she was."

I nodded slowly, "Me too, no-one seems interested, and the few that are can't wait to tell me about the ghost they've got, or they've seen."

Nia took a long drink of her tea then she said, "I think we ought to get a medium out here, and see if they can tell us what's going on. We can't get her exorcised; you can only do that if the ghost or spirit, or whatever, has done something evil and I don't think she's evil, – she sounds harmless."

"Oh, she's harmless enough alright," I said. "She's just an old lady doing things she did when she was alive."

"Yes, but why, and where is she coming from? I thought you went to heaven when you died; surely you don't die, and come back to do the washing or whatever?"

"Perhaps she doesn't know she's dead," I said feebly.

"Don't be daft; if everyone who died came back and got on with things, we wouldn't be able to live in our houses, they'd be too crowded. Talking of which, had the furniture changed when she was around, like when she was coming in from the garden?" Nia asked.

I shook my head. "No, now I come to think about it, it was the same as usual."

"So, in other words, the time zone only changes when she's on the scene. I wonder if it happens to her too when you appear?" Nia asked, and then she added, "By the way, I can solve the mystery of her and the nettles, apparently people used to use the fresh shoots of nettles for soup, they collected loads of it and boiled it, then they added butter and a bit of salt and mashed it when it was soft. Poor man's spinach they used to call it, apparently it clears the blood in spring and is very good for you. I suppose it's full of folic acid, is that what it's called? Anyway, I think that is what she was doing."

"I wonder where it is now?" I said thoughtfully, thinking of the headless nettles in the garden.

"Oh, I don't think you'll see that again; it will be with her, wherever she is, and has probably been cooked and eaten by now," Nia said, searching in her bag for her car keys.

"Do you think she's what they call an earthbound spirit?" I asked.

"I don't know, I get muddled thinking about it," said Nia.

"Because if they are earthbound, they must come back and do things they would do when they were alive. This old girl was doing different things both times you saw her. First time she was warming the teapot, you said. The second time, she was cutting nettles for soup." She stopped and gazed at me.

"So?" I asked.

"So, time must have passed, she had moved on to other things."

"So?" I asked again.

"Well, if time had passed, she was growing older wasn't she? And when she grew very old, she would die again, wouldn't she? Then what would happen? Where will she go? Will she be earthbound again, or will she go to heaven, wherever that is?" Nia said.

I was now as completely baffled as Nia was. We just stared at each other in bewildered silence.

Nia pulled her coat on in silence.

"There, let me know if you see her again, in the meantime I'll still try and find out who she is – was – and next time we'll see if we can get a good medium and try and solve the mystery, it's the only way we'll be able to find anything out."

She gave me a brief kiss on the cheek. "Right, I must dash now, don't be afraid if you see her again, she seems harmless enough. Give me a quick ring if she does arrive, I'd love to see her."

She gave me a quick smile and left.

Well, that was three weeks ago. I've heard nothing from Nia since, and had no more visitations.

The only thing I've heard are the sounds of the front door closing when I'm in on my own, and twice I've heard footsteps crossing the bedroom floor upstairs. The dogs have heard all these things too, they twitch their ears and lift their heads up, but they don't show any sign of fear now, they are just their normal selves again. It's almost as if she visited them and told them not to be afraid.

As for me, I'm more puzzled than frightened, but I'll have to see what my reaction will be if she does come again. And if she vanishes again, where will she go?

I must be a ghost to her. It's no good; I'll have to talk to Nia about finding a good medium otherwise I think I'll go mad.

Sorry for going on about it Bunty, I'll let you know if anything else happens – bye for now.

And with that she rang off.

CHAPTER 14

The Bull

I have written stories about the Bull Hotel in Llangefhi in other books, but this is one which I haven't had the time to include. Firstly for those who haven't read my first stories of the Bull, I will try to describe it to you. It stands right next door to the Market Hall, in the town centre of Llangefhi. It began life in medieval times as a lowly ale house, but it gradually grew with the custom of the local farmers on market day, and then when the age of the mail coaches, busy with letters and goods for the Irish ferries were supplemented by stage coaches carrying passengers from Ireland, it grew into a prosperous hotel.

Doctor Johnson was on his way to Dublin via Holyhead when one of the coach horses cast its shoe, and he had to stop in Llangefhi and dine at the Bull. A letter he wrote to a friend later said how much he had enjoyed the food he was offered, and how winsome and pretty the bar wenches were!

Anyhow, it grew and grew, and underwent many changes of structure. When Walt and I went there, we slept in a haunted four-poster bed, which had a sliding panel in its headboard, used to conceal the pistols and jewelry belonging to its occupants, from robbers of the centuries.

The haunting was a ball of orange light that traveled slowly up and down one of the bottom bed-posts, and when Walt (who was convinced it was a reflection from something outside) tried to blot it out by covering it with his hand, it shone right through his hand, and continued on its travels. Walt leaned back with his arms behind his head, gazing at it and trying to find a rational explanation for it, while I disappeared beneath the bedclothes, half-smothered, until he said, 'It's gone.'

I emerged and took a deep breath, but Walt hadn't figured it out. I have since learned that they are often seen and are known as 'orbs'. Still unexplained.

I had the great luck to be talking the other day to a young lady who was the girlfriend of one of the young waiters who had seen a ghost at the Bull.

Apparently, he had just come off duty at lunch time, and waved at the bar staff as he started to leap up the main staircase to his room upstairs. A couple of minutes later, he tottered down the staircase again, white-faced and shaking.

Hanging on to the newel post to keep himself upright, he told her (the girl in the bar) that he had gone up the first flight, just turned the corner to go up the next to his room, when he had glanced along the landing.

There, sitting sideways on to him, and looking out of the window, sat a lady in a rocking chair.

As he stared at her long black dress, lace collar and cameo broach, wondering who on earth she was, she turned and looked at him. Then, as their eyes met, she started to disappear; growing less and less visible until he was staring at the wallpaper.

He hadn't believed in ghosts until that moment, but his ideas changed suddenly, and he flew downstairs to be in the company of ordinary humans. It took a stiff brandy to bring him round.

We've learned a lot about the ghosts at the Bull from the cellars which are 10 feet below the surface of the car park, and yet contain mullioned windows that the then manager, Mr Roberts, said must have looked out on a garden or yard at one time and we wondered why it had been filled in, and where the blocked in stairs leading down through an archway in the present cellar led to; presumably even earlier cellars.

Mr Roberts says he wouldn't go down into the cellars again 'for a gold clock', because 'something sniggers in the corner and it's not a nice snigger, it's as if it knows I'm on my own down there, there's another member of staff who's heard it too, and he won't go down on his own'.

We went from the cellars all over the hotel to the attics. Now there was a nice atmosphere. There were two ghosts here, but sadly I didn't see either. The first is a ghost-dog. A little brown-and-white terrier, it is very friendly, and frequently seen by both staff and any workmen who are busy doing renovating work. It appears from the far corner of the attic, wagging its tail in pleasure as it approaches its audience. Then, it turns and scampers away, disappearing through the wall. It is very lifelike, and one maintenance worker spent ages, calling it and making 'come here' noises. No luck.

The other ghost (we think it's only one) is someone who must have lived hundreds of years ago, and is still doing his earthly job.

Running through the attics, at about waist height, is a very long oaken valley gutter, lead lined, which leads from the front of the hotel to the back. Hundreds of years ago, it carried all the rainwater that fell onto the roof at the front of the Bull, right through the attic, to the back. This of course needed clearing out regularly, leaves and debris must not be allowed to block it. It is the ghost of the gutter-cleaner that is seen, but is it also the ghost of John Williams?

A few years ago, when the Bull was being re-decorated two of the workmen who were about to repair the timbers in one of the attics, thinking they were the only two up there, were astonished to see another workman holding what appeared to be a bucket of white-wash and a brush, painting or rather daubing something on the sloping ceiling.

He turned, gave them a cheeky grin, and promptly vanished. As they were staring open-mouthed at the spot where he had been a moment before they saw what he had being doing.

The name 'John Williams' was painted across the wall; for a few seconds it looked new and white, but even as they stared, it aged and became yellowy and old. It is there to this day, and the two confused men couldn't explain what the man was wearing, or anything else about him, they were too flabbergasted, only able to say he looked like a workman in old-fashioned clothes.

Sometimes too, a man has been seen (as I said) cleaning out the gutter with a hand shovel, he too vanishes, so is this also John Williams? There is also a list of men's names and where they live written on one of the attic walls, but I was unable to decipher them.

The Bull went through a very bad phase in the 1970s/80s. It was sold, and the new owners sold all the beautiful antique furniture (including the four-poster bed) and the rooms were let to DHSS clients, and who left a legacy of kicked-in doors, trashed rooms, and smashed,

irreplaceable thin glass windows. Rare China pottery was replaced with cheap mugs, all the rare hunting prints went, and the once elegant hotel became a squalid haunt of druggies and alcoholics, using cheap tables and chairs. It was now avoided by the happy, law-abiding clientele it once housed. But the tables have been turned again; the then manager, Mr Roberts, got rid of the druggies and alcoholics. 'It was either them or me,' Mr Roberts told me tersely, he looks as if he can handle himself.

So now the antiques are being replaced, expensive and comfortable furniture is now in every room, and the decorating is of the best, so that anyone going in the Bull now is sure of a warm and comfortable stay – I know we did!

One last speculation, what happened to the ghosts during all this turmoil? Are they still the same? If anyone knows, please get in touch – I should love to find out.

John Williams' signature.

Old print of the centre, showing the town hall and the Bull (behind the clock).

CHAPTER 15

Richard Jones

This story goes back about ten years, before Derrick died, and I am still conning it over. Derrick is now, alas, dead, so I can't ask him the questions that still plague me.

I first saw Richard about fifteen years ago, and he became a familiar figure. He was small and thin, and carried himself as a true countryman always does, not walking quickly or in haste, but with that smart measured step that steadily eats up the miles. He wasn't young, in his sixties I reckon, but it was very hard to tell as his face was ageless. By that I mean he had a pleasant, always smiling expression set in the features of an old baby – hard to describe, but if you can imagine the cheerful fat face of a six-month-old baby, overlaid with the myriad wrinkles that sixty-odd years of weathering can bring, then you have the face of Richard.

In retirement from farm labouring he went to live in the local old folk's home, the ever-popular Brwynnog. He used to love walking, particularly doing the circuit from the Brwynnog out into the fields, and continue on his way between the fields and meadows in a large, roughly 2- or 3-mile circle around the boundary of Amlwch and back home in time for lunch.

Our house overlooks a section of this road that climbs gently from Llaneilian to the Bangor road and I have often seen him tramping steadily along it. Sometimes we would meet at the bottom of our drive when I went down to our post box. His face would beam with smiles when he saw me. Richard couldn't speak a word of English, and I could just about wish him good morning and ask him how he was in Welsh. Every time he came to a field or pasture where cows or bullocks grazed, he would stop, lean over the gate, and study them for minutes at a time.

I watched him one day when he was gazing at a herd of Limosin cows that had only just been put in the field. As I walked back up the drive, I saw Derrick in the yard that ran alongside and slightly below our drive. At the time I didn't know what Richard had done in his working life, and I commented on Richard's interest in the different herds in various farmers' fields.

'Well that was his job,' Derrick replied cheerfully, 'most of his life he was a stock-man at Llwyn farm, and you couldn't find a more knowledgeable man if you looked for days. Many farmers would take Richard when they went to market to buy cattle.' At that moment Richard passed the yard gate and we all waved to each other.

This little incident went on for years, and one spring morning I saw Richard leaning over a gate studying the occupants of the fields with his usual gaze. I was coming down for the

post and he was coming up the road. We met at the drive gate, and I called my usual greeting in Welsh, expecting his reply in such broad Welsh, I never had been able to understand it. Instead he raised his hand in his usual greeting, gave me a very warm smile, but didn't say a word and just walked steadily on up the road. At that precise moment, Derrick came belting down the road in the Toyota pick-up, and turned into the yard gate, with a squeal of tires. 'Morning Derrick,' I called, 'you must have only just missed Richard – did he have to jump out of the way?'

Derrick looked at me in bewilderment. 'What?' he asked.

'Richard. I had just said good morning to him and he had gone past when you came roaring down the middle of the road, I couldn't see you coming because of the road hedge, but I bet it was a near thing!'

'Are we talking about the same Richard – Richard Jones?'

'Well, I don't know of any other Richard who spends all his spare time looking at livestock,' I replied.

Derrick's face changed. 'Richard died last week,' he said.

CHAPTER 16

Amlwch Lockup

In the late nineteenth century, Amlwch was a boom town. The copper mine, smelting works and shipping were all working at full pelt, the town itself was full of riotous sailors, miners and others who all cocked a snoot at the law.

While most of the serious wrongdoers were promptly carried off to Holyhead, the minor offenders, like drunks and thieves, were placed overnight in the local lock-up.

This was a little building behind the first shop at the St Eleth church end of the main street of Amlwch, before one comes to the imposing edifice which is the bank.

It was still there just over twenty years ago (I am writing this in 2011), and anyone looking to the rear of the shops would see the little building – the end part of it anyway.

There was a stout outside door, with a strong lock and a small grilled window in it, which looked towards the gates of St Eleth church.

Over twenty years ago, the shop was renovated and the little lock-up redesigned and incorporated into the premises; the outside door and window was made into a wall, so that no trace remains of the old prison. Despite this, there have been many reports of people going past late at night seeing the old lock-up as it once was, complete with stout outside door. Not only that, but passers-by have been considerably startled by seeing the indistinct face of a man staring at them through the window, rapping hard on the glass with his knuckles, and calling, 'Ellen, Ellen, Ellen!' in a loud and desperate shout. People who have heard about the haunting, and have to go past it on a winter's night, give the place a wide berth by moving into the centre of the road to pass it, and averting their eyes from the door.

Tenants in nearby flats over shops have often heard the shouting on calm winter's nights, even though the lock-up has been demolished for years, and is now part of the shop which sells line-dancing accessories and western hats.

Who he was (and why he was in there) and who the mysterious Ellen was, is not now known, but it seems to me to have considerably more implications than a drunken brawl, for the emotional impact to have lasted all these many years.

When this story was told to me by Emlyn, who worked in John Jones's Chemist's at the time, he wondered whether a really good medium could unravel the mystery, but as Emlyn himself is now dead, we'll never know.

CHAPTER 17

New Ghost (Identity Unknown)

Mr John Williams had a small farm at Nebo, near Amlwch, Anglesey, which he and his wife worked successfully for many years until John's wife died of cancer. John struggled on for a few more years, but it grew too much for him to manage, and the death of his wife took the heart out of him, so he went to live (and still does at the time of writing) in sheltered accommodation in Amlwch.

I haven't heard the story from John's own lips, only from friends and neighbours who have also seen the ghost, which has only been haunting (or made itself known) for the last four years or so. Why it has started haunting is an absolute enigma, there was nothing to spoil the tranquility of the little farm a few years ago, when Mr and Mrs Williams lived there happily. It only started after the death of Mrs Williams, when John Williams lived there alone.

Even when he left his farm, he still visited 'Y Bedol' (the horseshoe) on Saturday evenings when he would spend a pleasant few hours with his mates. It was during one of these nights that he spoke about the ghost for the first time, and this is what he said:

After Bessie died, I was very depressed and lonely, and I was glad to come down to "Y Bedol" for a chat with you lot and have a few glasses of beer, and I was just going home one night, I'd climbed the wall stile onto my own land from the road, and I'd started walking up the hill. Suddenly I got the feeling that someone was behind me, so I stopped and turned and looked back, but there was no-one there. It was a clear calm night, no moon, but it was easy to see things. So I grasped hold of my stick again, and went on my way. I was following the footpath on the right hand side of the barn meadow and my house was at the top.

I still had a funny feeling that I was being followed, but every time I looked back I was alone. A wall dividing the barn meadow from a pasture was on my right, and I was walking alongside it when I happened to glance up. The wall was almost 5 feet high, perhaps a little higher, and I saw a man on the other side of it, also walking along, and keeping pace with me. I couldn't see much of him as the wall was so high, but I could see he was wearing a cap. There was only about four feet between us, even with the wall there, and I said "good evening" to him in Welsh, but he didn't answer, so I said it again in English, but he didn't take the slightest notice. I wondered who the heck he was. He wasn't local, and I couldn't make out why he was walking up my pasture at gone eleven o' clock on a November night. I kept staring at the side of the face that I could see, and I must admit he gave me a sort of cold feeling inside.

We walked on in silence, and I didn't like it one bit. Half way up the field there is a five-barred gate that gives entrance to the pasture, and we were getting near it, and I thought that then I would see him properly, what he looked like, you know? Well, we got to the gate, and as we were walking past it, I looked over at him. I didn't see his body, because he didn't have one – just a head! Floating along above the gate it was, and then when he'd passed the gate, floating along on his side of the wall – just a head.

It was such a shock, I stopped walking, because my heart was thumping, and my legs had turned to jelly. I just stood and stared, what was he going to do when we got to the farm-yard gate? There was a gate-way into it from the pasture, it led into the barn meadow first, then it joined the path I was on into the yard, which meant we'd go in together.

I must admit I was terrified, I just couldn't face it. I'm not ashamed to tell you that I turned and ran all the way back down to the stile, jumped over it and got back onto the road. There wasn't a soul about, and I stood there shivering, wondering what on earth to do. When I looked back up the slight rise to the stile, he was there standing looking down at me. Now he had all his body and I could see he was a youngish bloke in overalls, as if he was a farm laborer or something. He was waiting for me.

There was no way I was going past him and up to the farm again, so I started off back to the village.

There was no-one at home waiting for me, my wife had died and I lived alone. I had an Auntie living at Penysarn, she also lived alone, and I was going to ask her if I could sleep there for the night.

Anyway, I went there and knocked until she came downstairs and let me in. She took me into the kitchen and I told her my story, she was a great "chapel-goer" and I could tell she didn't believe me, because she said, "Too much beer at the Bedol, John," and then she made me a cup of tea. She said I could stay the night because, I was family, but if it had been anyone else she wouldn't have let them in.

"Drink this, then you can go to bed and sleep it off," she said, and passed me the cup. I'm sure she wanted me to go to the chapel with her the next day, but she was ashamed of me and she thought going into pubs was a sinful thing to do – she'd often told me to change my ways.

I got into the spare bed she had, but I didn't get much sleep. I was just glad there were houses each side of me in the street; I couldn't imagine staying in the farm on my own.

The lads in the bar listened to this in silence; one or two of the younger ones made jokes about taking more water with it and suchlike, but the ones who had known John all his life and knew him for a truthful serious man, shut them up by glaring at them.

There was a silence while they all had a drink and thought over John's story, and then a young man who had been standing at the bar and listening to John drifted over to him, and straddled an empty stool next to him.

He was local and known to them all; they acknowledged him with nods of their heads. He nodded back, but he was looking earnestly at the storyteller.

'John,' he said, putting his pint on the table.

'Ivor,' John said and waited.

'I've got something to add to that story,' Ivor said quietly, never taking his eyes off John. 'You remember that my dad used to work for you when you had more stock on?' John

nodded curiously. 'I bet you wondered why Dad left you and went to work at the Power Station?'

'More money, better wages,' John said.

'Yes, that was one thing, but not the main reason. He liked farm work, and didn't want to leave.'

John was silent waiting for Ivor to go on. 'I was only a boy at the time, but I can remember how edgy my mum would get when autumn came in and the days grew shorter. She wouldn't relax until Dad came home from work and she could lock the front door. He didn't tell me for years after; it was only when he was very ill with cancer and knew he was dying. Here Ivor paused, looking into his glass, and then he looked up at John and said, 'Dad said your place is haunted.'

John didn't move a muscle, his eyes bored into Ivor's. 'Go on,' he said evenly.

'Well, he worked for you for about five years, right?' – a short nod from John.

Well, he was quite happy for about four years, everything was OK. It was the last year he was there that things went haywire.

One day when it was knocking off time, nearly five o'clock. He'd seen to the horse, said cheerio to you and collected his dinner bag. He'd started bringing sandwiches because it was getting too much for your wife to cook two meals in one day – dinner time and night, she wasn't very well then was she?

Anyway, he set off home down the barn meadow like he always did, and half-way down he got a funny feeling that someone was behind him, so he turned round, and sure enough there was a man behind him, just coming out of the yard gate, and setting off down the path after him. So Dad walked more slowly giving him time to catch up, but when he looked back there was no-one to be seen. He wondered where the man had gone, and thought it was funny that he hadn't seen him at the farm.

Anyway, he turned to go on home, and he got the fright of his life. There, in front of him, was the same figure, just getting over the stile. He hadn't passed Dad, and there was no other way he could have overtaken him. Dad was shaken. So he started to run down to the stile, then to the road to catch him, but there was nobody in sight. When he got onto the road, he looked back up at the stile, and saw the man standing there, staring down at him. Then he just slowly faded away. My dad said he thought he must be going mad.

Anyway, November came then and he started being haunted in earnest. Sometimes, as he was coming home, the mists would come down, and it would rain, or be foggy, and all sorts of things would happen. Once, he saw the man leaning against a tree watching him, and as Dad stared, the ghost slowly faded away. Once he saw an arm come around the comer of the house and wave at him. When he shut the stable door one night, he just turned around and someone stood up from where he'd been hiding behind the big oaken trough.

Dad got a good look for the first time at his face then and said it was all wrong somehow, evil, and grinning a horrible grin; it was something that you wouldn't want to stare at for long – it made his skin crawl. Then the ghost spun round and vanished.

Poor Dad, he must have been scared to death.

He never knew where to look after that day. First he'd pop up over a wall near Dad then he'd drift across the field, all mixed up with the fog, or he would be standing on the roof staring down at him.

'Did he ever say anything?' Sion asked him.

Ivor shook his head. 'No, he never spoke, but Dad did say the worst thing he ever did was he suddenly sniggered in Dad's ear, and when Dad spun round, the ghost was waving to him from the edge of the wood half-a-mile away. The time of day Dad hated most was those miserable November afternoons, when everything was foggy, and you couldn't see anything properly.' There was a deep silence before Ivor said, 'That was the real reason why Dad left, John, it was really getting him down, but he didn't tell you in case you thought he was a bit daft.'

There was another silence broken by John, who said, 'Well, everybody in this village seems to know what's happened for about the last two hundred years, does anyone know who this chap is, and why he's suddenly started haunting the farm? And why was this autumn the first time he let me see him?' He stared at his audience. 'Well, do you know?'

Silently, all heads were shaken.

'Well,' said John, 'ask around, and let me know anything you can find out, I'll be waiting.'

So, there it is. The ghost of a lean man in his thirties (they think), wearing overalls, with the ability to materialise anywhere within seconds, and who has only just started to haunt the little farm that lies north-east of Nebo. But why? How? And who is he?

John said that if anyone found anything out he would be waiting. He still is.

CHAPTER 18

Trial of Dic Richardson for Murder (and the Haunting)

Mr and Mrs Edwin Sturton were natives of Anglesey, and they moved to Bethesda in 1950. They returned for a visit in the late 1950s, and stayed with a Mrs Owen, a friend of theirs, who lived on a small farm near Llanfaethlu.

One Sunday night she took them to her friend's farm, which adjoined her land. This lady was Mrs Gwen Jones. They enjoyed their evening, catching up with all the news and gossip about the people they all knew.

They took their leave about 9 p.m. It was November, and although it was dark it was a fine evening. Nia Owen set off at a smart pace towards the boundary wall and stile that lay at the bottom of the field. Over the wall lay another field belonging to the Owens, carrying the footpath they were walking on into their farmyard.

As they approached the wall, Nia reminded them to take care not to step into the ditch, which lay near the stile they had to clamber over. She went first and as she was drawing near to the stile she gave a gasp of dismay, her hands flew to her face she suddenly stopped and pointed down. 'My God!' she said, stepping backwards, 'who's that?'

'It's a body!' The Sturtons stepped forward to look and to their horror saw what she was gazing at. Mrs Sturton (now in her eighties) remembered it well:

> We all looked and we could clearly see it. It looked like an old man. He was lying on his back with his arms flung out and one leg bent under him. I think it was his right leg. We couldn't see his face properly because it was dark, but he looked dead. We were all bending forward looking at him, when suddenly he vanished!
>
> One minute he was there, lying in the mud, and the next we were all staring at the empty ditch, at the side of the field.
>
> It would be an understatement to say we were surprised, we were frozen with shock, I should say shocks actually, because one minute we had seen a dead body, that was bad enough, and the next it had vanished into thin air.
>
> We must have looked weird; three of us all gazing at nothing, and then Nia grabbed my arm and said, "Quick, over the stile!" We didn't need telling twice, we leapt up over the stile into Nia's field; we didn't stop running until we were in her house and she'd slammed the door.
>
> Her husband Jack heard the door slam, and came into the kitchen, when he saw our faces he said, "What's up?"
>
> Nia looked at him, she was dead white and she couldn't stop shaking. "We've just seen him!"

Jack looked baffled and said, "Seen who?"

"Old Richards," Nia blurted, "he was lying by the stile, we all bent to look at him, then he just disappeared."

Jack said, "What do you mean, he just disappeared – who was it? Where did he go?"

Nia slumped down on the settee; it was as if she hadn't heard him. "So it's true then, what people say, he really does haunt that place."

Jack looked round at all our faces. "I'll put the kettle on," he said.

Edwin and I hadn't got a clue what she was talking about, and we just sat there in a daze, we were still in shock. Edwin came round first, he got up to help Jack carry four mugs of tea in, and as they were passing it round, he said to Jack. "What's all this about a ghost? And who's Old Richards?"

Jack was looking at Nia anxiously, "Shall I get you a Paracetamol love?"

She half smiled and shook her head. "No thanks, I'm coming round now."

Jack nodded and turned to Edwin. "Old Richards was the farmer who lived here at Rhianfa nearly a hundred years ago. He was murdered by that stile one night, they didn't find him until next morning, and people have always said he still haunts the place, because quite a number of people have seen him."

"Perhaps he's looking for justice," I said, "he wants his killer found."

"Oh, he was found alright, he was hanged for it, but he never confessed to the killing. He was the last man to be hanged at Beaumaris Gaol, it was a very famous trial in its day, and his ghost has been seen for years. I thought it was all old wives' tales, I don't believe in ghosts." A frown of uncertainty wrinkled his forehead as he added, "Until now I didn't; now I'm not so sure." He was looking at Nia's face, and I could see he didn't know what to believe.

"Tell us about it," I said to Nia, but she just shook her head and said, "Not tonight if you don't mind, I'll tell you another day. Let's talk about something else."

Well, the "another day" didn't arrive – she was going away for two weeks holiday, and I couldn't wait that long, so I asked around and as usual was told the vague half-tales, or stories that had obviously been dressed up to make a good story around the fire on a winter Sunday evening. I set out to find the truth, which still eludes me, and everyone else who took an interest in this case.

After noting down all the details and relevant stories, I turned to my old allies, the ladies in the Archive. These girls are talented and dedicated and seemingly nothing is too much trouble for them. They went back in their files, and to my delight sent me photocopies of the newspapers of 1862 that covered the trial.

I settled down to read them, and if my mind was muddled to begin with, it certainly was when I had finished.

I must say the general reporting of crimes a century ago was abysmal. To begin with, any questions asked by court officials were not printed, only the answers given by witnesses, so I had to try and guess what the questions were, what a job that was! Anyway, here is the story, as clear as I can make it, sadly short of the atmosphere, and the gossip that must have flown around at the time.

An old farmer, one Richard Williams, went to his neighbour's farm one dark November night, and on the way back he was brutally battered to death at the stile on his boundary field. He wasn't discovered until the next morning (Saturday).

Briefly explained, his son-in-law Richard Rowlands was tried and hanged for his murder on circumstantial evidence alone.

Old Richard Williams was a widower, and in his house lived his daughter Elinor, her four children, one boy and three girls. At the time of his murder, another of his married daughters was staying at the house; she was on a brief visit from America. Elinor was pregnant, and the father was a middle-aged widower from Llanbadrig, who had married her because of his unborn child.

His name was Richard Williams, known as Dic, and his first wife Emma Owens, who had died. He was heard of in 1842, but then seemed to disappear until 1861 when he was found at Carrog as a farm labourer.

He was known as a "bad lot", who took after his maternal grandfather, also a "bad lot", but I don't know in what respect. Although he had married Elinor, his new father-in-law initially barred him from living at the farm, then relented slightly, persuaded by his daughter to let him (Dic) stay at weekends, on condition that they would find somewhere else to live, and all move out on Labour Day, 1 November.

Although the old man disliked Dic, he was never heard to say a wrong word against him, and they never quarreled once, presumably they kept out of each other's way.

So that is the scene set for the night of the murder.

Mr Richard Williams went out on Friday evening, 1 November to his friend's home, which happened to be the adjoining farm. He often spent an evening there, having a natter about local matters, but this evening the subject was threshing machines, as Mr Williams wanted his corn threshed the following morning.

He stayed at his friend's house for a couple of hours, and when he left to return home, his friend Owen Owens went with him as far as the stables, and watched the old man leisurely tramping down the field to his farm house, contentedly smoking his pipe.

Owen junior, who was watering the horses at the farmyard pool, before turning them into the field, also watched the old man going down the footpath on his way home, then he himself closed the field gate behind the horses, and turned back home.

As Mr Richards climbed the boundary wall, someone, [we will never know who] attacked him viciously with a hammer or pick. It is also not known as to whether a quarrel preceded the murderous act.

At the trial [not the immediate inquest, but at the end of the rumour-ridden winter, when everyone's "memory" seemed to be amazingly replenished], young Owen said he had heard two voices raised as if in argument. He knew the voice of the old man, but not the other. He also heard the name "Richard" called out, but only once. Now all this happened on Friday night, and no-one noticed that Old Richards hadn't come home, until his body was discovered on Saturday morning.

As it was the weekend, Dic Richards had come to stay at the farm. When he came in, he asked his wife if she had heard about a house, this was given in evidence by his step-daughter who was sitting by the fire. She didn't hear what her mother's reply was. Then Dic asked where the old man was, and was told he was at the next door farm. After a little time, Dic went out, and came back in again just as the boys were going out at 7 p.m.

They were going to the "shoe club", which was held at the local chapel. The shoe club was held once a week when everyone sent a few coppers regularly, to ensure that they had enough money for a pair of stout winter shoes or boots each. Times were hard, and people were poor.

When Dic came in, he asked his wife for some water with which to wash his hands – he said they were oily from the old machine he had been mending. This was just about the time that the old man was murdered. Seven o'clock was the time stated, but time keeping was vague and elastic – it was stated he stayed at his friend's house for "about an hour, or an hour and a half," but the exact time he left wasn't reported.

As I stated, Dic was arrested on Monday morning after the inquest and was put in prison at Holyhead by Inspector Richard Ellis, who had been put in charge of the newly formed Anglesey Police Constabulary. This was his first big case, indeed it was a big case for the whole of Britain.

The village was teeming with reporters of national newspapers, and suddenly the locals were in the centre of the nation's gaze, and instead of being cowed and awed by the fame, they began to enjoy themselves hugely. William Jones, one of the first adults at the murder scene, had a lot to say. It was he who sent for the cart to take the body home. (Interestingly, Dic Rowlands when being questioned said to his knowledge there was no bad feeling between anyone and his father-in-law, except for William Jones, they heartily disliked one another.)

William Jones hadn't said much at the inquest, he said he was too scared, but after a winter of giving interviews he waxed lyrical at the trial. As already stated, the trial was convened on Saturday 22 March 1862, in the full panoply of the law. It was said that the jury was made up of the dead man's peers.

This was hardly true, his peers would have been poor, hard-working farmers like himself, but it comprised many wealthy landowners, aristocrats and other prominent members of the North Wales society, all anxious to be seen at this famous trial – the most famous to have ever taken place in Anglesey.

Now, to go back to the weekend Richards was killed. Everyone in the area was talking about it; in fact some were openly saying that Dic had killed him. Dic heard the rumours and was scared he was being accused. He knew it was because he had a bad name. On the Saturday night he was eating a bowl of stir-about (stew) by the fire with Elinor Hughes (the lady from America), and said it was a good job she was there because she could tell the police that he hadn't been out the night before. [Why did he ask her to lie?] She didn't, of course, but told the police and the court that he had been out and had only just come back before the boys went to the shoe club.

On the Monday morning the Inspector of Police, Richard Ellis, came and arrested Dic, taking him to the lock-up at Holyhead. In the afternoon the inquest was held at the Black Lion public house, where an overawed William Jones gave evidence, and then the inquest was adjourned until after the post-mortem on the body. It was resumed on the Thursday at the Baptist Chapel, more evidence was heard, and a verdict of wilful murder by Richard Rowlands (Dic Rolant) was brought in.

Now, I'll try and explain the mind-set of the collective people involved. Firstly, the jury, who was made up as stated by all the local gentry, was eager to be seen and heard during this momentous trial. Secondly, the law makers; His Lordship Sir Henry Keating was the judge.

The prosecutors were Mr McIntyre and Mr Trevor Parkit, and Mr Morgan Lloyd stood for the defence. They were all very famous barristers, and all on the North Wales circuit. Next came Inspector Richard Ellis, newly installed in the Anglesey Constabulary, and anxious to make his mark in this trial of the century.

The trial itself didn't take place until 22 March and during that winter Ellis had plenty of time to interview witnesses. He made William Jones his principal witness, and William blossomed under the attention of the police, once he realised that they regarded him as a valuable witness and not as a suspect – remember he and old Richards were sworn enemies. The press reporters also made him an important person as he was one of the first men at the murder scene.

His evidence at the trial was far different from what he had said at the inquest; he stood so happily gazing around him from the witness box that the judge told him sharply, just to stick to answering the questions.

Firstly he told them that when Dic came to tell him about finding the body, and took him to the spot, saying he thought the old man had fallen in a fit and cracked his head on the wall, John said, "When I saw the old man, I could see his head had been beaten to a jelly" and I said to him, "My dear Dick Rowlands, he didn't have a fit, he's been killed!"

Doubt had already been cast upon the watertightness of the case, and even the press at the time wondered if William Jones had been "got at" by the police to help place the blame firmly on Dic. Also, he told the police that he had seen Dic on the night of the murder (Friday) and that Dic had a large spot of blood on his whisker. When William told him about it, he brushed at the whisker on the wrong side of his face.

He asked "Has it gone now?" William told him he was brushing the wrong side, but he seemed "too distracted" to take any notice, and the blood was still there when he left.

All the principal witnesses at the farm said that there was no blood at all on Dic's face that night.

The case was very unsubstantial, and quite a few people felt uneasy at the flimsiness of the whole thing.

The witness who next gave evidence was Elinor Hughes, telling the court that Dic had been out at seven o' clock, the time of the murder. The jury retired, but came back to ask if they could hear her evidence again. When they returned a second time they gave a verdict of "Guilty".

Dic was sentenced to death by hanging, and the execution was set for 4 April, a Friday. All the while Dic had protested his innocence. In the condemned cell church ministers urged him daily to confess, but he would not do so. Eventually Dic convinced the ministers that he was innocent and they prepared a strong petition for leniency, but it was not taken up.

In the week of 4 April 1862, the atmosphere in the condemned cell was very melancholy. Dic was steadfast in the declaration of his innocence, the ministers saw him daily, as did his wife. On the Wednesday before he was hanged, his wife fainted with the horror, and his son by his first marriage was so distressed he had to be taken out.

At eight o'clock on the morning 4 April 1862, Dic was hanged in public by William Balcraft outside Beaumaris Gaol, in front of a huge crowd, who were in sympathy with him, thinking he was innocent and not guilty.

There was uproar after his death; no man's trial should depend on flimsy circumstantial evidence like his did, and a lot of questions were raised in the press. For me, the greatest factor in the case was the element of time. Not every household had a clock, and the variants in time-keeping were enormous. For instance, "the old man stayed at his neighbour's house for roughly over an hour and a half", but no-one says what time this was, or what time he set off home.

It was said vaguely that he set off for home just before seven; at least we know he was neither at his friend's house, nor his home at seven. But when was 7 p.m.? It varied from place to place.

When Dic came home, the boys were just leaving for the shoe club. Now absorb this bit of compelling reading about the evidence given at the trial.

Caernarfon and *Denbigh Herald* 29 March 1862

The evidence of H. Owen, at the trial of Richard Rowlands.

H. Owen – I live at Ty'n Rhos. I'm a farmer, and I remember the shoe club being held at the Baptist Chapel, on Friday 1 November.

I called over the names of the members at seven. The Gower boys were not there then. I called at half-past seven and they were present. Our time is about ten minutes faster than railway time. The country time is about twenty minutes to half an hour faster than chapel time. I walked part of the way home with the Gower boys. I was at home by half-past nine. They had a shorter way than I had. (Cross examined). They might have been home by railway time from nine to ten minutes past.

Now, in this entire welter of times and o' clocks, did anyone work out the actual time Dic got back home? And when exactly was the old man killed? It was all so vague, even to the fact that the "Gower boys" were plural, when there was only supposed to be one boy and four girls at Gower.

Another thing I pondered on was the fact that Inspector Ellis drew attention to the night of the murder, when William Jones had seen blood upon Dic Rowlands' whiskers. This conversation was denied by the prisoner; all the main witnesses at home said they hadn't seen any blood at all, and even the press spoke of it as a "clumsy effort on behalf of the police, with the collaboration of Jones to strengthen a very flimsy case which rested on the circumstantial evidence alone."

The jewel in the crown and satisfactory outcome of the trial would have been the ultimate confession of Dic, which he steadfastly refused to give – his heartbroken wife and children, and the ministers of the Church all begged him to change his plea, but he repeatedly said that he would not confess to a crime he did not commit.

In the end, everyone agreed with him, even the four high-ranking ministers who were with him daily, put in a very urgent plea for leniency, but this was turned down. Why? Was it the police who blocked it? Or the prosecuting barristers? Or the jury themselves? Dic wouldn't have gone to his maker with a sin like an unconfessed murder on his soul surely? Did every official concerned with the case think that everything had ended satisfactorily?

In case I appear biased in Dic's innocence, there is another unanswered query; remember that Richards was cruelly battered to death on 1 November? And that Dic, his wife and family had to move out of the farm by Labour Day? That was 1 November.

The first question Dic asked his wife when he came home from work on Friday evening, was, had she heard anything about a house? His stepdaughter heard the question, but didn't hear her mother's reply. Subsequently it turned out to be yes.

Nowhere in any conversation did the family say they were packing their clothes and belongings; it seemed so unimportant, no reference to the move was made. Yet this was the day they were supposed to be leaving the house.

Instead of which the boys went as usual to the weekly shoe club, and the rest of the family sat by the fire and that was the day old Richards was killed.

Well, this started off as a ghost story and if your poor brain isn't too addled by the killing, it will finish off as a ghost story.

The latest sighting of the ghost (to my knowledge) was last November (2010). I was told this on the phone by Miss Nia Hughes, a young school teacher who lives in Llangefni.

She and her boyfriend were taking an evening stroll along the edge of the boundary field, which features in this story (it is now a public path) when her partner suddenly grasped her arm and said, 'Watch it!'

She thought she had inadvertently strayed too near the ditch that lies below the wall (now covered in growths of ivy, bramble and nettles, etc.) and she stopped and looked down.

It was not at the ground he was looking – he was staring at the wall. She looked too, and saw the figure of an old man, hands outstretched to grasp the stones at the top of the wall, but he wasn't climbing up, he was perfectly still. As she looked in surprise, he very gradually started to become invisible – as she puts it, 'He was like fog that was starting to clear.' She said a feeling of great fear came over her; she was so frightened she thought she would pass out, and she grasped her partner's hand.

'I couldn't get away from there fast enough,' she told me later, 'I could feel anger and fear in the atmosphere. I've felt atmosphere before but not as strong as that; it was so strong particularly where the old man had been, so I said to Bill, "Come on, quick, run!" and we belted off down the field and didn't stop running until we got to the road.'

Answering my question she said, 'Well, I only saw him for a short while. His hands were gripping the top of the wall, and he was pressed flat against it. I thought he might fall backwards, but then he started to dissolve. Who was he Bunty? Why is he haunting that stile? People have told me there was a murder there years ago, but no-one seems to be able to tell me any facts about it, so I thought perhaps you would know?'

Well Nia, I've done my best, this is everything I know, but what I don't know, is why old Richards is still not at rest. Even after over 100 years, fear and anger still seem palpable at that spot, and no-one knows why. Has his killer been brought to justice or not?

It looks as if his ghost is not going to fade out with time, and no-one – only he and his killer – really knows what happened that night. Perhaps a séance is the only solution?

CHAPTER 19

What Happened to Megan?

Two years ago in Spring, Walt and I were driving back from Bangor to Llaneilian and we'd got as far as the hill which descends to Llanallgo.

I was busy looking across Walt to my right to look for the wood anemones that usually are the first to come out around here, when Walt, glancing to his left said suddenly, 'What's that?'

I swiveled my head around and looked out of my side window. We were just passing the crown of the hill, which although wooded on the right (descending the hill) was on the left not wooded, but scattered with mature trees, and edged with blocks of dressed stone, which appeared to have been a fortification of some kind, or a field wall, although the dressed blocks were large and somehow too superior to be a rough field wall.

I had the impression of horses, and men in uniform, but we were nearly past before I could focus properly.

'What the heck?' said Walt, as we drove downhill, 'let's go back and look! Maybe they're making a film.'

So we went down until we found somewhere to turn around, and drove back up again, until we could turn once more and park near the spot where we had seen the moving figures. But it was peaceful, quiet and empty. Walt sat with his arms on the wheel. 'What did you see?' he asked me.

'Well, I didn't see much, I was looking the other way, but what I did see was a sort of rabble of men in uniform, with a couple riding horses at the front. They were crossing the grass and were going that way.' I waved my hand back over my shoulder. 'But where have they gone?' I looked around, but there wasn't a sign of life anywhere.

'Did you see the girl?' Walt asked. 'The girl they had with them.'

'No, it all happened so suddenly,' I said.

We had to go, we were meeting Walt's business friends from Chatsworth House, who were coming for lunch, and we were late already. We didn't have chance to go that way again for a couple of weeks. When we did, it was in a friend's car. Walt took his cameras, and on the way back our friend stopped while we got out and took some photos. We didn't like to ask if they would wait whilst we explored around the hill on foot; and we never heard anything about a film.

It must have been a month later when we stopped at the same place to look around, and this time Walt told me what he had seen.

There was a bunch of men, I should say about twenty in all, and they were just passing across the pasture in the centre of the gap. There were two men on horses at the front, and they mainly all seemed to be in uniform – drab, dark colours. They were obviously soldiers; from what I saw they were Cromwell's men. Their uniforms were so plain, and one was carrying his hat. I think he was the leader, he was on horse-back, and his hair was cut short all round – I know you've told me that's why they were called "roundheads".

He wasn't in uniform; he had a dark suit on and a tallish hat with a buckle at the front. He and an officer were riding in front, and the soldiers at the back were dragging a young girl along. She seemed to be crying and screaming, but I couldn't hear any noise.

'Were they moving or still like on a picture?' I asked.

'Oh, they were moving, but not very fast because they were dragging the girl along. She fell down. I don't know whether it was on purpose or not. She certainly didn't want to go with them, she was resisting with all her might, but then some of them picked her up by the arms and legs and carried her.'

'What did she look like?' I asked curiously.

'Well, she was young, a teenager I should think, with long brown hair. Pretty I suppose, but you couldn't really tell she was crying so much.'

'How was she dressed?'

'Couldn't see properly, because of the soldiers around her, but I could see she had a long blue skirt on that came to the ground.'

'Blimey! You saw a lot, did they vanish or what?'

'Haven't got a clue, we were past before I could see any more, but they definitely didn't belong to this age.'

We were puzzled, and I told Nia Jones in the bread shop as soon as we got back to Amlwch. She was very interested, but told us she had never heard of haunting at that spot. Perhaps they were making a film about the civil war, but she hadn't heard anything. She'd certainly let us know if she did.

Well, we had to be content with that, we never saw anything else at that spot, and we certainly couldn't find out any details about anybody else seeing them.

Then, one day, I was taking Mrs Owen of Myn Drew her Sunday newspapers, and she had something very interesting to tell me. 'Bunty, do you remember earlier this year when you saw those soldiers on the top of the hill at Bryn Refail? Well I told Daffydd Jones about it, he lives in a little house near Llanallgo, and he knew quite a lot. He left his phone number for you, give him a ring and speak to him yourself.'

So I did, and he invited us round to his cosy cottage at Llanallgo, gave us tea and biscuits, and this is what he told us:

'Now,' he said, 'I don't know how true the story is, but there must be something in it for it to have survived all this time. I guess also because quite a number of people have seen what you saw, and more than that.' Daffydd got up and poked the fire into a sharp blaze, careful not to tread on Lap, a black and white border collie who was sprawled comfortably on the hearth rug.

Lap lifted his head up, regarded the replenished fire with approval, then sank back to sleep with a satisfied sigh.

Well, it goes back to the civil war; you know Cromwell's troops were all over the place? There were all firm Royalists, but Cromwell's men came over and meted out slaughter to anyone who was a King's man; they were a bunch of ruffians in uniform, and didn't care what havoc they wreaked. They killed indiscriminately – there are many stories of murder, and people have told tales of what happened in their families.

Now, I'm a bit of a local historian, or like to think I am, and I'll tell you all I know and have heard about the scene you saw.

During the civil war, Cromwell sent many of his soldiers by boat from the mainland. Hundreds of them there were; boatload after boatload. Usually they were fairly untrained. He had sent his officers out onto the streets to enlist as many men as they could find, and believe me, they were all eager to enlist, a uniform, power and pay, most couldn't believe their luck. Of course, they had a certain amount of training, and the officers were very tough, but they turned a blind eye to a lot of the men's behaviour.

Now, I'll try and tell you what lay behind the scene you witnessed, it's a well-known tale, and it doesn't vary in the telling by whoever sees it, which seems to be fairly often, and always in broad daylight.

Apparently, during the height of the civil war, when Cromwell's forces seemed to be winning, boatloads of soldiers and officers arrived at Moelfre, where they set up camp. I say set up camp, but in reality it meant that the officers ejected the villagers from their homes and installed themselves comfortably in them.

Only the foot soldiers made camp, and they weren't there for long, the same as anywhere else they spread in Anglesey – just long enough to kill any Royalists who took up arms against them. They made sure the men with Parliamentarian leanings were left in charge, then once that place was subdued, moved on again, leaving behind a few officers and men to keep order.

In the early days of course there were many Royalists here, big landowners and titled people, who were loyal to the King. But these people had to merge into the background, and pretend that they were Parliamentarians. Murder, kidnaps and rape were the order of the day, and the scene, which you and many others have seen re-enacted, seems to have its roots in the story.

Below the hill you came down, known locally as Bryn Mawr the land is fairly flat and fertile and on it stood a farm known as Pant-y-Dwr, which belonged to a farmer named John Jones. He lived there with his wife Nia, his son John Bach, and his pretty teenage daughter Megan.

John was an ardent Royalist, and didn't even pretend loyalty to Cromwell, in fact he detested anything that related to him, and this included his troops. He let his views be known amongst many of his fellow farmers, and of course there is always someone who will say a word in the right place to get a man in trouble, and so it was in the case of John Jones.

One morning in spring, when it seemed to the people of Anglesey that Cromwell's reign was now well established, John Jones and Johnnie Bach were busy lambing in the paddock, when a party of Roundheads came swarming into the yard.

They were a rough bunch, armed and dangerous, and as John and his son stared open-mouthed, some shouldered their way into the house. Two more picked up hens that were laying in the nest boxes, wringing their necks and thrusting them into a sack they were carrying.

Screams from the women in the house galvanised John into action, he grabbed the wood axe that was thrust into the chopping block, and made a dash for the officer who was with them. He was grabbed and overpowered, and flung to the ground, where he screamed curses at the Roundheads, and swore oaths about Cromwell.

While they sat on his struggling form, one soldier grabbed his mouth, opened it wide, and cut out his tongue, thrusting it back into his mouth and forcing it down his throat.

"There," yelled the soldier, "let's hear you swear at Cromwell now!"

The others guffawed, and watched in amusement as John choked and died in his own blood.

Johnnie Bach stood frozen with horror until a piercing scream came from the doorway of the house, and he turned and saw his pretty sister being dragged out by two soldiers, one with his hands tangled in her long brown hair. He flew across the yard to rescue her, but was jumped upon by a gaggle of soldiers who knocked him down and set upon hacking him to bits with their daggers. Briefly, his screams of agony mingled with his sister's, but they quickly stopped. He was dead. Megan was thrown across the back of one of the seated officers' horses, but she thrashed about so much, the animal reared and nearly broke away so that the officer was nearly unseated.

He roared at the men to drag her off and tie her behind a horse on a rope, but Megan was half-mad with fear, and fell to the ground, so that was no use.

Finally, the men tied a rope around the waist of the sobbing struggling girl, and set off with her as captive to go back to their camp at Moelfre. They tried to pull her along, but she fought them every inch of the way, by flinging herself to the ground. She must have been mad with fear and horror, as she saw her father's body, with blood streaming from his mouth, and her brother Johnnie lying dead in a welter of blood, his eyes open and staring.

A farmhand, hiding in the hayloft, saw the last two soldiers come out of the house with a huge pile of newly baked bread in a sheet, and his companion with pots of newly made butter. Then they all disappeared up the hill, Megan's screams becoming fainter with distance.

That was the last time anyone ever saw her. Everyone knew what her fate would be, either she was raped and kept alive for future use, or she was raped and killed. Her body was never found, and most strangely of all, no-one seems to know what happened to her mother.

Daffydd finished his story and sat in thought. We were all spellbound, until Daffydd said, 'I've heard your story told many times by many different people, so it must be true, her terror and horror must have covered the centuries, and not faded with time, but why that particular scene?'

We sat in silence again. 'What I can't understand is why people don't see anything in the farmyard where two people were killed, and why nothing more was said about the mother?' Walt queried.

'We don't know anything really do we?' I asked.

'These sort of things seem to be governed by rules of their own, like what should appear and why and when.'

'Well, all I have told you is just what I have heard,' said Daffydd. 'The people who have seen it are very serious about it; one said he would swear on the Bible, but I can't say anything myself, because I have never seen it.' And neither have we, since.

This was the area where Megan was seen being dragged by Cromwell's men.

CHAPTER 20

What Was It?

Close by the village of Brynteg, further down the valley lies a smallholding called Ty Gwyn. It belonged in the late twentieth century to Mr and Mrs Rowlands, who lived there with their two sons.

The two boys never got on together, they were forever falling out and when the old couple died, and they were left, the rows grew more acrimonious, particularly on matters pertaining to the running of the farm.

Things went from bad to worse, the few acres of land they had could not sustain them, and Norman, the younger man, wanted to sell up, while Tom wouldn't hear of leaving and kept introducing plans to make them richer, which only had the opposite effect. In the end, they barely spoke without it ending in a violent row.

Then, one day in winter, when gales howled in off the Irish Sea, two of the ridge tiles from the apex of the roof blew off and smashed in the yard. The men both knew that if the remaining tiles blew off, the whole roof would go, slate by slate, so instant protection was necessary. The house was tall, with steep roofs and high chimneys, not an easy climb on a calm summer's day, let alone in a wind that flattened most things in its path.

Tom ordered Norman to go and cut a big clod of grass and earth from the garden, about a foot square, and 4 or 5 inches deep, carry it up to the roof in a sack, then lay it over the hole, and press it down firmly and it would protect the roof until a permanent repair job could be done by the local roofers.

Norman objected, he didn't want to go up, he hated heights, and how could he climb the steeply sloping roof without a cat-ladder? It ended up in a fiery argument, and a neighbour, who was just opening the yard gate, told his wife later that Tom had grabbed Norman by the throat, thrust him against the wall, and was repeatedly banging Norman's head on it, obviously swearing but the neighbour couldn't hear what he was saying.

The farmer had come to look at the last two bullocks on the farm that Tom was selling, so Tom walked to meet him at the gate. The last thing he saw was Norman fetching a spade from the shed, and making for the garden. He had to grab the sack on his shoulder to stop it being blown away by the wind.

Tom and his neighbour went into the cow-shed where the beasts were, the farmer examined them, and after a lot of haggling, a price was agreed, and away went the neighbour, saying he would pick them up in the morning.

Tom went back to the house. He looked up to the ridge of the roof and saw the big, heavy clod of earth was securely in place, hanging down on each side. The thick, wet,

weight of it ensured that the gale would not move it an inch. Of Norman there was no sign.

Tom gave a satisfied nod; this method had been used by people in his grandfather's time. He remembered too that cow muck mixed with straw could be used instead of plaster on any hole in the outside wall of the house which may have wind funneling through between the stones and causing a strong draught in the room beyond and promised himself that he would look around the walls when the wind had abated, to see if any outside repairs were needed. Of course, all these things were done when agricultural working men built their own houses, which were mostly only one storey high, and had earthen floors. Looking up at the big clod of turf that was protecting the house, Tom felt a sneaking admiration for his younger brother, climbing up the high walls and steep roof, to place the clod where he had.

Then as he came around the corner, he felt a surge of irritation to see the ladder had not been put away, but was still leaning against the house-side.

The fool, he thought savagely, if the wind caught that, it would slide sideways and smash to bits on the cobbles of the yard. Where was the young devil?

Suddenly he stopped. Norman lay at his feet, with his head at an unusual angle. He lay dead with a broken neck.

Well now, I learned all of this yesterday from the lady who had bought Ty Gwyn, or rather her husband had, from Tom Rowlands, two years previously.

The lady and her husband were Mr and Mrs Lomas, who had sold their house in Bolton to come and live on the Island. They had bought the house, Ty Gwyn, with a quarter of an acre of garden, and the farm land had been sold off separately.

She had come to see me to tell me her story, and I gathered the above details from her, as she was kicking off her shoes (at my invitation), and stretching her feet out cosily to the warmth of the fire.

'Well now, where was I?' she mused:

Ah yes, what I was going to tell you was Bill fell in love with the place as soon as he saw it, but I felt uneasy about it, the whole time. It looked very shabby and dilapidated, it hadn't been painted for years, and some of the windows had rotted frames. And as for the inside, well! I ask you, the man had been living on his own since his brother died and you can imagine what the room looked like!

Anyway, in the end they agreed on a price, I thought it was too expensive, but Bill said not, so he bought it, and we moved in a few weeks later. Mr Rowlands left the district, he got a job walling for a big company who build motorways, and the last I heard he was up in Scotland somewhere.

Anyway, we started to put the house to rights, plastering and painting, having new windows and doors put in, the old ones were all rotten.

Well, we moved in, Bill had such plans, he'd always wanted a house in the country with a bit of land, he dug a vegetable garden, and bought some hens, and he was happy as a pig in muck!

I wasn't though, I felt frightened somehow, and the atmosphere was very heavy and brooding at times. I tried to tell Bill about it, but he said it was very warm and welcoming, and it felt like "home". He said I was overreacting because it was the first time I had lived somewhere without neighbours, and I'd soon get used to it; the fresh sea air was better than Bolton, and I would make friends.

Then one of the hens went broody, and nothing would do except put a baker's dozen eggs under her, and wait for the eggs to hatch. Well, we waited and waited, she was a good broody, but even after we had waited four weeks, still nothing. Bill took one of the eggs and smashed it. No chick inside, it was just addled.

Anyway, that was the first thing to go wrong, that's when I became aware that the place didn't like us, and wanted us to go. Poor Bill, I felt so sorry for him.

'Sorry to interrupt Meg, but what breed are your hens?' I interrupted.

'Oh, I think they are called Warrens, we have a cockerel too.'

'And did you use Warren eggs for your sitting?'

'Yes, of course, they were our own from the hens.'

'Well, don't blame the place because your eggs didn't hatch, they wouldn't have hatched if you'd left them there till Christmas. Warrens are hybrids, and you can't breed from hybrids.'

Meg was surprised, 'Oh, we didn't know that, I'll have to tell Bill when he comes in, at least he'll know it wasn't his fault! He'd done everything correctly.'

'Well, you did say when you rang that you thought the place was haunted, what was that about?' I asked.

Meg continued:

I started to think it was haunted when we first moved in, because when I put my handbag down on the hall chair, I turned around to pick it up, it was in the sitting room on Bill's chair, I hadn't even been in the sitting room!

When I told Bill he didn't take much notice, he said it was one of the first signs of dementia, and I'd better watch it, otherwise they'd be sending for the men in the white coats!

Then lots of little things started to happen – I made tea in the pot in the kitchen and, while it brewed under the tea cosy, I went to fetch the cups and milk and things, but when I came back to pour it out, there was nothing under the cosy, and the pot was clean and dry and back in its place on the shelf!

'Was the pot warm or cold then?' I asked.

'It was quite cold, as if it had never been touched!' Meg replied.

'Weird!' I said. 'Go on then, what else?'

Well, one night that week we were both sitting on the settee, with our little dog Cap lying between us, he does that every night and he loves it.

Well, we were watching television and he was fast asleep, then all of a sudden he woke up, stared at something behind us in the corner, and he started to growl. He growled very fiercely at first, and all the hair on the back of his neck bristled. Then he started barking and growling and showing his teeth, we turned our heads round and we couldn't see anything and Cap's growling turned to whining, he jumped down from the settee and tried to hide between our feet, then he leapt up onto Bill's knee and hid his head under Bill's pullover. He was trembling all over and crying.

We both stared into the corner, but we couldn't see a thing. Anyway Cap soon became quite normal again, but it gave us something to think about I can tell you!

Well, we'd been there a few weeks, and I felt as if the atmosphere was getting worse. One night Bill got out of bed and started creeping to the door, and when I asked him if he was alright, he said "shush", and went out of the room.

Of course I was on pins until he came back, and when he did, and I asked him what the matter was, he said he had heard the sitting-room door close, you can always tell it's that door because it creaks. He said it creaked, and then closed very sharply.

Bill thought someone had broken in, and he crept downstairs right away, and he found the sitting-room door wide open! He couldn't explain that away, it made me think.

Things started to happen thick and fast after that. I went out to feed the hens, and I left the back door wide open. It was pouring with rain, so I hurried up and fed the hens, collected the eggs, and I was just coming back when the door slammed in my face. I was locked out, and Cap and I had to shelter in the greenhouse out of the rain. We had to wait in there for two hours until Bill came home.

'Was there any draught that had caused it? Like open windows or anything?' I said.

No, no chance, there wasn't any wind, it was very still. Then, I think it was that week, I had to go to the bathroom in the middle of the night, a moonlit night I remember, and had just got into the bathroom when I nearly tripped over a body on the floor.

I remember her quite clearly, she was big and stout, and she looked as if she was dead, she was lying flat on her face with her arms stretched out above her head.

It gave me such a shock, I cried out and Bill jumped out of bed and came rushing along the landing, and just as he got there the body disappeared.

I couldn't stop shaking, Bill put me back to bed, and I lay there clutching him like a drowning man. He wanted to go downstairs to make me a cup of tea, but I couldn't bear to be alone; I wouldn't let him go.

'Who was she? Did you ever find out?' I cut in. 'Well, Bill made a lot of enquiries, and apparently Mrs Rowlands, the mother, had suffered a massive heart attack in that room and dropped dead. It was just after that that the noises started.'

'Noises? What noises?' I questioned.

Well, the first ones were just sighs. They happened every now and again, mainly to me, and always when I was alone. The first one happened when I was in the kitchen, peeling potatoes at the sink. Suddenly I heard this deep sigh in my ears, as if someone was standing at my shoulder, I jumped and turned round but there was nobody there. It happened again on the same day, this time I was folding the ironing and putting it away in the linen cupboard. It was louder this time – and it was sort of exasperated. I was alone in the house, and I was frightened to death, I just dropped the ironing and flew downstairs and into the garden. Bill was just pulling into the drive and I shot into the car and told him all about it.

'Do you think it was the ghost of a man or a woman?' I asked.

Oh, I think it was a man, and a very strong man at that, I'll tell you why. Bill and I were in the kitchen, he was putting up some shelves and I was preparing vegetables. We were

talking about my brother-in-law in Old Colwyn. He was hopeless at DIY and he was very proud of the shelf he had just put up in the bathroom – we all had to go and admire it.

Well, when we were all gathered there, he got a new tube of toothpaste and placed it with great ceremony in the middle of the shelf. As soon as he let go of it, it started to roll sideways and fell off the end of the shelf! He hadn't got the shelf level you see!

Well, Bill and I were happy and laughing when all of a sudden the big carving knife, which was in the knife block with two other knives, rose up in the air as if someone had grabbed it, then it came whooshing down again, and the end of the blade was driven into the bread-board to about an inch and a half in depth and there it stuck.

It was just as if something didn't like us being happy and laughing, and it drove the knife down to show its anger. It took all Bill's strength to pull it out again. Whoever or whatever it is, it didn't like happiness or the things we enjoy.

For instance, a couple of weeks ago, we bought two bedside night stands from Llandudno – you know the types I mean, little square cabinets with drawers in. These are made of solid oak, and they are very heavy and hard to shift. Well we put them in place with our bedside lights on them, and we lay in bed admiring them, then we switched them off and lay down to sleep.

That's when the noises started, we couldn't make out what they were and what made them, but I'll try and explain.

There was a little silence here as Meg tried to get her thoughts together, then she said:

It was a quick loud noise, you know what a cane sounds like or did sound like when the teacher brings it down through the air, then hits the wood?

Well, like that, only on Bill's new bedside cabinet. It happened only once, but it was very loud. Bill sat up and switched his light on, to look at his new cabinet, but there was nothing there.

He got out of bed and examined it all over pulling out the drawers and tapping the sides, then he said, "That was odd, probably the wood expanding in the change of heat, shouldn't do that though, they're solid oak and well seasoned."

Well, we'd just got back in bed when the noise came again, twice, this time on my side, then another slap on Bill's side.

I was scared stiff, but Bill said, "Don't worry, lie still, it'll stop soon." So I did, and it didn't happen again.

The same thing happened the next night and the next night too, the same swish and thwack, first on Bill's side, then on mine, but when we pretended not to take any notice, it stopped again.

We've heard it a lot of times since; sometimes when we're not even in the room. I feel very uneasy in the whole house now, and so I asked Bill and he agreed to put the house up for sale, and find somewhere else. I know he loves this place, but not as much as he did; I think even he is beginning to feel the atmosphere, and he knows I'm frightened here. I'm sure he'll settle down if we can find somewhere else with a bit of land.

'Gosh! That's a surprise! I thought you were settled for life, how long have you been there?'

Oh, only about two years now, but it was what happened last Saturday night that was the most frightening, and it made up our minds for us.

The atmosphere was getting worse, thicker somehow, like when you add flour to gravy to make it thick, even other people were noticing it, or feeling it, whatever. When they sat down, they didn't seem to settle, they kept fidgeting and looking over their shoulders, and nobody stayed long.

Then my brother John came to stay last Saturday for the weekend with his wife Pat.

We've always been close, and Pat is a lovely girl. Saturday afternoon we had a ride out to Llandudno, then later on in the evening, the lads decided they would go to the California for a pint, and asked if we would like to go with them. We declined and said we'd rather stay in with a big fire and a bottle of wine.

We wanted a natter; we hadn't seen each other for ages, so they went out about half-past eight to the California – that's the local pub; it's very popular.

Well, Pat and I enjoyed a good gossip and a bottle of wine, and then about ten o'clock we decided to make a pile of sandwiches – some for us, and some for the men when they came back. We made a big plateful of corned beef sandwiches, and a dish of home-made pickles, and we started to carry ours through to the sitting-room.

Pat went first, we'd left the kitchen door open, and she'd just got to the door, when she suddenly stopped and said "What's that?"

I was just behind her carrying my sandwiches, and I bumped into her back, and I said, "Whoops!" because all the sandwiches were nearly falling off the plate.

I tilted the plate so they slid back, then I looked over her shoulder at what she was looking at. "I think your cat has got under the hall carpet," she said.

"We haven't got a cat."

"Well what's that lump then?" She pointed to where the hall carpet began near the door.

We both stood and stared. Just where the fitted carpet began near the front door, and underneath it, there was a lump, cat-sized, under the carpet, and part of it, what we took to be the head, was slowly undulating from side to side.

"What the heck is that?" I asked incredulously, "and how the heck did it get there?" We both stared, it was well and truly under the carpet, but how?

The carpet was still thoroughly and tightly nailed down, the stretchers were still in place, and the carpet was skin-tight with the hall-floor, there wasn't a gap anywhere at the edges, and yet there was a lump in the middle, as if the carpet was made of elastic, and could stretch all over the place without tearing itself away from the stretch strips at each side. It came towards us very slowly, every now and then stopping as if to listen. I felt a crawling sense of horror as I watched. It grew as it moved, and changed shape, the head part of it slowly moving from side to side, cat-sized at first, then gradually to that of a large dog, slowly advancing on us.

The pink and green flowers on the carpet that covered the monstrosity only added to the fearfulness of it, as the size of it increased to that of a large calf, all the time advancing on us slowly and deliberately, pausing now and then as if to listen or catch our scent. There was a sound coming from it now, a sort of mewling whine, which got louder as the thing drew near.

When it was a couple of yards away it seemed to rear up on its back legs, and became a human form. I say a human form, but the mewling whine had become louder and more menacing as it drew near, and I became aware of a dark mist that surrounded it which gave off an overpowering sense of evil, my blood seemed to run cold.

Beside me, Pat was uttering dry, strangled sobs, and I suddenly became terrified that the carpet would fall away, and reveal what?

My plate dropped from my nerveless hands; Pat's was already in pieces at our feet, and I grabbed her arm and cried "Quick!" and dragged her back from the door, slamming it behind me. We raced across the kitchen, out of the back door, and didn't stop running until we were half-way to the California. Jack and Bill were sitting at a table near the bar, and as we gabbled out our story, Bill fetched us two large brandies. We couldn't describe our fear properly, and it must have sounded a very weird story, but they both believed us.

When we had finished the brandy, we all went back home, and Pat and I waited in Jack's car. We wouldn't go into the house while the men went in to search. When they came back they said the house was quite normal, nothing amiss; the carpet looked as if it had never been moved, the nails were still firmly in the stretching rods at the side and they couldn't move it.

I told Bill there was no way I was going to sleep in that house, and Pat agreed, I said we could stay in the caravan, which we had kept, and finally we decided we women would sleep in the caravan and the men (who I think wanted to appear macho) would stay in the house. So Bill and Jack went to collect our night things and we stayed where we were, happy not to have to go back in. The men scoffed a bit, Jack more than Bill, because Bill was aware that something was strange about the house.

Anyhow, armed with a few cans of lager from the fridge, they said goodnight and left us and we got ready and made up the bunks for bed.

When we were safely tucked up, I said to Pat, "Who or what do you think the ghost is Pat?"

"Haven't got a clue, I don't know whether it just hates us or people in general," she said.

'Would you let me write the story of it one day please?' I asked.

'Of course, if you change the names of all the people and the house, so no-one could figure it all out,' she said.

I assured her as honestly as I could, 'Oh, I don't think anyone will guess where it is.' (I suddenly remembered a certain Mr Roberts of Brynteg – you'll guess where it is won't you Mr Roberts?) 'So you are going to put the house up for sale are you?'

Oh, we're half-way there already; because there was a young couple who were after it when Bill bought it and every time I see her she asks how and what we were doing, and says she wishes they had offered more. They're living with her mum, and still looking around. When I saw her on Monday, and told her we were thinking of selling up and moving on, she almost begged me to let them have first chance, and not even put it on the market.

So the men talked to each other on the phone, and they've more or less agreed on the price. I think it's a good idea, we could be out of that place in a few days – we've been living in the caravan since Saturday, and honestly, I can't get away quick enough.

Then she hesitated, and she said, 'So that's what I've come to tell you Bunty, the whole story, except for one thing that is troubling me, and I'd value your advice on it.'

'Oh, and what's that?' I asked curiously.

She gazed at me, and her eyes were troubled. 'Shall I tell them it's haunted or not?' I thought long and hard about this. Then I thought about you who are reading this. What would you do?

CHAPTER 21

The Weeping Ghost

The sitting-room door burst open and Mary, red-faced and tearful, rushed in, banging the door closed behind her, and staring at us with eyes like saucers.

'She's there again,' she gasped, 'there again.' Then she sank down on a chair as if her legs wouldn't hold her up any longer, and sat shaking wordlessly, covering her face with her hands.

Mrs Roberts of Steeple Lane, Beaumaris, had come to tell me her story, and I didn't interrupt, the tape machine was working steadily, and up to now, I had no questions.

My husband Bryn lowered his paper and said, 'Who's where and what on earth are you babbling about girl?'

Mary looked at me, a question in her eyes, I think she was beyond speech, and I shook my head at her, and said, 'No, I haven't told him yet.'

Mary was our new cleaner, she had only been with us for a couple of weeks, she was just eighteen, a hard worker, cheerful and efficient, and we all liked each other, which is quite important in a small household.

As you know, we live in Steeple Lane, quite near to the gaol, which is now a heritage site. Mary starts work with us at 7.30 a.m., three times a week, and of course in winter as it is now, its pitch-dark. She comes early because she has started a course at Bangor University; she only moved down from Liverpool a few weeks ago, and she has a couple of little jobs to help pay her way.

She is taking a degree in Marine Biology and is a bright kid, not given to hysterical fits, and I knew she had been badly frightened. I told her to go and make herself a coffee while I told Bryn the story.

Apparently, two weeks ago, she had been coming up to our house in Steeple Lane; we live on the other side of the road to the prison. It was pitch-dark, but the street lights were on, and a few house windows were lit up, so she could see where she was going. As she approached the prison (on the opposite side), she saw, in front of her, across the road, the figure of a woman standing still, and gazing up at the outside wall above the gate. She had a long skirt on and a heavy shawl around her shoulders.

She was crying, and seemed to be mopping her eyes with her shawl and was obviously in great distress. Mary, being the warm-hearted girl that she was, made a bee-line for her, and was just about to cross the road when a car came past, she saw the woman more clearly in the headlights, and said she looked to be in her thirties, was slim and pretty, with very short hair which she had covered with the wool shawl, which had now slipped down from her head, as she dried her eyes with it.

Mary had said she was looking upwards, above the Gaol door, at another door above that; she never took her eyes from it. 'I couldn't get over to her fast enough,' she said, 'she looked so sad and lonely, my heart went out to her.'

She waited impatiently for the car to pass, and stood on the edge of the kerb, looking at the woman all the time. The cars headlights picked out more details of her dress than Mary had seen before and, in the few seconds that she was illuminated, Mary saw that she had on a stiff black jacket beneath the shawl, drawn in at the waist, and her dark skirt was full and long, and floor-length. But it was hair that caught Mary's attention. It seemed to be cut short and stood frizzy all over her head. She stood there, and every line of her body was showing her misery. Then, still looking up at the closed top prison door, she opened her arms before her, her hands wide in supplication. As the young girl stated, the figure had vanished, and Steeple Lane was empty.

Mary stood there stunned, she couldn't believe her eyes, and rushed across the road, wondering if the woman had fallen down or fainted or something. But the pavement was empty, Mary looked up and down the Lane, there was no sign of the woman, there was no sign of anyone, and nowhere she could have run.

She told me later that as she stood there, she suddenly had a great feeling of dread; she said her hair went all stiff, and she became covered in goose pimples. She knew for certain that what she had seen wasn't normal, the way the woman stood crying and looking upwards, her arms open to somebody or something, and then to vanish in a split-second, was something her mind could not comprehend. When she was able to use her legs again, Mary turned and made a bee-line for our house, and gabbled out her story when she found herself back again in the normality of warmth and light.

That was two weeks ago, and now it had happened again – the same woman, same clothes, and the same piteous gesture. But this time Mary had come round more quickly.

I slipped on my coat and hurried out to the spot in the Lane, but of course there was nothing there. We talked about it over a cup of tea, and Bryn and I both said we would go down to the bus-stop to meet her next week, so she wouldn't be alone if the phantom (because that is what we decided it was) should re-appear.

In the meantime we would all try and find out just who she was and why she stood there crying.

Mrs Roberts said the person she asked first was the young postman that she had become friendly with. He didn't know anything, but advised her to go and ask at the post office, as the postmaster had been there for some years and knew a lot about the place.

So she did, but the postmaster was away on holiday, so she called to a middle-aged postman, loading his van at the time. Here she struck gold, because he had just finished reading my book *Anglesey Ghosts*, and he remembered there had been a story in it about Beaumaris Gaol, and the executions that had taken place there – he wondered whether there was any connection with the ghost of the woman.

Anyhow, to cut a long story short, she had tracked me down and we made a date for her to come for an interview – and here she was.

When Mrs Roberts had gone, I played the tape back to see if I had asked all the relevant questions. After visits to the Archives and after looking through the realms of old newspapers, I finally came up with an answer. The ghost lady had been staring at the Gaol, which had opened in 1828, and was fully equipped with the punishments rooms and tools of that day.

The year after it had been built, the first public execution had taken place. It caused a great stir, for no-one had been executed in Anglesey before, and everyone was curious to see what actually took place.

The prisoner who was to meet his doom was a man by the name of Richard Griffiths, a man who was disliked by all who knew him. He was a bigamist, a drunkard, and a man with a furious temper who was very violent when drunk. He was feared and avoided even by those he had stolen from.

He was good-looking, though, and charmed the ladies, whose money he used for drink, and then dropped when their money had gone. He had left his first wife years ago – no-one knew her name, nevermind where she lived – and then he had met a young woman who worked hard and had a few guineas in the bank, which she slowly added to, saving up. She was slim and pretty, with long dark hair she dressed in the fashion of the day, piled high on her head.

Griffiths was attached to her, her money, and her house. He could charm women, and she (her name isn't printed anywhere) was no exception, as after a brief courtship, they married and he moved in.

At the start, he was loving and attentive, and she absolutely adored him. Like a fool, she gave him money every time he asked, telling her he was looking for a job and needed money for fares. He hardly ever went further than the nearest pub, where he got very, very drunk.

She knew how to deal with him, but soon the money in the bank ran out, and they had to rely on the little money she earned by cleaning every day. Then his charm, which he had only used to extract money from her, rapidly vanished and he became his true self, the wages she earned from cleaning disappeared into the pub, and food became scarce in the house.

Violent rows became frequent; her neighbours heard her screaming when he beat her, and he spent most of his time drinking. He would beat her and curse her, and then storm off for a drinking bout. Nearly always she had a black eye, or a swollen lip, sometimes she limped when he had kicked her, but she was always loyal to him, no-one ever heard her say a word against him.

One day when her screams echoed down the street the neighbors came and stood in their doorways. Some wanted to intervene, but they knew Griffiths was very drunk, and in an uncontrollable rage, so they hesitated. As they did so, the door of Griffiths' house flew open, and he staggered out, and glared at his newest neighbour.

'Well! That's the end to it then,' he snarled, gazing with fury at them all. He stumbled off up the street, and disappeared from sight. They could hear a loud choking noise, corning from his house. They crowded round the door, and saw a horrible scene.

Griffiths's wife lay half-beaten to death in the fireplace. Her head had been thrust into the fire, and her long dark hair was well alight and burning furiously. They dragged her out just in time (minutes later she would have been dead) and doused her head with a wet towel to stop the flames. The rasping, choking noise she was making was because a wide, rough piece of wood had been forced into her mouth, cutting it badly, and down her throat as far as it would go.

Slowly and gently it was pulled out. It took great care and time, she kept fainting with the pain, but at last it was out, and she was gently carried to a neighbour's house and put to bed. Griffiths had done his best to kill her, and the final act of putting her head in the fire left no reason to doubt it. Then he had disappeared.

His crime was reported, and within days he was caught, arrested, and sent to Beaumaris Gaol. He was accused of murder.

In the cell, before the trial, no-one could be found who could say a good thing about him. Everyone who had ever had any dealings with him, or who lived near him, could only attest to the fact that he was a brutal drunk, a liar and a thief.

Somehow, Griffiths got word to his wife, who now, weeks after her ordeal, could only speak in a rasping whisper, and whose once long dark hair was a mass of short, blistered frizz.

The poor besotted soul was still in love with him, and he put on his charm again, saying how sorry he was, and painted a glowing picture of their future together, he would get a job, stop drinking and become a model husband. He was very tender towards her, using all his old courting wiles, working on her with all the pretended love he could muster, because in reality he wanted her to speak up to the judge and jury in his favour. Nobody else would.

As the day of the trial approached people of the Island were divided into two camps. How could a man be accused of murder when his victim was still alive?

The other side, mainly people who knew him, said he meant to kill her, and if it wasn't for the timely intervention of the neighbours who had acted so swiftly and saved her life, he would have succeeded. Why else would he try to disappear without trace, and have to be searched for by the police?

Feelings ran very high. The local hangman refused to take any part in it, workmen boycotted building the bridge that would lead from the upper jail, across the prison yard to the newly built gallows over the outer door, so more workmen had to be brought in from Liverpool.

Everyone expected a riot, and 'javelin men' were placed beneath the gallows where the hangmen would work.

Anyway, although the mood of the crowd was very ugly, the actual execution of Griffiths (see *Anglesey Ghosts*), and his slow and noisy death so sickened the crowd, who had never seen an execution before, that a deep silence reigned.

Among the crowd, at the back and all on her own, stood his battered, half strangled wife, with tear-stained face, and hands raised in supplication.

But is it her? I asked around the town, and found that whilst only three people have seen this sad ghost, standing alone against a house wall opposite the Gaol, nearly everyone in the bread shop, butchers or post office, (places where people go to exchange gossip) had been told about her from their elders, and they were all firmly convinced that it was the widow of Griffiths.

Still, I couldn't find out her name, or which street they had lived in. The last sighting of her grief-stricken figure seemed to have been in the late 1990s, but who knows how many times she has appeared unseen in the dark morning of a cold winter's day.

Do please let me know if you know any more?

CHAPTER 22

Lynas Point is Haunted

There is definitely something weird about Point Lynas. Anyone who has read *Anglesey Ghosts* will also have read the story in it called 'Road to Point Lynas', in which a man in a heavy old-fashioned overcoat followed Walt and I as we walked back from the lighthouse down the steep sunken road. He was really striding along; we were strolling, so we walked in single file until he had gone past.

He never went past. I turned around to see how close he was. There was no-one behind us, the road was absolutely empty, and there was nowhere he could have gone.

As I said, the lane was cut deeply between the grassy banks, and even if he had managed to scale the sides, we would still have been able to see him, as we were nearly at the bottom of the hill, and the lane was now level, no trees or bushes behind which he could hide, just miles of springy turf scattered to the cliff-tops with pink thrift flowers, which bloomed in summer.

That was the first puzzle; the second was when we told the story to our very able plumber, Mike Jones of Pen-y-Sarn. He told us about two friends of his who were going fishing one dark night, to Point Lynas. Men fish there off the rocks at night, using very powerful lights shining into the sea to attract the fish. Sometimes the rocks are studded with these bright lights; rain or wind never seems to deter such doughty men if the tides are right, and their catches always seem to be worthwhile.

Anyhow, I digress. Apparently, these two men had just climbed over the hill, making for their favourite spot on the rocks, when suddenly, out of the dark in front of them, appeared two strange creatures who stood and stared at them.

Their eyes looked almost human, their bodies were covered in skin, not fur or wool or even hair, and they were standing on four legs.

Then they started to walk slowly towards the two petrified men, who turned and fled. They never went back there again, and they never found out what the 'horrible' (their word) creatures were – two incidents and no explanation for either. After this, I kept a file on Lynas, but nothing seemed to happen, until this year.

Let me first describe Point Lynas to those who don't know it. It stands on the north-eastern tip of Anglesey, over a very rocky promontory, where many turbulent currents clash together, creating a surging maelstrom of boiling sea, which has been the grave of many ships and their crews. At one time, the lighthouse had a staff of head keeper and two assistant keepers. It belonged to the Mersey Docks & Harbour Board, and must have been a very busy place years ago from trade.

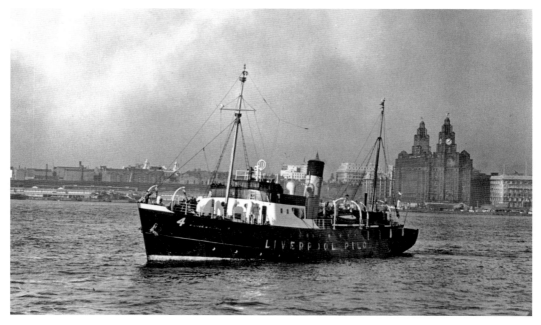

Liverpool Pilot Boat No. 4, built in 1937.

These days, the keepers have all gone, the light is automatically controlled from Liverpool, and I have been told that the assistant keepers' houses are now holiday homes.

The silence is now only broken by the shrilling of the ever-present wind in the struts of the tall wireless arial, and the eerie moaning of the fog horn, which sounds about every sixty seconds when the fog is thick.

As I said, my file on Lynas was very thin, the only things I haven't mentioned being the new accommodation block built for the Liverpool Pilots.

The Liverpool Pilots are a body of brave, capable seamen, whose main job is to escort vessels in and out of Liverpool, over the Bar, and through the dangerous and ever-shifting channels. Most of the pilots come from Liverpool, and they usually arrive (and leave) by taxi from the Pool.

The pilot boats used to be based in the port, but it got busier, and as it was quite a dangerous place to be, owing to the high tides and gales, it was decided to build a special jetty for the Pilot Boats, and the right place was found.

To the lee of the lighthouse is a fairly sheltered bay, in which vessels bound for Liverpool await their pilot. This was a perfect place, so in 1974 work began on the jetty, which was made of greenheart wood, a wood of exotic origin, which is practically impervious to sea water.

A long concrete path from the bottom of the lighthouse road was constructed across the land to the jetty itself, which is a very solid wooden structure about three tiers deep, each reached by ladder, and each tier used according to the height of the tide.

A modern, very well-equipped bunkhouse, complete with bedrooms, central heating, deep freeze, etc., was built for the pilots who had arrived by vessel or taxi, and needed a meal and perhaps a night's sleep before the next stage of their journey.

Any ship's pilot could tell you hair-raising stories about boarding ships. They take their lives in their hands when they stand in the pilot boats alongside the ship, and extend their hands to grab hold of the ship's rope ladder as it is thrown down to them, over the side of the vessel upon which they are about to embark. Then they climb slowly upwards – don't forget both vessels are rising and falling in the sea-swell at different rates, and if the sea is very rough it can be a very tricky business. Now, they are the only things I know about Lynas – the factual and the unexplained. This file was 'dead' until last week.

I have painted the background of Lynas for you, and now I'll tell you the story.

One Thursday afternoon last week I got a phone call from Mr and Mrs Oram of Buxton, who had come to Anglesey for an extended holiday in their caravan. Mrs Oram said she had read my books, and she was sure I'd be interested in a story she wanted to tell me, which I shall now tell you.

Mrs Oram started like this:

We have been coming to Anglesey with our caravan for years, but never to this part of the Island. Anyway, about two weeks ago, we went in the car to the little bay at the bottom of Llaneilian, intending to have a pre-breakfast walk up to the Point.

We had got more than half-way up without seeing a soul when Bill, my husband, looked over the wall on the left hand side of the road. He stopped and called me over. "Hey Jean! Come and look at this!"

I looked over and saw a vegetable garden so well kept there wasn't a blade of grass out of place or a stray weed anywhere. The whole garden was made up of vegetable beds all neatly raked and prepared for their new crops. I could see a bed of last year's sprouts and winter cabbage, nearly empty now – don't forget it is only early spring.

At the end of the garden there was a shed and a big water butt, and in front of them was a potato patch. I could see the plants just emerging from the soil; everything was ready for summer.

Bill had walked along a bit, stopped and was looking over the wall at another garden. In this one, sticks for runner beans were half-done and the bean plants themselves were beginning to sprout.

There were three gardens altogether, each with a shed and a tank or butt for water, and all neatly tended. All three had bushes along one wall. There were blackcurrant bushes, gooseberry bushes, elderberry trees, and damson trees; all healthy and beginning to leaf.

"These gardens must belong to the lighthouse keeper," said Bill, "I bet they keep him busy."

I nodded, "Just look at these herb-beds too." We saw sage, thyme, mint, rosemary, lavender – all sorts.

"Somebody must have to do a lot of jamming and preserving," I said, "I wonder where she got all her jars from?"

My friends and relatives were all asked to save their jars; I made a great deal of jam each summer, and dried herbs to hang from the rafters in the kitchen, so I felt a kinship with the unknown house-wife.

Eventually, we went on up the hill to the top of the road, which ended in two massive metal gates, where a big weather worn notice headed, "Mersey Docks and Harbour Board" was situated, with an official looking statement beneath. Bill started to read it, but I was

busy peering through the gate at the buildings within. Directly opposite me, on the seaward side, stood the light room itself. Below it were living quarters, obviously for the head keeper, and flanking it on both sides were two cottages, where the two assistant keepers lived. Outside one was a pram, and outside the other was a full washing line, flapping madly in the wind.

All the houses looked neat and well tended, gleaming windows and fresh paint on the doors. We climbed up the well-worn footpath at the side of the wall, which took us in a circle around the lighthouse, and tried not to stare into the windows as we walked past the huddle of buildings.

We started at the lamp room, containing the massive lamp and Bill said, "That can be seen up to 8 miles out to sea, no wonder at that size!"

"What with that glaring and the fog-horn wailing, I bet they don't get much sleep!" I said.

After we had circled the lighthouse, we climbed back down onto the rocky road. We had enjoyed the walk, but now we were hungry.

"I can't wait for a bacon butty," Bill grinned, and we set off back down the hill to the car.

A week later, we woke up to the sun streaming in, and I thought it was a very good idea when Bill suggested another walk to the Point. So off we set, parking in the little bay like we did before, and setting off up the hill in high spirits.

We'd got nearly half-way up, when we both saw a big sign on our left which said "Car Park £2.00."

"I didn't see that last week," Bill said, as we drew level with the sign and pointing arrow. It was at the edge of what had been a field, but there was no grass growing in it, it was covered with gravel, or slate chipping or something, to keep cars from getting bogged down. It was very level, and it looked as if it was well used, although very new.

We only glanced at it as we walked on, before something else caught our eyes. It was the big building that was the pilots' accommodation, fronted by a low wall all around it, with a level gravelled car park, which was empty. We stopped and stared, absolutely baffled. "Well!" Bill said, "I didn't notice that last week, did you? It must have been there; it hasn't been built in a week. We must be blind not to have seen it."

As there didn't seem to be anyone about, we walked over and peered through some of the windows, and saw what I have already described.

I heard footsteps behind us, and said to Bill, "Somebody's coming."

We both turned around and saw a man crossing the car park diagonally. I turned around away from the windows feeling a bit guilty for peeping and we both smiled at the man, and chorused, "Good Morning!" and Bill added "Lovely day."

He smiled back and nodded, but didn't speak, and walked on across the car park. He was quite a youngish man, and as far as I can remember; he wore a pair of dark trousers and a jacket. The jacket looked semi-official; it had a badge on the pocket, the picture of a large bird (I think it was done in gold thread), which had a long neck, long head, and half-open wings. He also wore what I thought was a peaked cap.

He cleared the car park and went through a purpose-built gap in the low wall, then on to a well-worn rocky path, that led down the hill to the cliffs, and vanished from our sight.

We left too, still feeling very puzzled that we hadn't seen the building the week before; it was big enough and obvious enough.

We carried on up the road. Half-way up I turned and looked back to where the man had walked down from the accommodation block. Then I caught hold of Bill's sleeve and said, "There's something else we didn't notice last time."

I pointed down with my finger. There sticking out of the cliff, and at the end of the path the man had taken, was a sturdy constructed wooden jetty, its furthest end in the sea.

Standing on it, and gazing sideways was the young man who had passed us, he was leaning on the rail and gazing along the waterline as if he expected to see something.

"I wonder if he's one of the keepers?" I asked. Bill shrugged; he didn't know any more than I did.

By now we were nearly level with the gardens. Bill turned back from looking at the jetty, and looked over the wall. Then he gasped.

"Hey look, there's something funny here," he said. I joined him and we both stared at the garden.

Gone were the neat rows of growing veg. Gone were the first shoots of runner beans and peas. No potato plants either; all I could see was a mass of long, tangled grass. The shed had gone, the water butt lay on its side, all green and mossy. The only things that were left were a few spindly fruit trees and bushes, mainly elderberry and damson; the others had all died off. We goggled at the garden in disbelief, and then looked around at the other two. They were all the same, no sheds, no crops, nothing but long grass. It looked as if the gardens hadn't been tended for years, and we moved from one to the other in disbelief.

As I stood in the wild grass outside the garden, I suddenly smelt a sharp crisp tang. I moved my foot and bent to look at what I had trodden on. It was mint, growing outside the wall. It looked healthy and mature, and obviously had been thriving there for years.

"Hey! Look at this Bill," I said, bending down and clearing grass away from the green leaves.

"Looks as if this was thrown out when someone was weeding, you know how it spreads and takes over."

"Must have been ages ago for it to spread like that outside the wall in that thick grass," Bill said. He ran his fingers through his hair in bewilderment.

"What on earth's going on. I'd swear I was dreaming if you weren't with me, we only looked last week, and now it looks as if these gardens haven't been touched for years, what's happened?"

"I feel as if I'm going mad," I said, "I wish there was someone about we could tell it to, or show them."

Bill looked up and down the road, there was no-one about. We turned to look at the jetty. Still standing on it, gazing out at the empty sea, stood the man who had passed us.

We watched him for at least three minutes, he never moved once, he stood as still as a carved statue, there was something eerie about his stillness. Then suddenly he blinked out. Not a slow vanishing, one second he was there, the next nothing. It was as if someone clicked a switch, he was gone. We both stood immobile, gazing at the empty jetty. Then the shock of it hit me, first the gardens, then the man, and was the jetty there yesterday?

My legs went weak, and I would have collapsed if Bill hadn't thrown his arm around me, and pushed me on.

"Come on, let's get to the car," he muttered, and we set off back down the hill.

We never said a word all the way home, we must have been in shock, and when we got to the caravan, we sat staring at each other speechlessly.

"Well, I don't know what on earth happened there," Bill said. "If I'd been on my own and come back and told you all that, you would have thought I was making it all up, wouldn't you?"

I nodded, busy with my thoughts.

"Do you think that man was part of it too, the man who passed us and then vanished on the jetty?"

Bill shook his head in bewilderment.

"I don't know, I've never believed in ghosts, but I saw him disappear with my own eyes, and we had never seen that building before, or the jetty, and as for the gardens," he lifted his shoulders. "Something was very wrong there today, perhaps we went through a time warp or something – whatever that is."

"People who live here will know what happened and when," I said. "Let's ask about it tomorrow."

Well, that's all we can tell you. We didn't go around asking people, they might have thought we were a bit dotty or something, but we remembered you and your books on Anglesey ghosts, and we thought if anybody knew anything it would be you, you've lived here for years haven't you?

'Twenty-three to be exact,' I said, 'and the jetty was here then, so was the pilots' accommodation. The assistant keepers have been gone for years. I don't know about the head keeper though, and I think the gardens were deserted when we came – I can't remember.'

'What about the young man? Had anyone been killed or drowned by the jetty, we wondered whether he was a ghost?'

'I haven't got a clue,' I said, 'can't help you there, but I'll certainly find out for you if I can.' And that is what I set about doing.

I was down in Amlwch Library, and I asked a lady called Mary if she knew whether Lynas Point jetty was haunted. She said her daughter had been for a walk there with two of her friends one very cold day last winter. She was taking their dog Sam for a walk, and with her two friends Sue and Amy, they had set off to walk to the point. As they got near the pilots' house, as they called it, very heavy rain started, an absolute downpour, so they made a run for the building and sheltered against the wall as the rain was being driven in from the sea. As they stood there, a sea fog drifted in, it was clear where they were, but it was very misty further up, and the fog-horn started to moan.

They were bored and wet, but didn't dare to start back home until the rain had eased off. Then suddenly, they saw someone coming up the road, and they all looked to see who was braving the rain, without hurrying for shelter.

It was a young man, striding briskly towards them; he turned in at the gate, and started to cross the car park. He was a tall, good-looking young man my daughter said, wearing a dark jacket and a peaked cap, and smiling as he walked towards them. The girls all smiled back, they were teenagers, and very impressionable. My daughter said he looked as if he should be there, he had an air of authority about him, and looked as if he was used to the place, and knew all about it.

They thought he was coming into the pilots' accommodation, but when he suddenly changed course and veered off to the left, going through a gap in the wall, leaving the graveled car park for the stony footpath that seemed to lead down to the jetty.

Amy, the youngest girl, staring at the man like the other girls were, said in a low voice, 'He doesn't look wet!'

They all stared at him. It was true, his peaked cap hadn't got a raindrop on it, and there was no sign of dampness on his clothes; his polished black shoes were quite dry. Amy took a tentative step forward, to look across at him, and he turned his head and gave her a warm smile. Amy smiled back. The girls realised she was smitten with him, and they all looked hard at him. As they did, he vanished.

They couldn't believe it at first, they all goggled at the place where he had been a moment before, but there was nothing there, just an empty wet landscape, and the moaning of the fog-horn.

Amy gave a little whimper of terror, and the group of girls who had been standing transfixed gazing at the place the man had been only moments ago, were galvanised into action. They surged forward across the car park, and raced down the road, they didn't stop running until they reached the bottom, panting and breathless, with Amy sobbing and hiccoughing as she ran. When they stopped at last, some doubled over out of breath, Amy flung her arms around my daughter's neck, clinging to her and crying with terror.

"Oh Sarah, he was a ghost, he was a ghost."

One of the other girls said, "Look at Sam, look at Sam," and pointed to our dog. He was huddled up by Sarah's feet, hair bristling on his neck, his tail was between his legs, and he was whining piteously.

Pilot boat jetty, going out to vessel.

Well, for the next few days I phoned, or met, most of the people who had seen the disappearing young man, they all seemed convinced that he had some affinity with the jetty, and they wondered if he was a pilot who had been killed or drowned there. So, my next task was to find out as much as I could about the Liverpool Pilots. I am very fortunate to have a friend, who is a retired pilot (1st Class), named Barry Hodson. He not only printed out a copy of his licence, presented to him by the Mersey Docks & Harbour Board, but also lent me his copy of the history of the Liverpool Pilots' service from 1734 to 1990. I found this invaluable.

I was also supplied with details of Lynas Point and the jetty from a serving pilot named Mr Geoffrey Price; he updated me on everything about the lighthouse.

So I owe the factual side of this story to those two intelligent and brave, but factual men, who dismiss their bravery as if theirs was an ordinary office job; in other words, don't talk about it.

First, the facts supplied by Mr Price:

Lynas Pilot was built in 1974, by local craftsmen, who put their not inconsiderable skills to work in its construction.

It is built of green heartwood, a wood that stands the test of sea-water for many years, and bolted together with steel. It came into use almost immediately, and then the Mersey Docks & Harbour Board realised waiting or returning pilots needed somewhere to stay, to either to sleep or to eat, while they waited for the next stage of their journey.

The accommodation building was designed by the wife of a pilot, Mrs Hockey, and the contract was awarded to Mc Alpines. They had as their sub-contractors, Jones Bros Builders, and work was commenced. The building was officially opened in December 1974 by the Director of Mersey Docks and Harbour Board, although it was already partly in use, his name was Mr George Brynyard. Although it lasted from 1974 until a couple of years ago, the jetty was abandoned, as the steel-work had become rusted and unsafe, and the wood had rotted. The pilots' quarters are still used now and again, by the men who are waiting for a vessel, or going back to Liverpool.

Fishermen used to fish from the pier, but people started to have barbeques on the jetty, and use it as a diving board, public access was stopped, and the jetty is now locked.

The assistant keepers' houses are empty and used for holiday lets, and the quarters of the head keeper has been bought privately by a gentleman who lives there with his wife. The gardens were abandoned years ago.

Well, thanks to Mr Price, you now know the factual bits (which I didn't) about Lynas, but we're still in the dark regarding the ghost.

The thing that mystifies me the most is the different people who have seen this man. The pilots and technical men dismiss it at once, no-one has seen it, but at least six local people, whose truthfulness goes without saying, are down in my book as witnesses, besides a few visitors.

I wondered if a pilot had drowned or been killed there, as Mrs Oram had suggested, so I turned to the book *List of Pilots: 1773 to 1990*, kindly lent to me by Mr Barry Hodson, to see if there was any record of any such disaster.

The list of pilots who died in service is very long. I couldn't find a specific incident regarding Lynas, but I jotted down the happenings in the vicinity. How far should I go back? I haven't a clue, for how long does a ghost haunt?

Anyway, here is a list of pilots who died in the vicinity:

The earliest record was 1783 – Pilot Sam Kenyon fell off rocks between Amlwch and Lynas and was drowned.

1789 – Pilot John Kennaugh washed overboard by Skerries, drowned.

1856 – Pilot Will Benson, drowned off Lynas Point when punt filled with water and broke adrift.

1866 – Pilot Thomas Lee drowned when his pilot boat was in collision with SS *China*.

1912 – Pilot Edward Evans died aboard *PB2* off Lynas Point.

1913 – Pilot Bryn Ellis fell into punt from Amlwch Pier and was killed.

1939 – Pilot Norman Wilcox died as Pilot of HM Submarine *Thetis* when she failed to surface during trials in Liverpool Bay. All crew lost.

1984 – Pilot James Fisher-Jones (pilot for Burma Oil Co. 1971–74) died in taxi accident on way to Lynas Point from Liverpool.

There are many, many more Liverpool Pilots who died while in service, all sorts of accidents aboard ships, too numerous to mention, and no indication where their deaths took place, so I have just chosen the ones in relation to Lynas Point vicinity.

No-one locally has heard of any deaths around Lynas Point Pier, nor could I find anything in the newspapers at the archives. It certainly would still be talked about in Amlwch.

So I am almost certain there wasn't a pilot killed there, but if so was it a pilot's badge on his jacket pocket?

This little story took a lot of researching, but while I was asking questions about it, lo and behold, I was told of two hauntings at the old lighthouse, of which I had no knowledge.

Listen to this: one day, a few years ago, a local man was taking his dog for a walk on the headland. He was taking the circular route around the buildings, which were all quiet and deserted. He was just passing one of the assistant keepers' houses, which was completely empty and had been for a few years, when he suddenly heard the sound of a baby crying with heartbroken sobs.

He looked through the window of the empty house, and he saw, to his horror, a toddler 'in a sort of cage', in front of an open, blazing fire. He stared at the crying child, who was hanging on to the bars of his cage, when suddenly, it all vanished, the fire, the cage, and the distressed baby. He found he was gazing into an empty room, everything had gone, even the fireplace was cleared and empty. To this day, he is a deeply puzzled man.

The second story is about a tall, well-dressed man. In good-quality clothes of a bygone era, he walks up the Lynas Point road, passes through the locked gates of the lighthouse buildings and, complete with elegant walking stick and a tall 'stove-pipe' top hat, disappears just before he reaches the main lighthouse building. He has been seen by numerous people,

but no-one can explain why he should appear or who he was. He sounds pretty official to me – probably one of the men from the Mersey Docks and Harbour Board (which is now the Mersey Docks Co.). If so, why is he walking? Surely he used a horse-drawn vehicle up that long road?

Our friend Arthur Lane told me that last week he and his wife Elaine were taking their two dogs for a walk and went to the locked-up jetty at Lynas.

One of their dogs, a lively border collie called Molly, was scampering about with her mate as they started along the jetty, but she soon stopped dead and stared ahead.

Then, with her tail down, and her neck hair bristling, she abruptly turned and fled back the way she had come. Along the concrete jetty and back up the stones she ran, and it wasn't until she had regained the road that she stopped.

They both called her to come back, but although she wagged her tail in an apologetic kind of way, she made no move to rejoin them and seemed very relieved when they came back. She jumped up to greet them, barking and wagging her tail. Arthur said that they hadn't seen anything odd, but 'there must be something weird about that place for Molly to behave like that'. Another mystery about Lynas, does anyone know any more?

A pilot boat travelling towards a small container ship.

CHAPTER 23

Waking the Dead

Irene had arrived with her two dogs in her little car, and I wouldn't hear of them being left outside, so she had brought them in, and while we talked they had looked all over the downstairs rooms. Now I could hear them padding about upstairs, and Irene had half-risen to her feet ready to call them down.

'I'm so sorry,' she said, 'I think they've gone upstairs.'

I made her sit down again. 'Leave them, they're not doing any harm, they're just exploring.'

'Are you sure you don't mind?' she asked.

'Of course not,' I said, and we both settled down again.

'Well now, where shall I begin?' Irene asked.

'The beginning is always a good place,' I said, taking a biscuit, and sipping my tea.

'Well,' Irene said slowly, 'I'll start with the first thing I saw.'

It was a cold afternoon in winter a few years ago. We'd only been here for about three years when Nick died. His death was very sudden and it left me feeling very lonely, but we'd always had dogs, and they are very good company. They took the edge off my loneliness.

They usually come with me when I go out, but I'd been for a lengthy session with the dentist that day, and it was too cold to leave them in the car.

Anyway, I got back OK and when I stopped the car and got out I listened for the excited barking – they know my car, and they kick up such a fuss when I get home, it's deafening. But there was no sound. It was so quiet I wondered if something had happened. Even when I stuck my key in the front door there wasn't a sound. When I opened it and went in, they were the first things I saw.

They were sitting on the stairs, about six stairs up, crouching back in the corner, and they were both trembling. When they saw me they both wagged their tails a bit, but when I called them, they made no effort to come to me; they just sat there whining and shivering.

So I went and picked them both up, they are only little dogs, and carried them into the sitting room.

They changed into their own personalities right away, tails wagging furiously, climbing all over me when I sat down, and licking any bit of me they found uncovered.

When I got up to put my shopping away, and make a cup of tea, they wouldn't leave the sitting room, but stood in the doorway looking down the hall, and up the stairs, tails down and whimpering softly. It was then I realised that they were scared, and I didn't know why.

They got better as the day went by, and I must admit I felt better myself. I hadn't really realised there had been a weird, heavy sort of atmosphere in the house all day and I had become nervous too.

Anyway, we had a normal evening, I let the dogs out before we went upstairs – they didn't take long, it was too cold – then we went to bed. They had no hesitation about going up to bed, they were perfectly happy climbing the stairs and going along the landing. They sleep in a big cosy dog basket at the side of my bed, and they climbed into it and settled down for the night as normal.

We all fell asleep peaceably. It must have been hours later, long after midnight, when I was rudely awakened by my two dogs, furiously burrowing down inside my bedclothes, trying to get as far down as they could, and scratching me painfully in the process.

I struggled up, tearing away blankets from my head, and I must admit using some colourful language.

As I sat up, yelling at the two frantic lumps that were wriggling away at the bottom of the bed, I noticed that while the bedroom was all very dark, there was a patch by the windows that caught my gaze. It was a queer, yellow glow, as if someone was playing a torch with a dim battery onto the bedroom carpet. As I stared, I saw that within the centre of the glow on the carpet was a pair of men's feet and part of the legs. I say part because the feet, ankles, and shins were quite normal; men's black shoes, polished well and neatly laced, a glimpse of grey socks, and neatly pressed blue trouser cuffs. Around where the shin joined the knee-joint, the whole thing ended. Not ended in the sense of being abruptly cut off, but they faded out.

They were so normal-looking that I had a feeling that a tall man was standing there, looking straight at me. I say that, because the shoes were a big size, as if they were on the feet of a tall man, and as the feet were pointing towards me I knew he was facing me.

I stared unbelievingly at first; then I was absolutely overcome with fright and I couldn't move. I was sure I could feel his eyes on me, then movement came back into my limbs, and I shot down the bed under the clothes and laid in a huddle with my two terrified dogs.

I don't know how long I lay there, clutching them for comfort. After a while I felt them relax; they became soft and pliable again – instead of stiff and wooden. Then I knew the apparition had gone.

I pushed myself up the bed and warily pulled down the sheet from my face, and looked around. All was still and normal, and the atmosphere in the room was lighter. It was only then that I realised the atmosphere changed before a visitation; it became heavy and leaden somehow.

A couple of weeks after that, I was cleaning out the porridge pan in the kitchen sink (I hate washing porridge pans) and I was muttering away to myself while I did it.

Out of the corner of my left eye I saw movement by the radiator at the other side of the kitchen. The radiator runs along that wall, and when the heat is on, which is nearly all the time in winter, I dry the hand-towel and the tea-towels on it.

Today there was a pink hand-towel in use, I had left it folded, drying out the damp on the radiator.

As I turned my head, I could see it was now off the radiator, and seemed to be in use. Someone or something was drying their hands on it, and I could see it waving about in the air. I stared hard, and saw a man's hands clearly busy with the towel.

Someone was drying their hands thoroughly, first the backs and wrists, then between the fingers themselves.

They were not the hands of someone with a manual job, they were smooth and soft-looking, and the nails were immaculately clean and manicured. There were hands, wrists, forearms and then … nothing. It was like the feet I'd seen before, although the hands and wrists were well defined, the forearms were only solid for about 6 inches, and then they became misty and blurred, gradually disappearing like smoke until there was nothing left.

I watched the twisting towel in utter disbelief, until a great feeling of terror engulfed me, and I threw the half-washed pan into the sink, and fled to the door, which thankfully was on the opposite wall to the radiator.

I made it on trembling legs to the door, and shot through it slamming it behind me, and then I sped down the hall and into the living room, where I fell on the sofa between the sleeping dogs. I waited fearfully, but nothing followed me, and the dogs didn't even wake up. I sat there until I'd got my breath back and the fear had melted away, longing for a cup of tea, but not daring to go back into the kitchen.

About an hour later, Jaf woke up, stretching, then jumped off the settee and made for the door, looking at me to open it for her. I did, and she padded down the hall to stand at the kitchen door, looking back at me again. I didn't think she would go in, after her display in the bedroom, but she crossed the kitchen quite normally, and went to lap at her water in the bowl. Timidly, I stood at the kitchen door and looked around. Nothing amiss, the pan still in the sink where I had left it and the pink hand-towel neatly folded and draped once more back on the radiator.

So I made my tea, and carried it back to the sitting room. Nothing more happened that night, nothing happened for the next few weeks actually, and I was just beginning to move normally from one room to another without sticking my head in for a look round first, when suddenly the ghost was back again.

I'd left the dogs in the dining room fast asleep, in their usual positions. Although Jaf was younger than Max, she took care of him in a very motherly way, and they lay together side by side, Jaf's foreleg stretched over Max's shoulder like an arm around him as they slept.

I carried my coffee into the drawing room, ready to watch television for the rest of the evening. Carefully, I put down my coffee cup on the low table, picked up the remote control and sank down on the settee, swinging my legs up, so that I was lying full-length, wriggling about until I was comfortable. It was then that I saw him. Not just bits this time, but the whole lot.

In the drawing room I've got a real coal fire and, grouped around it, I have a settee facing the fire, and two big winged chairs on either side. Someone was sitting in the left armchair – a man – looking perfectly solid and lifelike.

At first I thought he was a stranger who had just walked in, but there was something about him, something unearthly, although he looked earthy enough.

He was wearing a three-piece suit, complete with a neatly buttoned waistcoat. His trousers were immaculate, but dated by having turn-ups (the ones I had seen before) and he was looking at me fixedly.

I felt very frightened to begin with, but his look wasn't at all scary, in fact it was quite kindly, and he was looking straight at me, which meant he was aware of me – he was not

one of those ghosts that are still living in their own times, completely oblivious to the changes around them.

After a time, looking at him sitting at ease in the chair, looking completely at home, I lost my fear and decided to ask him who he was. I opened my mouth to speak, and in that instance he disappeared.

One minute he was sitting there as normal as I was, the next the chair was empty, not even an indentation in the cushion.

I sat there, I felt as if I was in shock, but to my amazement my greatest reaction was not fear, but disappointment. I was disappointed because my ghost had left me! I couldn't believe it at first, but when I thought about it in detail, I realised that he seemed to be a likeable person; he had a good face.

What I couldn't understand, whenever I thought about it during the following days, was the reaction of my dogs – why should they be afraid of such a friendly ghost?

The next time I saw him I was working in the kitchen, and when I turned around, he was leaning against the back door, his arms folded across his chest, gazing at me.

This time, the friendly look was absent; his eyes were cold and flat, and his lips a thin line. I opened my mouth to say hello, but as soon as I did, he vanished again.

This time, I didn't feel disappointed, I felt apprehension. A cold fear slid down my back. There had been something bad about him that time, I had a feeling the dogs hadn't been wrong.

The only thing I knew about him now, was that he vanished whenever I was about to speak to him. Were all ghosts the same? I read somewhere that ghosts can only speak if they are spoken to first, but how could this one possibly speak if I couldn't say a word?

I knew nothing at all about him, his name, if he had lived here, nothing. But I was determined to find out if I could.

I didn't know many people, but since Nick had died, I'd joined a club called the 'Ladies over Fifty'. We met once a week, had visitors to give talks, and we went on excursions to places of interest. It wasn't very exciting, but I got out and met people, and they were a nice crowd. I'd made some good friends there. One was a lady called Betty, and we'd got quite close. So the next day when she popped in to see if I wanted anything from the shops, I told her the whole story.

She listened very closely, nodding every now and again, and she looked quite excited. She gave a huge sigh when I'd finished, and leant back in her chair.

"So," she said, "it must be true then."

"What must be true?" I asked in bewilderment.

"The story that was going round, I thought it was just gossip. Listen, and I'll tell you, but first, how long have you lived here?"

I thought back, "About seven years I think."

"And this is the only time you have seen him?"

I nodded, "But who is he? Did he live here? Did you know him?"

"Don't be so impatient, you can ask your questions when I've finished what I know," Betty said, waving her hands about. "Now then," she marshaled her thoughts. "I've lived here for about twenty years, and when I first came, there was an old lady living here called Mrs Boulder. She was a widow, and she had a daughter called Wendy who was a nurse at

the hospital here. Wendy was married to a doctor at the hospital; nobody liked him much as a man, but he was a good doctor.

Well, they rented a house here, but Wendy wanted to come and live with her mother, she didn't like her being alone, and she had a weak heart. The old girl owned the house, Wendy would inherit it when her mother died so it seemed like a good idea. Her mother and Peter, her husband, disliked each other very much, but why should they pay rent when they could live for nothing?

So they moved in, and shortly after that old Mrs Boulder became bed-bound and Wendy had to look after her. Then Wendy herself became ill and two months later she was dead. The old lady and her son-in-law were left living together; they couldn't do anything else. As far as Peter was concerned, he was living there for nothing just when he needed to. He missed Wendy's wages, small as they were, and as for old Mrs Boulder, she couldn't have lived alone anyway, so Peter was better than nothing.

He had started seeing another nurse in the hospital, and he grudged the time he had to spend staying in the house looking after the old girl, who was getting weaker by the day. He only stayed because he knew the house would be his when his mother-in-law passed away, and then he could sell it and he'd have a few bob.

Anyway, old Mrs Boulder didn't survive her daughter by many months; the cleaning lady came in one day and found her dead in bed. Peter was at work in the hospital, so she had died alone – poor thing. They said it was death by natural causes, but something very strange had happened on the day of her funeral.

In her will, the old lady said she wanted a wake. All her friends were to go into her bedroom where she lay dead, with the coffin lid open, so that anyone could kiss her for the last time if they wanted to.

Well, one of her friends was called Mary, and she was psychic. She didn't spread it about, but her closest friends knew.

Anyhow, Mary went into Mrs Boulder's bedroom to give her a kiss, and when she came out she had an odd expression on her face as she went downstairs. Apparently, she went into the kitchen to get a glass of water, and her hands were shaking so much, the water splashed all over her dress.

She didn't say anything to anyone; she just sat quietly, and was white and trembling. She avoided Peter as much as she could, and she walked straight home from the graveside.

That evening, she went to her friend's house, and said if she didn't tell someone what had happened in Mrs Boulder's bedroom, she would go mad.

Apparently, she had just stepped inside the room and had closed the door, when she looked at the coffin lying on the bed, and she became transfixed. The whole scene at the bed-side changed like a film, and this is what she saw.

The coffin with the old lady in seemed to vanish, and she was looking at her lying asleep on her back. Apparently, Mrs Boulder had problems not being able to sleep, and her doctor had prescribed sleeping pills for her. She looked as if she'd taken one, because she was flat out. Standing next to her was Peter, and he had a pillow in his hands. He moved up the side of the bed until he was near Mrs Boulder's head then he put the pillow right across her face, and held it there firmly with both his hands pressing it down.

She didn't even struggle, she just lay there, and he stood still for ages, leaning forward with all his weight on his spread out hands.

After a long time, he stood up straight, and removed the pillow. She hadn't moved. He felt her pulse, gave a little nod, and put her arm back under the sheets.

He was just putting the pillow back and straightening the bed when the whole scene melted and he disappeared. There was the empty bed, and the coffin rested on it, containing the body of Mrs Boulder. Mary didn't kiss her; she left quickly, and was thoroughly shaken.

After the funeral, Peter sold the house and moved away, to live with the nurse he was having the affair with.

As I said, all this happened years ago, and there wasn't even any gossip about the death of Mrs Boulder. Mary couldn't say anything; she thought people would say she was mad, and how could she say it was murder when it was only a vision she saw, and she didn't have a shred of evidence?

'The people who bought the house never saw a thing, and then they left, you bought it, and this happened,' I stated. We both sat silently, gazing at the fire, deep in thought.

'Do you think this ghost is Peter then?' I asked her.

She shrugged. 'I don't know. I don't even know if Peter is dead. He might be; all this happened ages ago.'

'If it was him, and he did murder his mother-in-law, why has the haunting started now, after all this time?' I asked.

'Maybe he's only just died; maybe it wasn't him,' she said.

'And what is the meaning of it?'

'I don't know,' she said in bewilderment, 'but I think it's starting again; the way the dogs are behaving.'

'Have you seen him again?' I asked urgently.

No I haven't seen him, but last week Jaf was in the kitchen finishing her evening meal, and Max and I were in here. All of a sudden Jaf came flying in and jumped up straight onto my knee. All her neck hair was standing up stiff and she was trembling. I'm sure she saw something in the kitchen because she never went in again that night, and only yesterday Max woke up early in the morning, he gazed into the comer where the wardrobe is and started to growl deep in his throat. Then he jumped up and dived into the bed with me and he wouldn't come out for ages. No, I haven't seen anything, but I can feel the atmosphere changing.

'Well, what are you going to do now? Sell up, and tell the buyer about the place being haunted – it would only be fair to tell them – or stay here and be haunted yourself?' She looked at me expectantly, waiting for my reply. I sat there thinking. Could I go through the upheaval of moving, that's to say if anyone would buy it after being told it was haunted, or stay here on my own through the dark days of winter? I shivered. 'I haven't got a clue,' I said.

CHAPTER 24

Dead on Time

'I can believe it.' Claire said, 'The marsh at Pentre Berw is such a misty, eerie place, I wouldn't like to be out there on a dark winter's evening.'

I agreed with her, seeing in my mind the flat, sour swamp and hearing the peculiar whistling moan the wind made, blowing across the rushes.

I've mentioned it before ('The Haunted Marsh') and I know how many ghosts it harbours. More than anywhere else on the Island I should say; an ancient piece of land reclaimed from the sea.

I say I know how many ghosts there are, but there must be many stories I haven't heard, and many that remain untold, because the people who knew them are dying out. This particular tale was told to me by Mr John Hughes.

I shall never learn what seems to be a simple straightforward ghost story is never what it appears. It usually leads to many interviews with strangers who have to be tracked down, and who in their turn introduce me to others, advise me on visits to the County archives and our local Amlwch library, and tell me to read and re-read old newspapers. But in the end, it builds up a picture of old Anglesey and puts a few pieces of the Island's folklore into print for posterity.

I have recorded things exactly as they were given to me, how much is factual and how much has been added by the tellers of the stories (the icing on the cake as it were) is not for me to judge. I am only the recorder. Anyhow – to begin. For those who don't know Anglesey, I must explain that once the village of Pentre Berw stood at the edge of the sea. It was very well known to the Viking long ships, Phoenician traders, Romans galleys, and many more foreign sailing craft.

Pentre Berw stood at the mouth of the River Alaw, a river which flowed fast and deep. Eventually, the silt of the river and sand from the sea made the waters of the Irish Sea retreat from the port, and Pentre Berw became just another island village, standing on marshy, boggy land, with the River Alaw flowing at its side.

During the 1800s, the river was 'boxed in' so that its flood plain was drained, and what had once been the sea, was now only a soggy marsh, even unfit for grazing.

It was in the mid-1880s when the tourist trade began, and Anglesey saw what the railway had done for Llandudno and other coastal resorts, and decided to join in with a railway system of its own.

Pentre Berw, known officially as Holland Park opened up in 1865 as part of the central Anglesey line.

Branch lines sprouted up all over Anglesey, and there was a great demand for workers. Some of these were Anglesey men, but the majority came from Ireland, with a few Welshmen from the mainland.

So many people came to the Island, bringing their families. A village of over ninety houses was built, along with a shop and a school.

The more mature men settled down with their families and found jobs. With their wages they paid their rent, their bills, and put food on the table.

During this time, the theft of materials and machinery was tremendous. The firm of contractors had to employ two policemen, but the extent of the line workings was so considerable that a security firm had to be employed.

The stealing of materials had now become big business, so lucrative in fact that professional gangs became involved, and when the thieving was at its height, one of the security men (I think his name was Rowlands) was murdered, and the killer never discovered. He was only in his thirties, and was killed sometime in the 1840s.

The Welsh and Irish hated each other and would never work together. When under the influence of alcohol, the Irishmen would start fights at the slightest provocation. Sometimes the situation would get so tense that the Irishmen had to give up and return to Ireland by the ferry from Holyhead in full flight.

Some lived in the out-buildings of local farms. They paid the farmer a few pence per week for letting them have a roof over their heads. Others built rough sheds or shelters from wood.

Goodness knows what these men did for washing and shaving – personal hygiene did not come high on their list of priorities as much drinking and fighting did.

Mr Tomos Williams, of Porth Amlwch, told me a very interesting story, passed down in his family since around the mid-nineteenth century.

The story began with one of Mr Williams's ancestors, a butcher's boy in a local shop in Pentre Berw.

It was his job to go every morning with his friend, the baker's boy, along the newly laid railway track to where the 'navvies' were working. Huw, the butcher's boy, had a big basket of meat, mainly slices of raw beef, but also sausages, bacon and various cuts of pork, all ready prepared.

His mate from the bakers also had a big basket, full of freshly baked loaves, and together the lads would walk along among the men who lined the track. Many of them had blazing fires (mostly made from sleepers) at the side of the track. Every man would buy meat and a fresh loaf, and as the boys made their return journey with empty baskets, it would be dinner time and, the men would finish work, and begin to cook their dinner.

I say 'cook', but that was rather a grand description of what they were actually doing. To begin with, they scraped the mud, soil or rock fragments roughly off the blade of the shovel with a sharp stone, and stuck the shovel to heat on the fire. When the blade was hot, they then threw the meat on. It was not so much cooked as scorched. When it was brown on one side, it was turned over either with a handy bit of wood, or the clasp knife that the 'navvies' always carried.

When both sides were equally scorched, the shovel would be removed from the fire, and shovel and owner would retire to the side of the track. All this would be done in a few minutes, and the hungry workers would cut chunks of meat off with their knives. Inside the

meat would be red and raw, but the bread would then be torn into chunks, dipped into the pooled blood of the meat, and all would be wolfed down by the ravenous workers.

Drinks would be a bottle of cold tea if they were lucky enough to have someone make it for them, but usually it would be a bottle or two of beer.

The lifetime of a 'navvy' (navigational engineer) was usually quite short. The rough diet, squalid living conditions, and wet clothing, were not conducive to a great old age.

Many fatal accidents happened too. During the construction of Britannia Bridge alone, there were eighteen deaths recorded. If any of the navies were killed and no-one knew anything about them – address, relatives etc. They were given a Christian funeral in the nearest church, and then buried in a pauper's grave.

In the mid-1800s, a woman, who was the wife of a railway labourer was allowed to take her baby on a locomotive to Holyhead. She was very excited, but when the engine's boiler system developed a fault, scalding steam escaped, killing both the woman and her baby.

Ill luck seems to have always dogged the Pentre Berw section of the line. I was told that a whole train had been swallowed up (I can't find out the year, but I think it was in the late 1800s), at a spot on the marsh where the River Alaw flows along side by side with the railway for a short distance before coming to a a stone bridge. Sometime during the winter there was much rainfall, and the River Alaw was very swollen and flooded.

So much so the strong stone bridge had been washed away in the darkness of the night. Early next morning, when it was still dark, the first train of the day came puffing along as usual, and the engine and the carriage fell into the raging torrent.

Only one passenger was trapped and drowned, but the three-man crew died an awful death, when the boiler exploded and showered them with boiling steam.

When deaths occurred at the beginning of the construction of the railway, they were regarded with horror and reported nationally, but as time went on and the accidents became more commonplace, they were only recorded locally, especially when the victim was an unknown Irishman, whose address and relatives could not be traced.

We will never know how many killings took place by a violent blow on the head with a heavy rock, shovel, or whatever else came to hand. The body would be buried in an embankment, or a filled hollow where a smooth, weight-bearing track was required. The bosses could always be told that he had left the job, especially if he was an Irishman whose roots were unknown.

Even when the railway line was being used, and a timetable established, the line was not fenced off, and many animals were killed straying onto it, particularly at night when the train-driver couldn't see ahead.

One accident, which was reported as an obstacle on the line, occurred in 1920s, when a driver arriving at night at Amlwch station said he thought he had hit a large animal, like a cow. When the track was searched, the remnants of the bodies of a young man and a woman were found, part on the track, and part still adhering to the undercarriage of the train.

They were identified as a local courting couple, both in their twenties. So the railway was no stranger to death, particularly at night, in the dark.

How many unidentified navvies had tripped over the rails in the dark, and stayed in a drunken stupor, on their way back from the pub? Or another angle, what a way to get rid of someone you had just had a drink-fueled fight with, when you knew what time the next train was due? That is all pure speculation of course, but this next bit isn't.

I had begun this story with a phone conversation I was having with Mrs Claire Meade. I'd had a new boiler installed by Mr Malcolm Parry and his very efficient, friendly workmen. I happened to ask Mr O' Rorke if he had any ghost stories about Anglesey. A friend of his, named John, had in December gone for a day of shooting on the marshes at Pentre Berw. It was a dull day with leaden skies, and as the day began to give way to night, a cold steady rain began. John, and his mate Bryn, decided to shelter under the viaduct ahead. It was easy to reach as they were already on the overgrown track where the railway used to run.

Sheltering under the bridge (where I think the new A5 road crosses the track), they gazed down the bramble- and weed-covered old line. John had brought his dog, a highly trained and thoroughly reliable gun-dog, which was standing at his side, between John and Bryn. Suddenly, the dog growled deep in his throat, and John who had been fiddling with his gun, looked down in surprise.

The dog's upper lip was drawn backwards in a snarl, exposing his teeth, and looking very fierce. Not only that, but the hair of his neck was raised, stiff and bristly, and his snarl now had overtones of a whimper as he glared at something before him.

John couldn't see a thing, and just as he started to make reassuring noises, and stroke the dog, it relaxed and stopped snarling. At the same time, his mate Bryn let out a long shuddering breath, and said, 'What in God's name was that?'

John, now completely bewildered, asked 'What was what?'

Bryn turned to him in disbelief and said, 'Didn't you see him? He was standing right in front of you.'

'Didn't see a thing,' John replied, 'where did he go, and what did he look like?'

'He had no legs,' Bryn muttered faintly. Obviously shaken, he sank down on the dry grass in the tunnel, joined by an equally shaken Ben. Apparently, as they stood there gazing pensively down the rain-sodden track, a figure had formed right in front of them, perhaps a yard away.

Bryn described the figure in great detail. It was a working class man, dressed in old fashioned work clothes, an old cap and jacket, and a flannel collarless shirt. He wore braces, and a thick leather belt with a large brass buckle. His moleskin trousers were old too, but these 'faded out' at the thighs because, although the man in all other respects was young, tall and brawny, he didn't have any legs.

His cap was on the back of his head, his hair was black and curly, and he looked Irish. He stood straight in front of John, gazing into his eyes with a pleading expression, but John, who wasn't even aware of him, went on fiddling with his gun. The apparition stayed for a while, but then faded away. The dog stopped growling and became normal again.

They never went there shooting again, I don't even know if anyone else has ever seen it, and it does leave some questions behind. If it was the ghost of the young man who was killed on the line with his girlfriend, why was he in his working clothes, and why didn't the girl appear too? Or was he someone who had been murdered while working there and no-one knew about him? Had he not materialised fully (as ghosts often do) or had his legs been amputated by a train? If so, why don't people know about it? I just don't know.

CHAPTER 25

Does He Ever Get Home?

In the same batch of letters I received last week, were two that held my interest at once. The first one was the lovely story of 'Ella'. These stories are few and far between; usually they are of unhappy events, which are mostly incomplete, so that they nearly always leave a question hanging in the air.

The second one, from a lady in Grantham, has not yet got a title, because it consists of wisps and passing incidents, which seem to float by Mollie and disappear back into the world they inhabit.

Mollie, now living in Grantham, used to live on Anglesey – in Amlwch actually. She is going to sell her house in Grantham and move back here to live with her daughter Gail, who lives and works here for Dulas Estate. They seem to be a psychic family in a casual sort of way, I haven't met Gail yet, but Mollie talks about her visitors as if it is commonplace to everyone to see them. They are hardly likely to emit surprises to anyone, rather like a comment about the weather. Mollie used to live on the same road in Amlwch as the big school and, once, about ten years ago, she was busy sweeping away autumn leaves from the pavement outside her cottage. She was busy brushing the leaves off the pavement when she looked up and saw someone walking up the hill towards her. As he drew near, she could see him in detail – she described him as a 'tall, good-looking young man with dark hair'.

He was wearing a leather jacket, and carrying a motor-cycle helmet, as he walked up the hill. It seemed as if he was going in the direction of one of the large houses nearby.

When he nearly drew level with me, I said "Hello!" to him in a cheerful way; I was probably going to say something about the leaves, or the weather. He lifted his head up and gazed at me. Our eyes met and I'd just opened my mouth to go on talking to him, when he vanished before my very eyes; I couldn't believe it.

I stood there for a moment I was so shocked. I couldn't move, and just then a friend of mine came down the road. He was a good friend who lived in a bungalow further up the hill; he would sometimes have a coffee with me on the bench in front of my house. His name was Bill Waite.

He asked me if I was alright – he said afterwards that I looked very shocked. We went to sit on my bench and he made coffee. I told him what had happened, and he didn't seem a bit surprised. He said he'd heard many stories about the young man; quite a lot of people had seen him.

The story was that the young man lived in one of the large houses with his mother and Father. He had a very big powerful motor bike on which he would drive to work.

One evening he was coming home from work, and was nearing his house when a man driving a van pulled out in front of him. The young man hit the van full on and he was killed instantly.

His death broke his parents' hearts and, very shortly after, they sold the house and left the district.

Bill said he had known him quite well, and it was a great shame that he had been killed – he was such a nice young man. He had heard that since the accident the young man had been seen 'going home' by lots of people, and he had always vanished as they drew near.

I asked quite a few locals who accept the haunting with a vast amount of belief, and they all said the young man is still seen quite often. One old lady asked me if I knew about 'Jinny Tin-tack' and 'Mrs Jones Cigarette', who used to be shopkeepers in town, but before we could get into a deeper conversation, or even exchange telephone numbers, her daughter arrived and whisked her away in a car.

Leaving me with a great sense of curiosity, which I suppose will always be with me – unless of course anybody else knows about 'Jinny Tin-tack' and 'Mrs Jones Cigarette' and would be kind enough to tell me the story? Please?

CHAPTER 26

Last of the Line

'Oh no,' Betty groaned, 'not another power cut!' The lights had all gone out, leaving us to adapt to the flickering light of the fire.

'No wonder,' Pete said, 'with a wind like this, must be a force eight.' He got up, went to the window, and pushed the heavy curtains aside. 'Yes, I thought so; Coed Mawr is all in darkness too.'

Coed Mawr was the farm about a mile away, across the valley from us, and the only other human habitation we could see from our isolated house.

'Probably the lines are down, I wonder where though, and how long they'll be before they get the power back on.' Peter threw some more logs on the fire, and they started to crackle and hiss fussily.

'That means no electric blankets tonight, thank God for the Rayburn, at least we will be able to cook and have the central heating on,' I said.

'I feel sorry for the poor devils that rely on electricity for everything,' Bob said. We sat there snug and warm, smelling the chicken roasting in the oven. I must admit, I felt a bit smug.

At that moment, there came a sharp, insistent knock at the door. A moment's silence, and then it was repeated – three knocks, all very audible.

We all looked at each other. 'Who the heck?' Bob said, and at the same time, Pete muttered 'Who can that be, out in this wind?'

Bob moved towards the front door, with Pete behind him. As Bob opened the door the wind rushed in, whipping the letters for posting off the hall table and setting the pink overhead light swinging madly. Betty and I stayed where we were, listening intently.

After a moment, I said to Betty, 'Can you hear what they're saying?'

She shook her head, 'Can't hear a thing.' She got out of her chair and made for the door, me behind her.

The wind met us as we walked into the hall, but we hardly noticed it; our attention was riveted on the scene before us.

Everything was dark, not a light to be seen anywhere, but in front of the house, objects seemed to be lit by a faint glow.

I heard a gasp from Betty, just as I too figured out what it was. Unbelievably, on our drive in front of the main door where we were standing stood a vintage Victorian coach, bathed in a dim glow.

We all stared speechlessly. The coach itself was all black, with silver fittings. The sides and back were glass, and we could see through it clearly in the eerie glow that surrounded everything. Standing as still as statues in the shafts at the front, stood a pair of magnificent black horses, with plumes of black feathers on their heads.

Sitting behind them, high in the driver's seat was the coach-man, also dressed in black, complete with tall hat. We all stood and stared. In the back of the coach, unadorned with any flowers, a polished wooden coffin was placed.

At that moment, without turning his head towards us, the driver flicked the reins once, and the matched pair of black horses walked slowly forward. The coach moved slowly and silently around the side of the house.

The drive extends right around the house, coming out at the other side, which makes it very handy for anyone driving a vehicle – they don't have to worry about reversing to go back down the drive. It was built like that when the place was a working farm. Wagons loaded with animal feed, bales of bedding straw etc. They used to drive around the house, and into the farm yard at the back and to load and unload, and then continue on their way round the other side of the house, back onto the main drive again – all very simple.

So the four of us stood there, waiting for the coach to re-appear at the other side; we were hardly able to stand as each gust of wind hit us. We waited, and waited, but no coach appeared.

'He must have stopped,' Pete said in a puzzled voice, we were all shaken by what we'd seen, and stood in silence, looking at the corner.

'I'll go and see what's happening,' Pete mumbled, 'this has got to be some sort of joke.' He hunched his shoulders against the wind, and marched off after the coach, closely followed by Bob.

After a couple of minutes, they re-appeared at the other corner. 'Nothing,' Bob shrugged at our enquiring faces. 'There's absolutely nothing there, we've been all round the place, looked in the stables and everywhere, but it's just gone.'

'Gone where?' Betty looked as puzzled as I felt.

'I don't know, do I?' Bob said in an exasperated voice, 'If we hadn't all seen it, I would've thought my eyes were playing tricks or I was going mad or something. I suppose we did all see it, didn't we?' He looked around at us all in bewilderment, and gazing at the drive in front of the house, I pointed at the gravel and said, 'Of course we all saw it, it was standing right there, as clear as anything, those two black horses and the driver and the glass coach, it looked like –'

'A hearse,' Betty said in a low voice, 'it was a hearse.' For the first time I felt a trickle of fear run down my spine, 'and it had a coffin inside.'

We stood there for a moment in the darkness and blustering wind, staring up and down the drive and at the corner of the house where we'd been expecting the coach to re-appear, a small group of puzzled people. 'I'm going back in,' Bob said, 'out of this hellish wind.' He started back up the front steps, we all followed.

Just as we all entered, and Bob was locking the door, the lights came on. 'Thank goodness for that,' Pete said, 'the place looks more normal now.' We all settled down again in front of the fire, but we certainly didn't relax. The whole topic of conversation was the coach, or hearse, where it had come from and gone to, who had knocked at the door, and what was the nature of that ghostly glow that had surrounded the whole thing – even the horses.

We must have talked about it for a couple of hours, every detail was discussed, but we had no explanation – only questions and theories about what it could be. Betty and I were convinced it was of ghostly origin, and the men who usually scoffed at such things reluctantly agreed in the end.

Finally, we lapsed into an uneasy silence. Betty said in a firm voice, 'That was a sign you know; you all saw the coffin in the back.' She looked around us all and said theatrically, 'Someone's going to die.'

Bob said something like 'Harrumph,' in a disgusted voice, then got to his feet. 'Well, I don't know about you lot, but I could do with a good hot toddy, with honey and lemon and a stiff scotch, who's with me?' We all put our hands up without hesitation, and he gave a nod and a grin and made for the kitchen. Soon after, we went up to bed, but our sleep was patchy and uneasy.

The next morning Betty and Bob packed to go home after a week's holiday with us, which seemed to fly by. Our odd-job man, Ivor, came to work for the day, he was surly, but he was a good worker, so we overlooked his annoying manner – good workers were hard to get.

I helped Betty to pack, Ivor carried the cases downstairs, and we waved them off from the front. When they'd gone, Pete and Ivor began to repair the tractor and I sauntered down our long drive (more of a lane really) to collect the post from the box at the front gate.

Glyn, the postman was just pulling up in his bright-red van. He handed me the post through his driving window and looked up at Pete and Ivor, who had just come into view, riding on the tractor mower. He frowned when he saw Ivor.

'Didn't know you had him working here,' he said.

'Oh, he's been here a couple of weeks now. Pete said he's a good worker.'

'And he knows it. He knows everything that one does.'

'Well, I don't know much about him. I don't even know where he lives,' I said, gazing back up the drive.

'Anyone will tell you about Ivor,' Glyn said, 'he makes up a different tale about himself every week. He lives in that little caravan site behind the Bedol.'

I grinned at him. 'I gather you don't like him much?'

He grinned back, 'Well, let's just say I don't think his mum and dad were married!' He pulled a face at me and roared off.

I told Pete about it while we were having tea, and Pete said, 'I haven't met anyone yet who likes him, he is a bit overbearing, but while he works as well as he does, I can put up with that.'

'What does he do for the rest of the week Pete? Ater all he only works two days here – he said he is too busy to do more than two.'

'Oh, he does all sorts of things: gardening, repairing tractors and washing machines, cutting grass. He's a good all-rounder, but big-headed with it,' Pete answered.

Betty phoned up that night to thank us for the holiday, speculate about the coach and ask us if we had found out anything about it. 'No,' I said, 'but I'll ask Mary at the Co-op on Wednesday. She knows everybody in this place.'

I went down to the Co-op on Wednesday, and I got there just before lunch, knowing it was a quiet time. Mary was re-arranging the shelves. Grey hair neatly styled, her uniform was crisp and white. I told her all about the coach, the black horses, the driver, and the coffin in the back. I could tell she believed me, she was an islander through and through, and I knew

things happened on the Island that would be scoffed at on the mainland. She never took her eyes off my face, but when I had finished a tiny frown had appeared on her brow.

'Well,' I asked slightly defensively, 'do you believe me, and if so, can you explain it?'

Mary moved back behind the counter and sat on her stool.

'Oh, yes, I believe you, but there's one thing that doesn't make sense.' She leaned forward with her arms on the counter.

That coach has been sighted for nearly 200 years. We call it the Parry death coach. Apparently it first appeared when the only son of the Parry family was killed in the army, fighting abroad. I can't remember which war, but it was about 200 years ago. It appeared at his home a couple of days before he was shot. His mother saw it first and she fainted – she said it was a sign to say her son was going to be killed, and sure enough he was.

After that, whenever one of the male Parrys was going to die, the coach would appear at Tyddyn-y-Gwynt, which was the family home then. I know you live there now and many people have seen it at the front door.

'That's it,' I said excitedly, 'that's where it was!'

'But there's one thing I don't understand,' Mary said thoughtfully, 'the Parry family has more or less died out – the male line anyhow. The last time that coach was seen was over thirty years ago. The last male Parry died of a heart attack, quite young he was too. I remember him as a good looking man with an eye for the ladies. His widow left the house and went to live with her married daughter at Valley, and the Williams bought Tyddyn-y-Gwynt.' She smiled at me. 'I believe you saw it, but it must have been a mistake.' A customer came in then, and Mary moved away, leaving me to ponder the puzzle.

Pete and I discussed it that evening, and I told Betty on the phone, but none of us had any answer to the mystery.

The next day as I wandered down the drive in the afternoon, I saw the air ambulance, a red helicopter, just lifting up from the lawn of Coed Mawr. When it gained height, it flew off in the direction of Bangor Hospital.

'Someone must be very ill at Coed Mawr,' I reported to Pete when I got back, 'the air ambulance has just taken somebody to hospital.'

'Poor devil, whoever they are,' Pete replied, 'they must be pretty bad to be taken that way – it must be urgent.'

The following day Glyn the postman came up to the house with a parcel that had to be signed for.

As Pete was signing, I said 'What was the helicopter doing at Coed Mawr yesterday? Somebody must have been pretty ill.'

'Not ill, crushed. The poor devil, you know him, he worked for you – Ivor it was.' We looked at him aghast.

'Ivor? What happened?'

Well, he was working under a tractor that was up on blocks, but it slipped off them and crushed him. They flew him to A&E at Bangor, but he died.

Poor old Ivor, nobody liked him much, he never knew who he really was, and that's why he made up all those tales about going to boarding school and having a very rich father. All

in his head that was; he didn't even know who his father was. He was a married man who had an affair with a kitchen maid, and Ivor was the result.

Not many people knew, his mother's family were ashamed, and sent their daughter away to a relative in another village. The people who did know kept quiet about it, because both the man and his wife were well-liked, and she hadn't got a clue that her husband had been unfaithful to her. So the secret was kept. When Ivor came back to the village to work, his dad had died so they never met.

Anyway, he didn't have much of a start in life, but he was making a good name for himself as a reliable hard worker – even though people didn't like him much.

We all stood lost in thought then I said, 'When you said his mum and dad weren't married, I thought you were kidding.'

'Well,' said Glyn, turning away, 'it was true enough, but I wish I'd been a bit nicer to the poor devil – too late now.'

He opened his van door then looked up at the house. 'Ivor never knew it, but this should have been his family home. It had been in his family for many generations – centuries I should say.'

'Glyn, what was his dad's name?' I asked.

'Parry,' said Glyn, and drove away.

CHAPTER 27

Ella

This lovely little story, hand-written, was dropped into my post box one grey day in March; the sort of day when you think spring will never arrive.

It hardly needed editing, so here it is, written by Mrs Margaret Heath of Llaneilian.

We bought Ella for our (then) young grandchildren. She was a part-bred Welsh pony. At the time we had 1½ acres and a few hens. Ella not only cut the grass for us, but was wonderful with people, and was trustworthy with the little ones. Sadly, though, they gradually outgrew her.

We retired in 2005, and came to Anglesey, bringing Ella with us. She was now in her element with 7 acres of land to explore, and grass and herbs to discover.

We bought another little Welsh pony, called Bomber, and together they would run around, galloping up the hill-side meadow together. Bomber and Ella were the perfect match. He was always by her side, and he looked after her in his own way. He would get annoyed if she was taken out without him. I was involved with Riding for the Disabled (RDA) and luckily there was a branch just down the road from where I live, so I took Ella there to see how she would make out.

She passed all the tests with flying colours. She was a handy size for the little ones and the girls from RDA would come for her and ride her regularly. She was perfect and the children did what they wanted, more or less. They touched Ella all over, they knelt down by her, reached under her, touched her legs and fed her.

Bomber and Ella lived outside. They had their thick winter coats as Welsh ponies do. They used a loose box when they wanted to, but only really came into it to eat hay in winter. Perhaps I should explain that a loose box is a stable that always has the door fastened open, so the horses and ponies can use it when they wish.

One morning I found Ella lying down in the field in the rain and, from across the field, I knew she should not be down in the rain. Bomber was standing nearby. I shouted them to come in, usually they would come straight away, but Ella did not get up, and Bomber would not come without her.

There was nothing obviously wrong, as in cuts by injury or laminitis, which Ella had suffered from previously, so I phoned the vet. This was 9 a.m., and he said he would be there as soon as possible. He was there by 9.45 a.m. He said he thought it was colic, but he would give her a thorough examination first, which he did. He tested her heart, temperature, or any obvious lumps and bumps. Everything was OK. Next he gave her a drench, which is

a tube of solution down the throat and into the stomach, to flush out anything that was obstructing the system.

To me, colic in horses had always meant a twisted gut, and usually a lot of walking them around until a possible natural correction of the gut happened. I did this every half-hour as instructed by the vet.

By evening, she was just the same. She did not eat or drink and had no bowel movement, but by midnight she was standing OK.

I walked her round, and then went in just after twelve. I came out again to walk her round at 2 a.m., but still there wasn't any change. Again at 4 a.m., still the same.

The last time I walked her around for half an hour till 4.30 a.m. She did not want to go back into the stable, but followed me, so I left the stable door open so she could go in and out as she wanted.

At 5 a.m. I went inside, made my third cup of tea and went up into the bedroom. I did not get undressed, but sat on the side of the bed until I had drunk my tea.

I faced the window and was just staring out, but I couldn't see anything as it was dark. I was constantly thinking about what I could do next to help Ella, and I finally made up my mind to go out around 7 a.m.

I sat there feeling very sad, remembering all the happy times we had with our beloved Ella, knowing I was going to lose her, and feeling so helpless because there was nothing I could do. The room was black because it was still dark outside. As I sat looking out, I suddenly realised the bedroom wall on the left side of the window had become brighter. I looked at it, and knew it wasn't a reflection of car headlights or anything, because there was only the field and hill outside. It was getting brighter every minute.

As I stared, the bedroom started to become vague and indistinct, and suddenly I was outside, in this wonderful light. Then Ella appeared in front of me, full of health and energy, and brought with her a great feeling of happiness that filled my heart.

She just stood there for a moment, then she turned so she was sideways on to me. She half-reared, her mane was silky and flowing beautifully.

She was looking at me with a look that was full of expectancy and excitement, so much so I felt my heart lift, and I just shouted 'Go Gal!' She began to gallop up the hill and was gone.

I went out right away to the stable, shouting 'Ella!' all the way, but there was no reply from the stable. When I got in there, she was lying on the straw, dead. She had died sometime between 5 a.m. and 6 a.m. I bent down and stroked her and then I crept softly out and shut the stable door.

Now I will tell you what Ella looked like. She was a bay-coloured pony with three white socks, and a small white blaze. The pony that came (to say goodbye?) was pure white.

When Ella was alive she would always talk to me with little gentle whinnies, and was the most willing, forward-going little mare I ever had the pleasure of owning.

I will always believe what I saw that night, as I didn't go to sleep until midday on the day Ella died. She was fifteen years old.

Reading this story and thinking about it, I wondered if little Bomber would be fretting for his friend, so I phoned Margaret right away and asked her.

Then she explained that they also had another pony. He was a rescue pony and was called Nelson, because he was blind in one eye. He had always been with Ella and Bomber, but the other two were inseparable; Nelson just tagged along.

He was much bigger than Bomber, but now there was only the two of them, Bomber had taken him over. He bossed him about, and nipped his bottom when he didn't act as Bomber thought he should do. He seemed to know that Nelson was disadvantaged with a blind side, however, and he protected and looked after him always.

This seemed a very satisfactory end to a lovely little ghost story, one of the nicest I have come across.